THE FIELD HERPING GUIDE

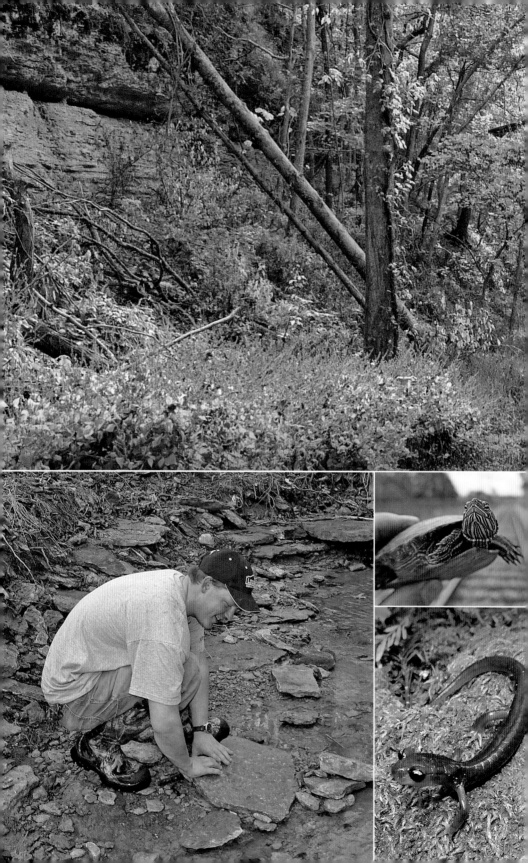

THE FIELD HERPING GUIDE

Finding Amphibians and Reptiles in the Wild

MIKE PINGLETON & JOSHUA HOLBROOK

The University of Georgia Press | Athens

A Wormsloe
FOUNDATION
nature book

© 2019 by the University of Georgia Press

Athens, Georgia 30602

www.ugapress.org

All rights reserved

Designed by Mindy Basinger Hill

Set in Minion Pro

Printed and bound by Versa Press

The paper in this book meets the guidelines for permanence and durability of the Committee on Production Guidelines for Book Longevity of the Council on Library Resources.

Most University of Georgia Press titles are available from popular e-book vendors.

Printed in the United States of America

24 23 22 21 20 P 5 4 3 2

Library of Congress Cataloging-in-Publication Data

Names: Pingleton, Mike, author.
Title: The field herping guide : finding amphibians and reptiles in the wild /
Mike Pingleton & Joshua Holbrook.
Description: Athens : The University of Georgia Press, [2019]. | Includes index.
Identifiers: LCCN 2018966793 | ISBN 9780820354583 (paperback)
Subjects: LCSH: Amphibians—North America—Identification. |
Reptiles—North America—Identification.
Classification: LCC QL651.P56 2019 | DDC 597.9/097—dc23
LC record available at https://lccn.loc.gov/2018966793

CONTENTS

ACKNOWLEDGMENTS

[*Mike*] First and foremost, thanks to my wife, Nell, for her unending support and for her patience during the absences this book required. Special thanks to first readers Tracey Mitchell and Tim Warfel and to Dan Fogell for his valuable input. Josh and I are also grateful for the input from our blind reviewers. Thanks to Justin Michels, finder of long-lost photographs; master birder Steve Coogan, for always being in my corner; Donald Becker and Christopher E. Smith, for shouldering the burdens of other projects when I needed to be absent; and Peter Berg, for unwavering support and some great advice. I'm grateful to a substantial number of field herpers, biologists, co-enablers, and deep thinkers, including Edvin Barrera, Dick and Patti Bartlett, Wayne Brekhus, Nick Burgmeier, Matt Cage, Kevin Caldwell, Michael Cravens, Daniel Dye, Andrew Durso, Joe Ehrenberger, Devon Graham, Kris Haas, Patrick Hammond, Erica Hoaglund, Andrew Hoffman, Jim Horton, Marisa Ai Ishimatsu, Patrick Kain, Rob and Nick Kreutzer, Alex Krohn, Jeff LeClere, Jeff Lemm, Chris MacDonald, Steve Marks, Erik McCormick, Armin Meier, Jeff Moorbeck, Jason Nelson, Andy O'Connor, Diego Ortiz, Emerson Pacaya, Todd Pierson, Matt Ricklefs, Dan Rosenberg, Jim Scharosch, Jake Scott, Lorrie Smith, Greg Stephens, Sky Stevens, John Sullivan, Kevin, Haley, and Ryan Urbanek, C. J. Vialpando, Shaun, Jeni, and Brandon Vought, Marty and Henry Whalin, Scott Waters, and Chad Whitney. Wittingly or unwittingly, directly or indirectly, you've all contributed to this work, while making the world a better place.

Thanks to my coauthor, Josh, for helping me down from a moldering pile of notes and into action and for catching my many instances of Yoda-Speak. Special thanks to Patrick Allen, Barbara Wojhoski, Melissa Bugbee Buchanan, and all the folks at the University of Georgia Press for taking on this project. Last but

not least, everyone has that special teacher; mine was Donald W. Keutzer, who introduced me to field herping back when it was called "snake hunting."

[Josh] Because this book is the product of years in the field, I feel indebted to a lot of people (and surely more I'm forgetting). Jason Thullbery, Lloyd Heilbrunn, Dermot Bowden, Brett Bartek, Don Filipiak, Chris Gillette, and Jon Mode were all go-to herping buddies during my years in Florida. Dan and Yvonne Dye are hospitality incarnate, and I appreciate their graciousness during my frequent visits to their biodiverse corner of northern Florida. Tom Chesnes from Palm Beach Atlantic University has been a good friend, herping buddy, mentor, and eventually colleague, and we are endlessly plotting more ways to have fun herping for "work." Nate Dorn from Florida Atlantic University was my advisor in graduate school and helped me, among many other things, integrate my understanding of herps into the larger world of ecology. The Herp Activity Model came to me the day he lectured on optimal foraging theory in our Advanced Ecology class and has been the paradigm for my understanding of herping ever since.

Other people I'd like to thank, in no particular order: the folks at the South Florida Herpetological Society, including Chris Bell and Caleb Bell; Team Aquatica — Dan and Yvonne Dye, Mike Dye, Jake Scott, Don Filipiak and Kyle Loucks; Mike Rochford; Chris Gillette; Ed Metzger; Danny Cueva; Berkeley Boone; Katie Ward; Cary Howe; Jason Butler; Josh Young; Tim Borski; the staff at Grassy Waters Preserve (especially Sarah and Sam); the staff at Jonathan Dickinson State Park (especially Rob Rossmanith); Scott Tedford with the Florida Park Service; the "Clarkii Crew" old and new — Hannah Boss, Jack Foote, Rebekah Petit, and Noah Benedictus; Amanda Berman for her help during my thesis work; and the Palm Beach Atlantic University Quality Initiative Grant for providing funding that contributed to my research for this book. In more recent time, my colleagues and students at Montreat College have provided fertile ground for continued learning about the natural world — it's always nice to have students like Jess, Ben, Abby, and Katy who are always game to probe its mysteries on a night hike or road cruise.

Finally, I'd like to thank the wandering herp wizard known as Tim Warfel for his incitement over the years; my coauthor, Mike, for his tireless pruning of my flowery writing and for his other hard work in this half-decade of a project; Pat, our editor at the University of Georgia Press, for believing in this book and its potential (and graciously dealing with our delays); three anonymous reviewers

who provided helpful insight, corrections, and encouragement in the development of this book; the LitWits, for keeping my writing sharp while discussing Norse mythology and Christian theology; and of course, my wife, Rebekah, and daughters, Chava and Josephine — it's especially fun to teach all this stuff to you two as you get older — I look forward to a thousand more salamander and snake hunts!

Many people go herping before they even know there's a word for it!

INTRODUCTION

What Is Field Herping?

Many people have had some kind of experience with amphibians and reptiles, and their first contact with these creatures often takes place as a child. Have you ever caught frogs near a pond or found a snake in the garden? Perhaps you found a salamander under a rock or enjoyed watching turtles basking on a log. All these scenarios are essentially field herping experiences, and your interest in this book indicates that you're looking for more.

In the context of this book, field herping, or more simply, herping, is the act of searching for amphibians and reptiles ("herps") as a recreational activity. As a rule, the animals are not collected, and when possible, they are observed "as is" without being disturbed. Any herps that are physically handled are treated with care and respect and are immediately released at the place of their capture.

Over the past few decades, public perception of amphibians and reptiles has changed dramatically, and many herps that were once reviled and feared are now regarded with fascination and respect. As a result, more and more people are developing an interest in field herping and getting involved with nature.

Field herping is a lot like bird-watching in many respects: both pursuits get people outside to look for interesting, charismatic animals. Many field herpers are also birders. Birding and herping can be enjoyed on many levels, from the casual weekend warrior to the avid, hard-core enthusiast. Field herpers *do* have a big advantage over birders; they can get close to many amphibians and reptiles, observing and photographing them from all angles, and in many cases, even touching and holding them. Birds, bears, and bees are hard to get in hand, and the sensory experience of handling herps and examining them up close makes field herping a great learning experience for adults and children.

How to Use This Book

Over the past two decades, field herping has grown into a worldwide recreational activity, thanks in no small part to the proliferation of the Internet and social media. More than likely, you've already had some experiences that have sparked your interest in amphibians and reptiles, and with this book we hope to fan the flames. While the material is intended for all levels of experience and interest, *The Field Herping Guide* is designed as a how-to manual and source book for beginning field herpers. The chapters and appendices cover information you will need to begin herping, improve your skills, and enrich your experiences. Using "herper" sidebars along the way, we provide some of our own field herping experiences (along with those of a few guests) to highlight practical knowledge. Each chapter builds on the information provided in previous chapters, and while we can hardly expect you to read the entire book before embarking on your next herping adventure, we hope you will look through the first six chapters at least.

While this book has a North American bias, the principles and practices within it apply worldwide. Field herping does not require a lot of specialized equipment or travel to exotic places; to get started all you need is an interest in herpetofauna, a curiosity to learn more, and the desire to step outside your door. Like anything worthwhile, your field herping experiences will improve with study and practice, and some of the concepts and methods covered here may make sense only after you have some hands-on experiences with them in the

field. While *The Field Herping Guide* can be tucked into your car or backpack, you're more likely to use it as a reference at home between field trips, where you can use it to help make sense of your animal encounters and strategically plan your next outing.

Basic Terminology

The terms *herp*, *herping*, and *herper* are derived from the word *herpetology*, the scientific study of amphibians and reptiles. *Herpetology* itself comes from the Greek *herpeton* (creeping thing) and *logos* (reason or knowledge). While amphibians and reptiles (herpetofauna) are not closely related on the tree of life, many of them are indeed creeping things, and long ago they were lumped together in one field of study. Most field herpers and herpetologists are okay with

WHY WE DID IT

If you're just getting into herping, chances are we were once in your shoes: we knew we loved herps but didn't know what we were doing; we rubbed other herpers the wrong way by brazenly asking for spots; we were less-than-ethical in our handling of amphibians and reptiles; and we experienced those long stretches of finding *nothing* only to find out later how off base we were in our field methods. We've been there, and we've seen other herpers there too; we learned many things the hard way. When we were starting out, there were no Internet forums (or Internet, in Mike's case), there were no close-knit communities of herpers in every region, and the few herpetological societies were centered in large metropolises. Much of that has changed, but field herpers are still left to stumble around on their own, making many mistakes and gradually (hopefully) getting better at it. If that's you, we have written this book for you. First, because we remember our first attempts at herping, we want to save you some time and effort, while sparing you from some of the negative aspects. Second, herping is becoming exponentially more popular, and with increasing numbers comes an increase of everything that goes with it. More herpers *can* mean more habitat destruction, more animals harassed and injured, and more cramped, cluttered natural areas. We want to steer you in a direction that is beneficial for you, your herping experiences, the animals, and the habitats they live in. We wrote this book for you — sit back and enjoy.

[Josh and Mike]

that — amphibians and reptiles often share the same traits, habits, and habitats. For the most part, herpetologists are biologists by training. Few have an actual degree in herpetology (indeed, few colleges and universities offer one), but they study amphibians and reptiles as a professional research interest.

Field herpers, on the other hand, come from all sorts of professions and walks of life, and most are not herpetologists, but some herpetologists are also field herpers, both for science and for pleasure. Field herpers often make contributions to the science of herpetology and to the conservation of herpetofauna. Generally, field herpers and herpetologists get along well within their common area of interest.

People who keep amphibians and reptiles in captivity are sometimes called herpers, and while some people are involved in both areas, many field herpers do not want to be confused with the keeper community. The term *field herping* came into common use late in the last century, when the growing popularity of the activity called for a more distinctive term.

The words *herpes* and *herp* are derived from the same Greek root word as herpetology, and this is sometimes a source of irritation to field herpers. The herpes virus is no laughing matter, but some people make lame jokes associating herpes with herps and herping. Field herpers and herpetologists alike are very tired of this, and sometimes wish for a more appropriate term than *herp* for their interest. Unfortunately, despite countless conversations in social media, at conferences, around campfires, and in vehicles road-cruising desert highways at night, nothing better has come to light. The authors are comfortable with the term but expect the debates (and the bad jokes) to continue.

Use of Scientific and Common Names

When they are described to science, all animals, plants, and other living things are given a scientific name. This name is a unique descriptor that makes it possible for anyone, speaking any language, to know which organism is being referred to. Scientific names also help us know where they fit on the tree of life. Since many herps have multiple common names, scientific names are widely used to pinpoint the exact species. In some cases, the scientific name can also provide a unique "shorthand" name — for example, the Trans-Pecos ratsnake (*Bogertophis subocularis*) is commonly referred to as a "suboc."

In recent years, genetic studies have shed new light on the relationships

GET OUT THERE!

It might seem obvious, but "being outside" can be woefully neglected nowadays, when television and the Internet can bring you the beautiful illusion of nature without your actually being there. Back in high school, I wanted to get into an agriscience program and focus on the environmental science classes it offered, and in the interview I was asked about my experience with the subject. I said I had spent lots of time hiking in the woods near my New England home, exploring and getting acquainted with the plants and animals. The teacher interviewing me was flabbergasted — nearly every other person interviewed for the program had gotten his or her wildlife "experience" from cable TV documentaries! Hearing that someone was going out and having experiences firsthand was a joy to her ears, and to me a lesson not to let the ease of technology take the place of outdoor experiences. Learning about herps firsthand, through trial and error, is the best way for new herpers to really appreciate the amazing animals they find. [*Josh*]

within some groups of herps, resulting in many changes to scientific names, and in some cases, common names as well (see chapter 7 for more on this). Some of the recent changes are widely accepted, while others remain controversial; we have used the most up-to-date names in *The Field Herping Guide*, except in cases where it may cause confusion, or when we have solid reasons to disagree with the current naming and classification. There is plenty of argument in some circles about the validity of subspecies, but field herpers as a group use them, so we make use of them as appropriate.

The use of standard English common names is also important, and we have striven not to stray too far off the path. When an amphibian or reptile is first referred to in this book, we use the standard common name and the scientific name, but in subsequent uses we shorten the reference to either the common name, the scientific name, or a colloquial name like "snapper." Our reference for both standard common names and scientific names is the Checklist of the Standard English & Scientific Names of Amphibians & Reptiles, compiled by the Society of the Study of Amphibians and Reptiles (ssar). The ssar's list can be found on the society's website (https://ssarherps.org). However, the ssar list only covers the species found in the United States and Canada. For species found

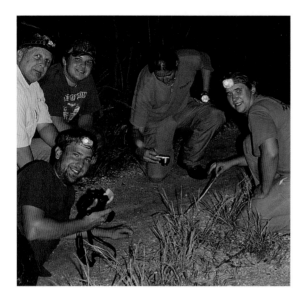

A happy group
of herpers.

elsewhere that are mentioned in this text, we referred to the Reptile Database (www.reptile-database.org) and Amphibian Species of the World, the American Museum of Natural History's online reference (http://research.amnh.org).

The Joy of Herping

What attracts people to field herping, and what makes it a pleasurable activity? People sometimes find it hard to explain why they find amphibians and reptiles so fascinating, even after years in the field, but good reasons to go herping are manifold:

Beauty Many amphibians and reptiles are visually stunning, with amazing colors, intricate patterns, and interesting shapes. Aesthetics aside, field herpers often come to appreciate less tangible forms of herp beauty: their courtship and reproduction strategies, survival tactics, locomotion, venom, countless ways of adaptation, and so on. A sidewinder moving across a stretch of desert sand is a wonderful thing to see. It also doesn't hurt that many herps are found in some beautiful places around the world.

Accessibility Tactile experiences with amphibians and reptiles have a powerful attraction, and many species that can't be caught or touched are at least

approachable. If you're able to catch a given herp, it can be temporarily "detained" for closer inspection and photographs, something not easily done with other life forms.

Mystery Some herps are hard to find, hard to see, and their habits and life histories poorly understood — causing many herps to be labeled a "cryptic species." They are puzzles waiting to be solved, and that sort of challenge appeals to many people. Looking for herps is always fun, but finding them, and figuring out how to reliably find them, can be a much more satisfying experience. Through this process, solving one mystery often uncovers another.

The quest Humans love looking for things and finding them, and doing so often leads to adventures and new experiences. You may succeed in your quest to find herps, or you may fail — but either way you can learn more about them and polish your fieldcraft. You may also learn some things about yourself along the way. Quests are not always easy: you may get wet, sunburned, bug-bitten, or lost, but you are likely to have a great time all the same and look back on your adventure fondly.

Adventure travel Though the act of field herping is in itself a worthwhile activity, it also opens up many opportunities to travel. You can visit new and exotic places, and you may come to appreciate old familiar spots with new eyes. Exploration, adventure, dramatic landscapes, and meeting new people are part of the travel package.

Aspects of Field Herping

There are several key elements of field herping, all these elements are woven into *The Field Herping Guide*, and many have their own chapters:

Natural history It is practically unavoidable: a herp encounter leads to many questions. How does it live? What does it eat? Why does it live here? Answers often lead to more questions, and the more you learn, the easier it becomes to find other herps. Along the way you may develop other side interests that are a natural fit with field herping, such as geology, or spring wildflowers, or perhaps birds. The natural world is an amazing place, and field herping can be your portal.

Photography As you'll see in a later chapter, photography is an essential element of field herping, and for some herpers it becomes a serious interest in

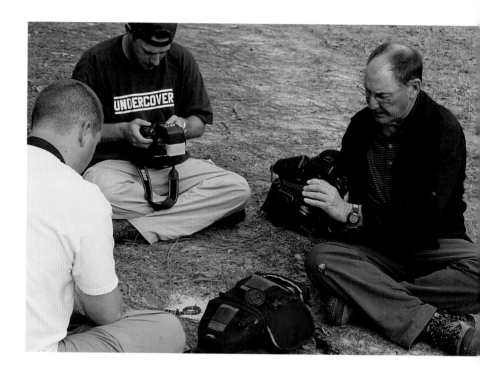

its own right. Photography allows you to record the herps you find, as well as the habitat and location, and photo vouchers can aid citizen science projects. Photos are also a great tool for identifying herps, studying habitat, and improving your fieldcraft. Digital images also make it easy to participate in herp-related social media.

Life listing The practice of keeping a "life list" originated with birders, but many herpers have adopted the practice as well. A life list is a way to keep track of all the herp species you have seen. Whether you decide on a simple list or a complex collection of data, your life list can help you record what you've seen and set goals for the future.

Field surveys and data collection When you're out in the field, why not be a force for herp conservation? The role of the citizen scientist is expanding, and volunteers are always needed for herp surveys, bio-blitzes, and other conservation efforts. Information about even the most common species can be valuable to researchers and conservation agencies. Data repositories such as state herp

atlases, HerpMapper, and iNaturalist are good places to record your observations for use by researchers.

Social aspects Before the Internet and social media existed to facilitate interest and meetups, field herping could be a lonesome activity. The Internet has made a global field-herping community possible. Facebook, Twitter, Instagram, and forums like Field Herp Forum provide opportunities to communicate, make new friends, and share your experiences.

The great outdoors Field herping often includes hiking, camping, and other pleasurable outdoor activities. You may find that as you spend more time outside, you'll want to spend less time inside. Adventure awaits!

What Are Amphibians?

Amphibians typically have moist, permeable, scaleless skin, and most species require access to water. While some amphibians are able to live away from water (such as toads and newts in their eft stage), nearly all amphibians must return to the water to lay their eggs — some even spend their whole life in the water. Amphibian eggs lack a shell and instead are encased in a gelatinous coating. Offspring undergo different stages of larval development, leaving the water only after they transform into adults. Frogs, toads, salamanders, and caecilians are

GETTING INTO FIELD HERPING

If you're new to field herping, the first thing I want to say to you is welcome! If your first attempts at finding amphibians and reptiles were less than successful, don't worry too much. Field herping is an activity where skills and experience accumulate over time, and learning from each outing and from your mistakes is part of the process. While field herping is not as popular as bird-watching, the number of participants is growing, and you'll find that many herpers are friendly and helpful people. Over the years, field herping has taken me to many awesome places; I've been fortunate to see some amazing animals, and I've made some great friends along the way. I hope your field herping experiences are equally great. [Mike]

grouped together in the class Amphibia, and more than seven thousand species have been described to date across three different orders:

Order Anura: Frogs and toads. 6,200+ species.

Order Caudata: Salamanders and newts. 650+ species.

Order Gymnophiona: Caecilians. 190+ species.

What Are Reptiles?

Reptiles are equipped with thick skin, scales, and in the case of turtles, shells. These characteristics allow them to retain moisture within the body, and many are able to live in habitats with little or no water. Reptiles lay their hard-shelled eggs away from water, which means that aquatic reptiles (like sea turtles) must return to land to lay their eggs. For some species such as gartersnakes and pit vipers, the young develop internally, and the female gives birth to live young. Unlike amphibians, reptiles do not have a larval stage: neonates have the same body form as adults, although they often have different colors and patterns.

Turtles, crocodilians, tuataras, snakes, and lizards are generally grouped together in the class Reptilia, and more than ten thousand species have been described to date across four orders:

Order Testudines: Turtles, terrapins, and tortoises. 400+ species

Order Crocodilia: Crocodiles, gavials, caimans, and alligators. 25 species.

Order Sphenodontia: New Zealand tuataras. 1 or 2 species.

Order Squamata: Lizards, worm lizards, and snakes. 9,600+ species.
The order Squamata is divided into three suborders, two of which are very familiar to most people:

Suborder Lacertilia: Lizards. 6,000+ species.

Suborder Amphisbaenia: Worm lizards. 180+ species.

Suborder Serpentes: Snakes. 3,400+ species.

Field herpers photographing their find, a cottonmouth (*Agkistrodon piscivorus*) in the wilds of South Carolina.

CHAPTER 1
GETTING STARTED

What do you need to know to go field herping? What equipment do you need? Where do you go, and when, and what do you do when you get there? What do you need to know about herps? This chapter and the two following it provide answers to these questions and more, along with a framework for putting that knowledge to work. We'll begin with three "know before you go" items to consider.

Before You Go

The Learning Cycle

Like so many other endeavors, field herping is a cumulative, learn-as-you-go activity, and the more effort you put into it, the more you will get out of it. The cycle of learning starts in the field:

- Going herping and recording details (photos, notes, memories) of your experience
- Thinking about your experiences and the herps you found (or didn't find)
- Further reading and research and perhaps learning from other herpers
- Applying the knowledge gained on your next herping trip

The cycle of learning is continuous: field herpers with decades of experience are still working to improve their fieldcraft (and spending time in the field with experienced field herpers can accelerate your own learning process). Along with learning how to find and identify herps and understanding their behaviors and natural history, experience will help you conserve precious resources such as time, energy, and money.

Identification

Identification is fundamental to field herping. If an animal can be identified, its natural history can be considered, and your observations can be placed in a proper context. Proper identification is also important for sharing your experiences with others and for building relationships in the field herping community. Learning to identify herps is part of the learning cycle, and the next section will cover some tools and practices to help with the process.

Identification tends to flow along lines of taxonomic classification (class, order, family, genus, species), and the top levels are often obvious. When you find a frog, you've already established the class as Amphibia and the order as Anura, leaving the family, genus, species, and perhaps subspecies to be figured out. With practice and experience, you'll get to know the field marks, body shapes, and other identifiers that will allow you to jump right to genus and species (see chapter 7 for more details on taxonomic organization). Location can sometimes be of great help, allowing you to narrow the range of possibilities. For instance, if you find a lizard in Connecticut, you can make a confident identification, since that state has only one native lizard species, the common five-lined skink (*Plestiodon fasciatus*).

Identification can sometimes be a challenge, since herps don't always look like the illustrations in field guides, but this also provides opportunities to sharpen your skills. The identification process is based on color, patterns, body shapes,

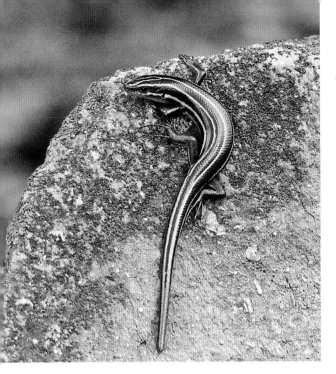

Plestiodon fasciatus, Connecticut's only native lizard.

scale configurations, pupil shapes within the eye, voice, and other characteristics. Fortunately, the human brain is very good at pattern matching, and identification can often be made based on just one or two key details. Identification is a mental skill that develops over time, and after enough experiences, you can often name a herp from the briefest of glimpses. As your expertise develops, identification can take place on a subconscious level, as your brain automatically searches through mental pictures and impressions from your previous experiences.

Essential Tools

This last item in the "know before you go" section covers three essential tools for your field herping. Field guides, cameras, and notebooks are also included in the list of field herping gear (see next section), but they are essential to the learning cycle, and are just as important for use at home as in the field.

Field guides It would be difficult to take up field herping without the use of a field guide. Field guides show you which amphibians and reptiles are in your area and how to identify them. They typically contain photos and illustrations of the animals, identification keys, and range maps to show where they occur. We live in a golden age of field guides; there are many to choose from, and North

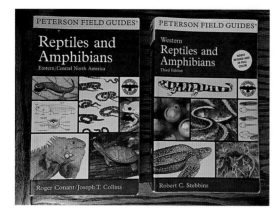

Peterson Field Guides are popular choices. These two guides cover the United States, Canada, and northern Mexico in some cases.

America as a whole is well represented. To start, we recommend picking up a regional field guide that covers your general area and a more specific guide for your state or province, if one is available.

While they are handy to have when herping, field guides are also powerful learning tools to be used at any time. Read through your field guide at home between herping trips. Spend time getting familiar with the contents — know what's in the guide and how the book is organized. Before your next herp trip, use the guide to learn which herps are found in the area and what their habitat preferences are and become familiar with their appearance.

Camera Like the field guide, a camera is an indispensable tool, both in the field and at home. Expensive cameras and elaborate gear are not necessary; a cell phone camera can meet most of your basic needs in the field. Naturally you will want to take pictures and video of the herps you find, but a camera can also serve as a learning tool. A herp needing identification can be photographed from different angles and aspects. Photos of herps "as found" and habitat shots can be useful in the learning process. Additionally, there is always the possibility of recording a rarely seen natural-history phenomenon (such as combat between two male rattlesnakes) or perhaps something that has never been documented. Herp photography has its own skill set; chapter 9 covers photographic ideas and techniques in greater detail.

Notebook The first time you need to recall details from a herp trip, you'll understand the value of taking notes. You may remember every herp found on the trip last week, but what about a year from now? Do you remember which roads and turns you took, and what county you were in? The name of the farmer

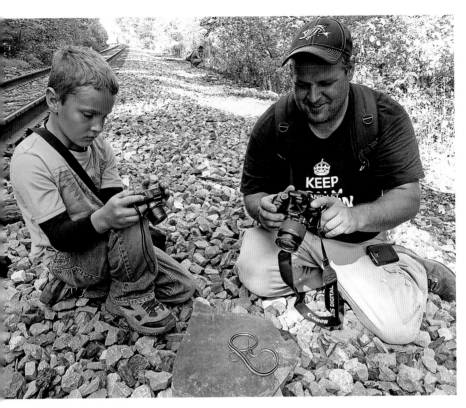

Cameras aren't just useful. They also capture memories that can last a lifetime.

who let you flip boards behind his barn? What was the weather like that day? What was that funny thing that Jim said?

The note-taking process can be tedious, but if you stick with it, your notes can become a valuable source of information that you can use and enjoy for years to come. Don't wait too long to get your observations down on paper — take advantage of any downtime in the field to keep your notes updated, and don't leave the task for when you get home. When it becomes a habit, taking field notes can help train your brain to see and remember details you might otherwise miss. Use a fresh page for each new trip and one for each day, and before too long you will find your comfort zone for note taking. Along with the basic details, record your takeaways — the things you learned that day or the things you want to research further. You can also add to your notes later, as you confirm an ID, recall more details, or realize important lessons. Often unique and fascinating,

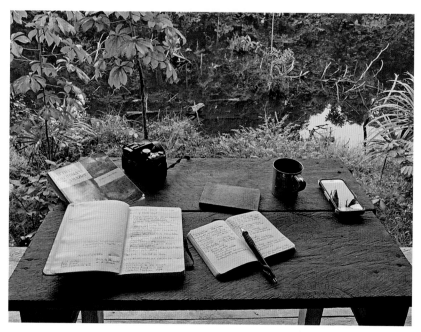

Morning coffee and catching up on notes.

and occasionally frustrating, your field experiences are worth recording and remembering, and you will be glad you did.

Field Herping Gear

For most situations, the basic gear for hiking is also the basic gear for herping, with a few special items added. Part of the fun is figuring out what gear works best for you and putting your own stamp on it. Specialty gear is covered in other chapters, and the camera, field guides, and notebook discussed earlier should also be on your pack list.

Water Staying hydrated is absolutely essential whether you're hiking in the desert or walking in bottomland swamps. Bring plenty of water with you, even on short outings, and make sure you're well hydrated before setting out. Plan for the unexpected—you may be out in the field longer than you anticipated, so bring extra "emergency" water. You may also need extra water to wet your hands before handling amphibians (avoid using chlorinated tap water for this purpose), for rinsing mud or sand off herps, and for washing your hands.

THE LEARNING CYCLE (OR, HEAT AND HERPS: BFFS?)

No matter how knowledgeable people become on any given subject, there is always a point in time when they were woefully ignorant about it, and herping is no exception. At the beginning of my learning cycle, I knew a little bit of herp biology and thus knew that snakes were, in fact, cold blooded (OK, so they're really poikilothermic ectotherms, but you get my point). With that kernel of truth, I made the logical leap that snakes need external heat; therefore snakes must like it as hot as possible. So I limited my herping to middays in July and August, when temperatures were in the high eighties and nineties. Needless to say, my finds were limited, and I would go home dismayed. So what was going wrong? Was Connecticut (my home state) completely devoid of snakes? Not nearly — as time passed, I began to learn and study snakes, and perhaps equally importantly, I got out with other herpers and realized that snakes don't necessarily like it when temperatures are extremely hot. Like other organisms, snakes have an optimal temperature range, and often this temperature is significantly lower than the hottest of the hot weather. I now realize that in the eastern United States at least, an eighty-five-degree day may be just as good for evening road cruising as a ninety-five-degree day — it may even be better. I also know that few snakes will be active during the heat of the day, just like most humans! Herping is a cumulative learning experience and depends on being humble enough to submit to the learning cycle — which means admitting when you simply don't know and always being eager to let new knowledge make your experiences better. [Josh]

Clothing, hat, and footwear Standard outdoor wear is recommended, and should be appropriate to the climate and weather conditions. Your clothing should be loose enough to allow bending and kneeling. Brimmed hats and long-sleeved shirts are essential for outings under a hot sun. Long pants are a must in areas with ticks, chiggers, and irritating plants such as poison oak, poison ivy, and stinging nettle. Sturdy hiking boots and good quality socks are appropriate for most situations. Specialty snake boots or gaiters are not usually necessary and are discussed in chapter 5. For aquatic adventures, rubber boots,

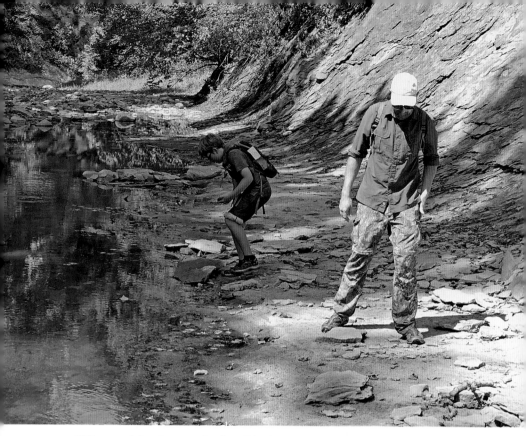

Hiking gear is herping gear. Creek-walking in Indiana.

water shoes, sandals, or dive boots should be considered. Think about rain gear as well — at the very least, tuck a cheap plastic poncho into your gear bag. Rain can be some of the best weather for certain kinds of herping, but it can be miserable without some protection from the elements.

Mobile device Cell phones are necessary for emergencies and are also handy for taking pictures and video, for recording GPS locations and tracking your movements, and for creating voucher records used in citizen science projects.

Insect repellent Typically, repellent is used in areas with ticks and mosquitoes, which should be taken seriously as carriers of disease. Most effective repellents contain either DEET or permethrin as an active ingredient and should be used only as directed. A serious problem with repellents is their toxic effect on amphibians. Make sure to wash your hands after applying, and avoid wading into water wearing repellent-laden clothing. Some repellents are notorious for

damaging plastic — be sure to keep them away from cameras and other gear. Bug jackets make a good alternative to insect repellant in many situations.

Flashlights and headlamps Selecting flashlights and headlamps is a source of pleasure for herpers, and many options are available. Along with their obvious use at night, flashlights are useful for lighting up the interiors of cracks and crevices. Headlamps keep your hands free for handling herps, taking photos, and keeping your balance. Think about your flashlight needs: Would a spotlight best suit you, or a floodlight? What about batteries? You may end up needing more after a long night in the field; commonly used batteries like AAs are available at most gas stations. You might also consider rechargeable batteries and using a car charger. Two light sources are better than one; think about bringing a backup flashlight, just in case.

Area maps Map programs loaded on a mobile device can be very useful but may not always be available in the field, so consider bringing a state or province road map. DeLorme state atlases are excellent; they show small roads, elevations, and natural land features in detail and are very useful for finding new

Headlamps leave your hands free for cameras and other objects.

left Using a DeLorme Gazetteer to plot the next day's adventure.

right Make sure you're prepared for the places field herping will take you!

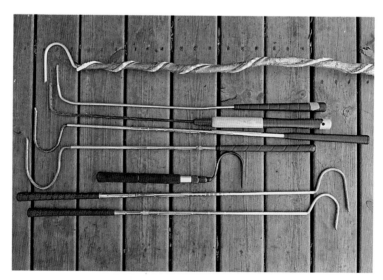

A portion of Mike's snake hook collection.

places to herp. National Geographic publishes regional maps that are sturdy and water-resistant.

Gear bags Backpacks are the preferred choice for carrying gear because they leave your hands free. Most people have some kind of backpack already, and for day trips, even an old school pack will do. There are an overwhelming number of backpacks on the market, but in general, look for one that is rugged yet comfortable, with multiple compartments and places to securely stow a water bottle or two. A waterproof bag, or one with a rain cover, is also worth considering.

Snake hooks Field herpers love snake hooks and often have more than one. This handy tool serves as an extension of the arm and hands and keeps them out of harm's way. Handling snakes (see chapter 4) is usually a secondary use; snake hooks are often used for lifting boards and other types of artificial cover and for poking around in bushes and leaf litter. There are many kinds of snake hooks on the market, and most people prefer a sturdy hook that will hold up to heavy use. Hooks can also serve as a walking stick, a camera monopod, and a weed whacker. The snake hook is the signature tool of the field herper; find (or make) one you like and carry it proudly. Keep in mind that snake hooks are often viewed by others as a tool for capturing herps and thus may not be allowed in some parks, wildlife refuges, and natural areas.

Where to Go

Amphibians and reptiles can be found in many places, even if you live in an urban area. Some herps may be as close as the neighborhood park or even in your own backyard.

Public lands Parks, nature preserves, natural areas, wildlife refuges, and conservation areas are good places to look for herps. Even city and suburban parks can have populations of amphibians, snakes, and aquatic turtles. Keep in mind that most types of public lands have rules and regulations concerning the plants and animals found there. Wildlife refuges are a good example; you may observe herps, but handling them is likely forbidden. See appendix 2 for more information on how different public lands are managed, the rules and regulations that apply, and how those rules may impact field herpers.

Water Flowing or still, permanent or temporary, all bodies of fresh water are herp attractors and concentrators. Water turtles, aquatic salamanders, and

crocodilians make their homes in the water, while frogs, toads, and snakes live along the bank. Water and the water's edge can also serve as a corridor for travel; most terrestrial amphibians must return to the water to breed and lay their eggs. In dry climates, herps are especially drawn to water or to places where water collects when it rains.

Trash dumps and abandoned buildings Piles of trash, appliances, furniture, and building materials are often dumped or left behind in vacant lots, old farm fields, around abandoned buildings, and along roadsides. Herpers refer to these cast-off objects as artificial cover (or AC), and they provide herps with refuges from predators, places to bask and to digest meals, and protected places to lay eggs. Artificial cover also attracts herp prey items such as insects and rodents. For herps and herpers both, boards and sheets of metal roofing are favorite AC items, but herps can also be found under mattresses, cardboard, carpet, roofing shingles, and other flat items that provide a desirable refuge. Watch your step in these places, where rusty nails and broken glass are common hazards.

EVERYTHING IS AWESOME

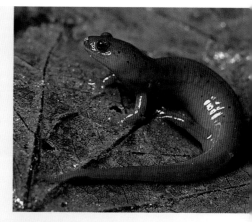

This little mud salamander (*Pseudotriton montanus*) has an interesting natural history and lives just a few hours away from millions of people.

A common misconception (thanks in part to nature documentaries and perhaps human nature) is that the *really fascinating* animals are found only in faraway, exotic locations. Consider that field herpers living elsewhere in the world think *your* local herps are exotic and awesome. A good example is North American box turtles (*Terrapene*), which can be locally common across the eastern two-thirds of the United States, yet herpers come from all over the world for the privilege of seeing one. While you're likely to start herping locally, you may end up traveling to other regions and countries, and any herpers you meet may be very interested in the common herps you find back home. [*Josh*]

left A stack of corrugated roofing is a herper's dream. There is a temperature gradient in the stack, warmer at the top, and cooler at the bottom. Animals can seek out different temperature levels, and each layer may have herps.

right Old billboards are always worth investigating. Plywood, boards, and other artificial cover are likely to be scattered underneath.

Occupied buildings and other structures Old equipment, building materials, and other kinds of AC are often hidden behind buildings. Gas stations in rural areas are worth checking — many have some kind of AC behind them. Billboards along roads and highways often have old sections of plywood and other cover items scattered around underneath. Roadway bridges and culverts spanning creeks and streams are good places to check — along with turtles and amphibians, many kinds of snakes use the space underneath them for refuge and for hunting prey. Urban and suburban backyards can provide habitat for snakes and lizards, especially if brick piles, boards, and other types of AC are present.

Agricultural areas Farm fields and adjacent areas can be very productive sites for herps, thanks to an abundance of food and cover. For example, the

sugarcane fields around Florida's Lake Okeechobee are famous for the numbers of Florida kingsnakes (*Lampropeltis floridana*) found there. The kingsnakes undoubtedly prey on the large populations of rats, mice, and other snakes that live in the cane fields. Farm fields may also have old barns, board piles, and other cover materials that attract snakes and lizards. In dry climates, cattle tanks and their steady supply of water attract herps, and some species may take up permanent residence in these man-made ponds.

Private land The most tempting places to herp are often frustratingly situated behind "No Trespassing" signs. While posted property should be respected, it is often possible to gain access by talking to the owner — check at the nearest house. In the authors' experience, most landowners give permission if approached in an honest and respectful manner. Friends, family, and neighbors may also know of private land where you can get permission to explore. In some parts of the country, it may be possible to gain access to hunt clubs, which often have plenty of good habitat for herping when hunting season is closed.

Privately owned land can provide many herping opportunities.
This dilapidated barn has many cover objects for herps to hide under.

ALWAYS CHECK BEHIND THE GAS STATION

Texas nightsnake (*Hypsiglena jani texana*).

On my first trip to west Texas many years ago, we had a flat tire fixed at a gas station in a small town (flat tires can be a common mishap in west Texas). Bored and tired of waiting, my friend Rick wandered behind the building. He came back in an excited state with a checkered gartersnake (*Thamnophis marcianus*), which he had found under a plank next to the back wall. Of course, the next time we stopped for gas we were eager to check behind the station, and we turned up a Texas nightsnake (*Hypsiglena jani texana*) and a Texas banded gecko (*Coleonyx brevis*). Since then, I've made it a habit to check around the back any time I stop for gas and behind hotels and restaurants as well. Often there's some kind of junk tucked out of sight behind the building, and my success rate is high enough to keep me checking. One of my favorite around-the-back finds was a beautiful eastern copperhead (*Agkistrodon contortrix*), found under a rusty tailgate behind a gas station in western Kentucky. Give it a try the next time you stop for gas. At night, don't forget to check the area around the building for frogs, toads, and geckos, which feed off insects attracted to lights. [*Mike*]

When to Go

In general, spring and fall are the peak seasons for field herping in North America, but your geographic location will dictate the kinds of herps you can find at different times of the year. In Florida, herpers have opportunities to get out during the winter, while Canadian herpers must wait until spring comes and the snow melts (or jump in the car and head south). In the desert Southwest, prime time for herping is late summer, when the monsoon rains come. The answer to the question, "When?" isn't strictly based on location or the calendar; it can depend on temperatures and weather conditions and the natural history of the herps you are seeking.

Amphibians

In temperate climates, late winter and spring are generally the best times to see most frogs, toads, and salamanders because this is when the breeding season begins. They are often active in colder conditions when reptiles are still dormant. During the hot, dry summer months, many amphibians retreat underground, doing their best to conserve moisture until it rains. In regions with dry climates, amphibians may remain underground for much of the year, emerging only during periods of rainfall or at night.

In regions with ice and snow, terrestrial salamanders typically spend the winter underground or in layers of leaf litter. Further south, salamanders may be active year round in places with adequate moisture. North America has some fully aquatic salamanders (hellbenders, sirens, amphiumas, and waterdogs), which are active in all seasons. In northern regions, waterdogs actively feed under the ice and are sometimes caught by ice fishermen.

Many species of mole salamanders (*Ambystoma* spp.) emerge to breed in winter or early spring. The timetable depends on when temperatures climb above freezing, when the rains come, and in northern regions, when the snow melts. Responding to these seasonal triggers, ambystomatids such as spotted salamanders (*Ambystoma maculatum*) emerge from deep under the ground and, under the cover of darkness and rain, make their way to breeding ponds, where they lay their eggs. Clad in rain gear, headlamps, and rubber boots, many herpers begin their field season by witnessing these nocturnal migrations to vernal pools.

On rainy nights, try driving on roads running through appropriate amphibian habitat. You may find frogs, toads, and salamanders crossing the road. Others may be observed soaking up water from the surface or feeding on earthworms and other invertebrates.

Like terrestrial salamanders, frogs and toads may be active year round in warmer regions without ice and snow, but further north, they must hunker down to wait for spring. Some types burrow into the soil, while others wiggle into the muck at the bottom of ponds, lakes, and streams. Rising temperatures, melting snow, and rainfall trigger their emergence and often stimulate reproduction. Frogs and toads do not all breed at the same time of year — each species has its own timetable for courtship and mating, with some waiting until late spring.

In arid climates where rain may be absent for many months, frogs and toads breed during the heavy monsoon rains that fall in late summer. Finding amphib-

A spotted salamander (*Ambystoma maculatum*) along the edge of a vernal pool in southern Indiana.

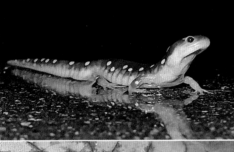

This spotted salamander was one of many out on the mountain roads of North Carolina on a rainy autumn night.

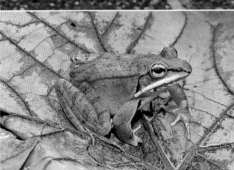

A wood frog (*Lithobates sylvaticus*) found near a vernal pool in early March.

ians in desert regions depends on paying attention to the weather, and getting out in the field either when it rains or immediately afterward.

Reptiles

April, May, and June are the peak months for reptile activity across much of North America, and warm, sunny days are best for finding them. In southern regions, some reptiles may be active during the winter on such mild days. In desert climates, many reptiles have a period of increased activity during the monsoon rains of late summer.

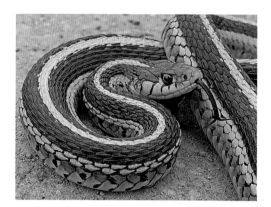

A red-sided gartersnake (*Thamnophis sirtalis parietalis*) found in early spring in central Kansas.

Most reptiles do not have the cold tolerance of amphibians, and they require warmer temperatures in order to function. Their activity depends on the sun, either directly or indirectly. In colder climates, most reptiles do not emerge until freezing temperatures are near an end and the ground begins to thaw. Some reptiles become active earlier than others; you may see gartersnakes and ribbonsnakes (*Thamnophis* spp.) on sunny days with snow still on the ground, and aquatic turtles are sometimes seen swimming underneath the ice. Spring weather can be fickle, and when cold weather returns, reptiles retreat to sheltered places above or below ground.

During the summer, daytime temperatures may be too high for reptiles to be active, and once again this depends on geographic location, patterns of rainfall, and the species involved. Diurnal desert lizards often reduce their surface activity during the heat of the summer, appearing only in the morning and late afternoon. Other diurnal reptiles may become nocturnal in order to beat the heat. Like the activity of amphibians, reptile activity often increases during and after rainfall in many regions.

Autumn can also be a great time for observing reptiles. Cooler temperatures bring an increase in daytime activity, as reptiles forage for their last meals of the season and as they move toward their winter quarters. It is also the time of year when neonates are present in large numbers, and they too must actively search for food and shelter. In desert regions, neonate rattlesnakes are commonly seen on roads at night during late summer and fall.

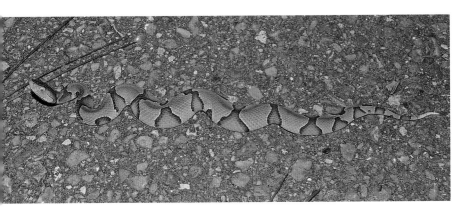

Copperheads (*Agkistrodon contortrix*) are often found crossing roads on hot summer nights.

Time to Go Herping! Basic Fieldcraft

While we recommend reading at least the first six chapters, we can hardly expect you to read this book cover-to-cover before getting out in the field. In this section we'll briefly touch on some basic elements of fieldcraft for you to consider.

Watch and listen Keep your eyes and ears open for movement — you may be surprised at how many herps can be found by catching their motion or by the noise they make. Along with the ground directly in front of you, scan the middle ground as well. You can sometimes find a herp based on its silhouette against the horizon or by looking down a path or a side road.

Move slowly, move quietly Fast movements are easily detected by herps and are often noisy — many herps have ears and can hear your approach. You will see more herps by moving slowly and paying close attention. Quiet movements also allow you to hear some herps as they move. With experience, you may find that you can move at a near-normal pace while remaining quiet and attentive.

Look under everything Rocks, logs, boards, and metal objects are obvious choices, but herps will also make use of thick grass, bushes, and fallen slabs of tree bark for cover. They may also be found under cardboard, carpet, tires, shingles, and other man-made objects that provide shelter.

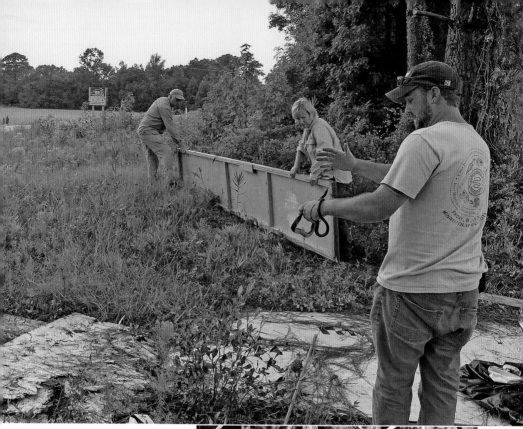

A northern black racer (*Coluber constrictor constrictor*) found under fallen sign boards along a North Carolina highway.

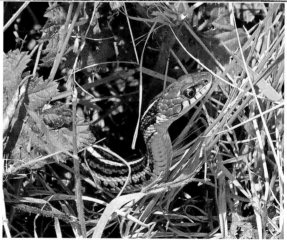

This San Francisco gartersnake (*Thamnophis sirtalis tetrataenia*) was observed for more than thirty minutes as it foraged along the edge between thick brush and open ground. Hanging back and observing behaviors can be a rewarding experience.

SEARCH IMAGES

Sometimes field herping is like finding Waldo: you're looking for creatures that often blend in very well with their surroundings. Fortunately, we humans have an extraordinary pattern-matching ability, and once you see a herp that is hiding in plain sight, your brain begins to develop a "search image" for that creature. On my first trip to Arizona years ago, I looked high and low for banded rock rattlesnakes (*Crotalus lepidus klauberi*) in appropriate habitat. It took some time to find my first one, but once I did, I had a search image — I knew what they looked like and how they blended in with their surroundings. After that, I started seeing more rock

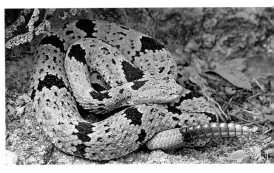

Crotalus lepidus klauberi.

rattlers — coiled alongside the trail, on rock piles, along roadsides, and so forth. The first few chapters of this book provide instructions on where to find herps, and your own brain, without any prompting, will help improve your success by building search images. [*Mike*]

Watch edges Time and again, you will find herps by focusing on habitat edges. Such areas are often corridors for movement, and they may also provide sunny basking spots.

Observe behaviors Your first instinct when encountering a herp may be to move in close and perhaps make a capture. If the animal is unaware of your presence, take some time to observe as it basks, looks for food, and so on. You may witness something awesome, and at the very least you'll learn more about that particular species.

Record behaviors and details Make notes on your encounters and get in the habit of thinking about the details. What was the herp doing? Was it out in the open or under an object? Record the time of day, weather conditions, and any other pertinent details.

Use your camera Along with taking pictures of the herps you find, put your camera to use in recording the surrounding habitat, the type of cover used, and other details. Most cameras also embed the time and date in the image file, and those with GPS capabilities (including mobile devices) record latitude, longitude, and elevation, which may help with your field note taking.

Now that you know some of the basics, it's time to start learning *why* amphibians and reptiles behave like they do. The next chapter introduces the Herp Activity Model, devised by the authors to help you understand herp behavior and to take you to the next level in the field.

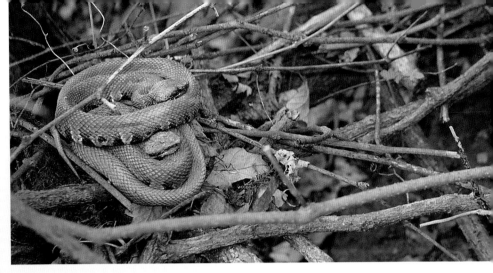

These cottonmouths (*Agkistrodon piscivorus*) were observed lying out in the open, near a pile of rocks, alongside a floodplain swamp. The Herp Activity Model can help explain their behavior.

CHAPTER 2
UNDERSTANDING HERP BEHAVIOR

The Herp Activity Model

It's possible to find herps without knowing much about them. You can visit the nearest lake or creek and see a frog, a turtle, or a snake with little effort, and indeed, this is how many field herpers get their start. To find more kinds of herps in different habitats, however, you must understand how amphibians and reptiles function and how that influences their activities and behaviors across the day and across the seasons. We'll examine these activities and behaviors as individual components, and taken as a group (with a little ecological theory added), they help form a model of herp activity. All the components within this model are related and dependent on each other. Applied in the field, the Herp Activity Model can tell you a lot about where and when to look for herps; the following chapter will cover putting that knowledge to work.

Thermoregulation

Like mammals, amphibians and reptiles require a certain range of body temperatures in order to perform basic functions such as physical movement, digestion, and the development of offspring. Unlike mammals, they are unable to produce enough internal body heat to perform those functions and must rely on external sources of heat. This reliance on external heat sources is called *ectothermy*, and amphibians and reptiles are commonly referred as *ectotherms*. The term *poikilotherm* is also used for amphibians and reptiles, which refers to organisms with varying internal body temperatures. To raise and maintain their internal body temperature, herps rely on the sun's warmth, either directly or indirectly. Throughout the day and across the seasons, they often move to find temperatures where they can function effectively and to avoid temperatures that are either too cold or too hot. This movement to maintain or change body temperature is called *thermoregulation*, and in climates and seasons with widely fluctuating temperatures, it is often the driving force behind herp behavior. The details of thermoregulation form the foundation of field herping.

Amphibians and reptiles have different approaches to thermoregulation, and often different temperature ranges at which they function effectively. For many amphibians, thermoregulation is more indirect, and their internal temperature is tied to the surrounding air, ground, or water. Basking to raise body temperature is difficult for many amphibians, thanks to their permeable skin and dependence on moisture. While frogs and some salamanders are exposed to direct sunlight at times, in most cases they would quickly dry out without access to water.

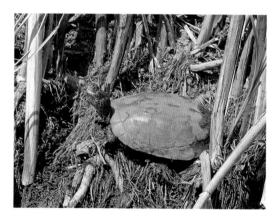

A western pond turtle (*Actinemys marmorata*) keeps a wary eye while basking on the bank of a small pond.

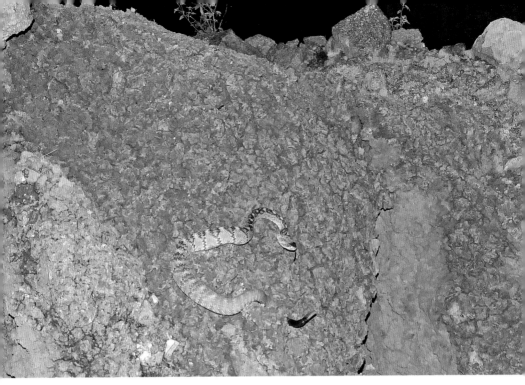

An eastern black-tailed rattlesnake (*Crotalus ornatus*) forages on a still-warm slab of rock.

With their tough, scaly skin, reptiles can take advantage of direct sunlight and higher temperatures with less risk of dehydration, making thermoregulation a frequent and important activity. After a cool night, reptiles can bask in the early-morning sun and quickly raise their body temperature, without needing to wait for the air or the ground to warm up.

In desert climates, everything under the sun accumulates heat during the day. After sunset, the ground and other objects release this heat, which continues to radiate long after the surrounding air has cooled. Nocturnal lizards will absorb heat from a boulder; snakes can soak up the lingering warmth of the sun from a desert highway, long after sundown. Radiant heat allows reptiles to remain active longer at night and provides opportunities for field herpers to find them on roads and rock faces.

When daytime temperatures decline, whether from a cold spell or the onset of winter, the internal temperatures of amphibians and reptiles also fall, and they are forced to become inactive. Conversely, when temperatures climb too high for herps to function, they also become inactive. These conditions are detailed in the next section.

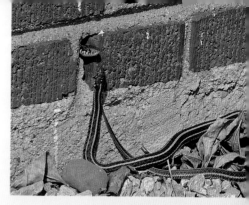

THERMOREGULATION AND GARTERSNAKES

The thermoregulation behaviors of amphibians and reptiles vary across the seasons and across geographic regions. The common gartersnake (*Thamnophis sirtalis*) provides a good example. Over much of their wide range, gartersnakes emerge from brumation in late winter or early spring and will bask on sunny days when temperatures rise. On cloudy, cooler days, they retreat underground to wait for the next warming trend. As spring progresses, and temperatures rise and become more stable, garters remain active on most days and for longer periods; their elevated body temperatures make regular basking unnecessary. When the heat of summer arrives, daytime temperatures often exceed

Plains gartersnakes (*Thamnophis radix*) emerging from their winter den in early spring.

their optimal body temperature. To avoid overheating, they often remain underground or under cover during the hottest portion of the day, confining their activity to the cooler hours of morning and evening and to overcast and rainy days. Autumn's cooler temperatures bring a return to daytime activity and basking for *Thamnophis sirtalis*, and in warmer climates they may be active on sunny days in the winter. [*Josh and Mike*]

Brumation and Aestivation

When temperatures are too low for amphibians and reptiles to function, their ectothermic nature forces them into an inactive state known as *brumation*. The term *hibernation* is often used, but strictly speaking, it refers to the extended state of sleep used by bears and other mammals; brumation is the correct term for herps. Winter in temperate climates can mean months of brumation for herps, while further south, they may have alternating periods of activity and inactivity (torpor), depending on the weather. Brumating herps use very little energy as they wait for the return of warmer temperatures. Unlike some hibernating mammals, amphibians and reptiles do not enter a state of deep sleep

during brumation. They sometimes move about, they drink water, and they may even leave their den during warm spells.

As temperatures drop in the autumn months, amphibians and reptiles must seek a place to spend the winter, either underground or underwater. Terrestrial herps must find a den below the frost line, the point below which the ground does not freeze. Aquatic herps seek out ponds, lakes, and other bodies of water that are too deep to freeze solid. Many species must travel for some distance to and from their winter dens, which means that fall migrations and spring emergences are great opportunities for observing herpetofauna.

When conditions are too hot or dry for amphibians and reptiles to function, they *aestivate*, a state similar to brumation. Much as they do in winter, herps seek places to aestivate underground, under rocks and logs, or in water. Instead of aestivating, some herps escape the heat by becoming active at night. Others may travel to water sources; brook salamanders (*Eurycea* spp.) move from the edges of springs and streams down into the water during the heat of summer. You can adopt some of the same tactics, herping at night or perhaps heading for a cool, shady creek on a hot summer day.

Brumation and aestivation are risky activities for amphibians and reptiles. If locations are not carefully chosen, or if they emerge too soon or too late, they can die from cold, asphyxiation, heat, or desiccation. Juveniles are especially at risk, and each year numbers of neonates fail to survive brumation or aestivation. To avoid this risk, some herp species use the same proven den site each year and for many generations. Many pit vipers famously use this technique; in late sum-

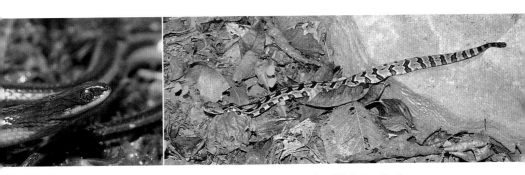

left When conditions get too hot and dry, striped swampsnakes (*Liodytes alleni*) may aestivate in crayfish burrows until more rain comes. They may brumate in those same burrows during the winter.

right A neonate timber rattlesnake (*Crotalus horridus*), just outside its winter den where it was born earlier in the year.

mer, females will return to their winter den sites to give birth, which allows the neonates to imprint on the location. The little snakes disperse for the remainder of the summer, and in the fall they return to the den to spend the coming winter months.

Conserving Resources

Conserving resources figures into all aspects of the Herp Activity Model. Movement burns calories, so all activities must be purposeful — herps don't move without a good reason. We might perceive this as laziness, but the natural urge to conserve resources is a survival trait. All movement, and nonmovement as well, carries both risk and reward. Risks of movement include being preyed upon and burning too many calories, while inactivity carries the risk that a herp won't find enough food to survive. Rewards of movement include finding food, finding a mate, and creating the next generation.

The next time you encounter a herp, ask yourself, Why is it moving (or not moving)? What is the animal doing, and what is the significance of its location? A snake observed moving across a field may be following the scent trail of prey or perhaps another of its kind. It may be moving toward water, or looking for a

Amphibians and reptiles use energy resources only when necessary. This large eastern diamond-backed rattlesnake (*Crotalus adamanteus*) remained in the same spot for several days. It was warm, well fed, and had easy access to water, so it had no reason to move.

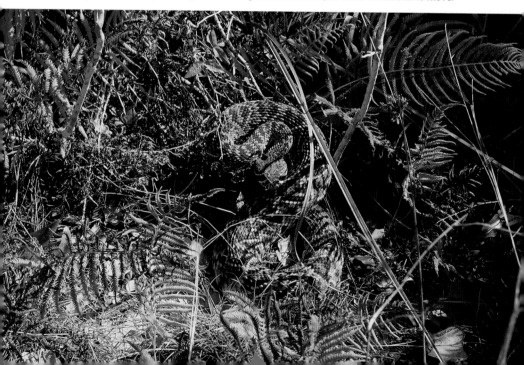

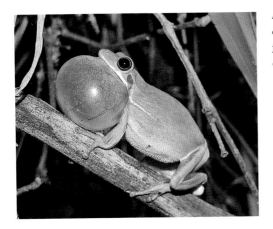

A male green treefrog (*Hyla cinerea*) calls from a branch just above the water in hopes of attracting a mate.

place to lay eggs, or searching for a place to spend the winter. At other times, the snake may have good reasons not to move and burn calories: it may be digesting a meal, it may be gravid, or perhaps it is getting ready to shed its skin. As noted in the last section, many amphibians and reptiles avoid movement during the hot and dry months of the year, when food and water are scarce and not worth burning calories to find.

Courtship and reproduction are good reasons to burn calories. Mole salamanders will often migrate great distances to reach their breeding pools. In the spring, male box turtles may seek out and follow the scent trails of females for some distance. Perhaps the most notable calorie burners are male frogs and toads, which expend resources when they inflate their vocal sacs to produce a distinctive call. Used to attract females and to establish territory, their repeated vocalizations use tremendous amounts of muscular energy, as they may call thousands of times during their breeding season. The associated risks for these vocalizing males are the large amounts of calories expended, the increased chances of being preyed upon, and the possibility that despite all their hard work, they may not succeed in attracting a female. The reward for male frogs and toads is the prime directive for all life on earth: to pass along their genes, and create the next generation.

As you might expect, finding food can consume large amounts of calories, and the trick is to take in more calories than are burned in the process of finding their source. Amphibians and reptiles use a number of different approaches to solve this problem, as we'll see in the next section.

BASKING PYTHONS AND THE HERP ACTIVITY MODEL

Do: Make babies, find food and water, and thermoregulate

Don't: Waste energy or get eaten

Simply put, the Herp Activity Model (HAM) is this: herps will seek to breed, find food and water, and thermoregulate, while avoiding being eaten and saving as much energy as possible in the process. Different species will balance these necessities in different ways, using unique strategies based on their individual natural history traits. Understanding the differences and how activity levels may expose herps to observation and capture can help herpers find a target species or a group of species with the same habits and behaviors.

As an example of how the HAM works, let's consider the introduced populations of Burmese pythons (*Python bivittatus*) in extreme southern Florida. Much of their range there consists of sawgrass marsh, sloughs, mangrove swamp, and other aquatic habitat. The pythons living in this swampy matrix spend the majority of their time resting and waiting in ambush, simultaneously conserving and trying to acquire more energy. To avoid predators while waiting for their next meal, they lie submerged or hide in brush thickets, making them difficult to find. Finding them can be so difficult that there have been cases where experienced herpetologists are barely able to find their study pythons with surgically implanted radio tracking devices. However, things change when southern Florida experiences a cool front, and the ambient temperature becomes too low to support the python's metabolism. The snakes must emerge from hiding and bask to raise their body temperature, making them easier to find as they use exposed areas like levees and hiking paths.

Herps don't always follow the rules (and they don't read field guides), but understanding the basic Herp Activity Model and the natural history of the species you are looking for will increase your chances for success in the field. [*Josh*]

A Burmese python basks on a levee on a chilly south Florida morning. Josh captured it and did measurements.

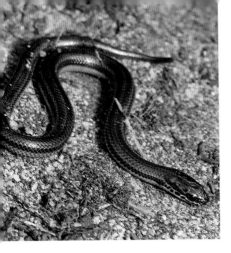

Rainbow snakes (*Farancia erytrogramma*) are dietary specialists that feed almost exclusively on eels.

Finding Food

"Follow the food" is good advice for field herpers. Understanding what different species eat and how and where they obtain food will aid you in your quest to find them.

Generalists and specialists Diet can dictate where some herps are found or not found. American bullfrogs (*Lithobates catesbeianus*) are dietary generalists, eating any moving object that will fit in their mouths, including rodents, birds, small turtles, snakes, and all kinds of insects. This wide diet allows bullfrogs to inhabit all types of permanent water. On the other end of the spectrum are specialists like crayfish snakes (*Regina* spp.), which feed almost exclusively on crayfish, or the highly prized rainbow snake (*Farancia erytrogramma*), which feeds on American eels. This specialization limits crayfish and rainbow snakes to bodies of water that support populations of their preferred prey. Most North American watersnakes (*Nerodia* spp.) fall somewhere in between the generalists like bullfrogs and the specialists like rainbow and crayfish snakes. Because *Nerodia* feed on a variety of fish, frogs, toads, salamanders, and crayfish, you can find them in most aquatic habitats within their range.

Active foragers and ambush predators Some herps actively forage for food, others wait for it to cross their path, and many use both approaches. Here the risks and rewards associated with expending and conserving resources come into play. Active foragers such as whipsnakes, coachwhips, and racers (*Coluber* spp.) and whiptail lizards (*Aspidoscelis* spp.) will spend the daylight hours hunting across open areas, and many terrestrial salamanders emerge from hiding at night to search for invertebrates. One risk for active foragers is the amount of

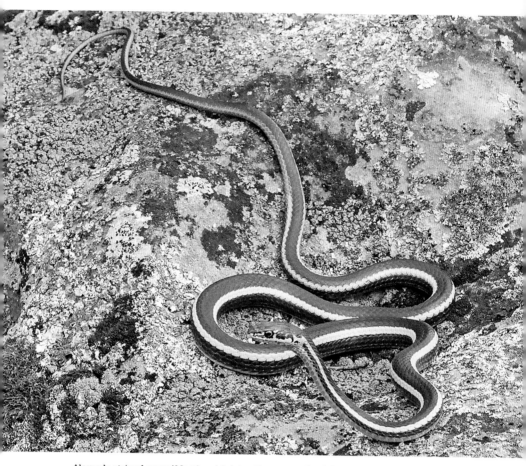

Alameda striped racer (*Masticophis lateralis euryxanthus*). Racers and whipsnakes are active foragers and "sight hunters"; raising their heads above the ground helps them spot movement and locate potential prey.

energy they use while searching for food; they need to eat more often to compensate for this extra expenditure of energy. Another risk is the possibility of being eaten themselves; movement can attract predators. Many active foragers have colors and patterns designed to confuse predators — for example, gartersnakes and ribbonsnakes have alternating light and dark stripes that can make their movements difficult to follow in vegetation (you're likely to experience this yourself when attempting to catch them).

Ambush predators remain in one place, waiting for prey to come to them. This approach burns far fewer calories, but it carries the risk of not getting

A large timber rattlesnake coiled in ambush position at the base of a tree. Prey animals may come around either side of the tree, or they may come right down the trunk.

enough food to eat; herps using this approach must carefully choose their place of ambush. Frogs are typical sit-and-wait predators, remaining motionless until insects and other prey venture too close. Rattlesnakes are also ambush predators. Their flicking tongues and vomeronasal organs provide a sense similar to smell, allowing them to locate the pathways frequented by small animals. When a suitable spot is found, they coil up nearby, ready to strike. Heat-sensitive pits detect the approach of warm-blooded mammals, allowing rattlesnakes to target and bite their prey even at night. Despite these advantages, success is not guaranteed; the rattlesnake may have to wait a long while for a prey item to come along, and small mammals are wary and alert and may avoid predation.

Ambush predators often have cryptic patterns and colors that allow them to blend in with their surroundings. It takes time to develop a search image for camouflaged herps, and even experienced field herpers can walk right by animals hiding in plain sight. Some ambush predators have lures to bring prey within striking distance; the neonates of pit vipers such as copperheads have a bright yellow tail, which they wiggle, imitating the movements of a worm or a caterpillar. Another example is the alligator snapping turtle (*Macrochelys* spp.), which has a predatory lure on the surface of its tongue that resembles a worm.

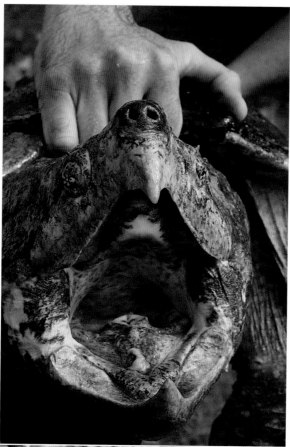

An alligator snapping
turtle shows off its
wormlike lingual lure.

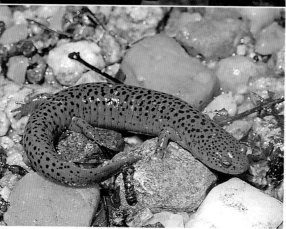

A red salamander
(*Pseudotriton ruber*)
out and about
on a rainy night in
North Carolina.

Lying motionless with their mouths open, the turtles use muscular movements to wiggle the "worm" and snap their jaws shut on any fish that swim a little too close.

Keep in mind that some species are able to change their feeding strategy based on the types of prey items that are available. Florida cottonmouths (*Agkistrodon conanti*), for instance, are typically ambush predators, but they have been observed foraging for fish dropped out of bird's nests near Cedar Key, Florida. Copperheads become active foragers during cicada emergences and have been observed climbing into trees and bushes in search of them.

Water

The relationship between herps and water is more complex than the simple need to drink. Some amphibians and reptiles are completely aquatic, using bodies of water as living space. Many frogs and salamanders are bound to water by their permeable skin, and nearly all terrestrial amphibians return to the water to breed. Other herps rely on water as a food source, specializing in aquatic prey. During hot, dry weather, terrestrial herps often seek out water to drink. Under these conditions, even small bodies of water can act as herp concentrators.

When little or no water is available, some herps may aestivate underground, in the mud, or under rocks and logs where some traces of moisture remain. In desert regions, the lack of water is a seasonal occurrence, and amphibians living there have adapted to spending some part of the year below the surface, waiting for the rains to return.

Along with herping around water sources, consider going out during or directly after it rains. Rainfall is often a great stimulator of herp activity and movement, especially for amphibians. It can trigger courtship and breeding and emergence from brumation and aestivation. Rain-soaked soil and vegetation enable frogs to hunt for insects in fields and prairies far from their water source. Most reptiles take advantage of rainfall to get a drink, but its effect on their activity can vary across species, regions, and seasons. In temperate climates, chilly fall and spring rains often curtail serpent activity, but a summer rain shower can get them moving. In southern Florida, rains during any season can make snakes difficult to find. In arid and semiarid regions throughout the world, rain and its associated change in barometric pressure can cause a great pulse in snake movement. Heavy rains can flood the burrows of fossorial herps, increasing their surface activity both before and after rainfall.

Pinesnakes (*Pituophis melanoleucus*) are a diurnal species, most active during morning hours.

Periods of Activity

Circadian rhythms are periods of activity and inactivity that center on the twenty-four-hour cycle of light and dark. Amphibians and reptiles follow one or more patterns of circadian rhythms; *diurnal* species are active during the day, while *nocturnal* herps are active at night. There are also *crepuscular* species, which have peak periods of activity in the morning and again in the late afternoon or early evening. Some herps can change their periods of activity across the seasons; for example, desert lizards are diurnal in the spring, when daytime temperatures are cooler and insects are more active, and then switch to a cre-

puscular lifestyle during the heat of summer. Others have physical adaptations that limit their periods of activity, such as the eublepharid geckos of the genus *Coleonyx*. These geckos have pupils adapted for seeing at night under low-light conditions, and bright sunlight (and your flashlight) can overwhelm their visual systems and leave them disoriented. *Coleonyx* and other nocturnal species also thermoregulate differently; instead of basking, they absorb heat from rigid surfaces. Nocturnal species face other challenges; because temperatures are cooler at night, the number of nights that are warm enough for activity is limited. This can reduce the length of the active season for nocturnal species with nighttime adaptations.

Reproduction

Like clockwork, seasonal rainfall and changes in temperature can stimulate courtship and breeding. Armed with a little natural-history knowledge, you can take advantage of these annual cycles. Herps engaged in courtship and breeding are more visible, and in the case of frogs, toads, and crocodilians, more audible. Many male lizards develop brilliant colors and engage in head bobbing and "push-up" displays as they court females and defend territories from other males. If they are focusing on courtship, reproduction, or laying eggs, some herps may ignore human presence altogether. Male snakes may engage in a combat dance when competing for a nearby female and pay little attention to their surroundings. When the females arrive at the pond, male frogs and toads are focused on calling to them and are often oblivious to camera-wielding field herpers.

The biological compulsion to breed can make many frogs oblivious to observers and sometimes even oblivious to their mate choices: a Cuban treefrog (*Osteopilus septentrionalis*) amplexes a barking treefrog (*Hyla gratiosa*).

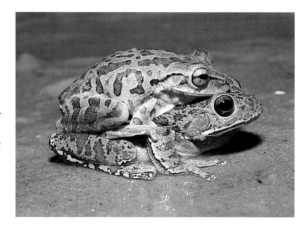

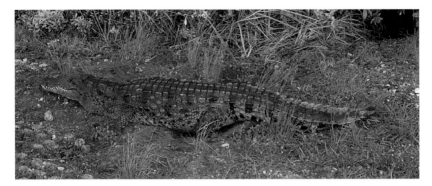

Crocodilians must return to land to lay their eggs. This female American crocodile (*Crocodylus acutus*) is nesting alongside the road and has entered a trancelike state while laying her eggs.

A great deal of movement is associated with herp reproduction, and much of it involves water. While toads have adapted to a terrestrial life, like most amphibians they must return to the water to breed and lay their eggs. After transforming from larvae into their adult forms, young frogs, toads, and terrestrial salamanders take up life on land and may move some distance away from water, often in large groups. Crocodilians and aquatic turtles travel in the opposite direction — they must move to dry land in order to lay their eggs. After hatching, the neonates make their way back to the water to take up their aquatic lives. All this passing back and forth provides opportunities for observation, especially if you are willing to get cold, wet, and muddy.

There are other movements associated with reproduction but unrelated to water. In the spring, male reptiles may move great distances in search of females. In summer, female pit vipers may return to their winter dens to give birth. This allows the offspring to imprint on the den site, so they can return in the fall and have a better chance of surviving their first winter. Neonate snakes of all kinds are active in late summer and early fall as they hunt for food, and they are often seen on roads at night and during the day.

Avoiding Predation

Herps use many strategies to avoid getting eaten. Perhaps the most common method is *crypsis* — adopting patterns and colors to blend in with their surroundings and confuse predators. Copperheads are a classic example of crypsis

in action; they can be very difficult to see against a background of fallen leaves. Tree lizards (*Urosaurus* spp.) are another; perched on a mesquite tree, they resemble knobby bits of bark. Learning to spot well-camouflaged herps can take some practice.

North American ratsnakes (*Pantherophis* spp.) often have an odd appearance when encountered in open areas. Instead of the usual smooth curves, their bodies are kinked in short, irregular segments; viewed from above, they look more

"HOGTOBER"

For many herpers, especially those in the southeastern United States, few reminders of the yearly reproductive cycle are as fun and exciting as "Hogtober," the yearly emergence of baby hognose snakes (*Heterodon* spp.) in October. In the Southeast, this is the best time to turn up both eastern hognoses (*Heterodon platirhinos*) and southern hognoses (*Heterodon simus*) in the sandhills and other dry habitat throughout the region. The fall movement pulse occurs within other parts of their range, with the little sausage-like snakes crossing roads and actively foraging in sand prairies, fields, and other sites with loose soils.

Adult hognose snakes typically search for mates in late April and May, traveling far and wide for the chance to breed. They use their spade-like rostral scales (the "nose" in their name) to dig an egg-laying chamber, and the eggs hatch in the fall, in time to kick off Hogtober. The young hatchlings traverse their habitat in a desperate attempt to find food before winter's cold sets in. Hogtober can be a great time for good friends to saddle up and ride sand roads in search of these interesting, tiny road-sausages — good luck! [*Josh*]

Both eastern (left) and southern (right) hognose snakes are common sights in sandy habitats and crossing dirt roads in the month of October.

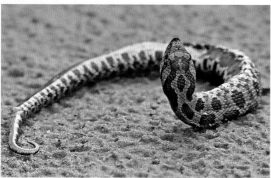

A hawk with serpent prey in west Texas.

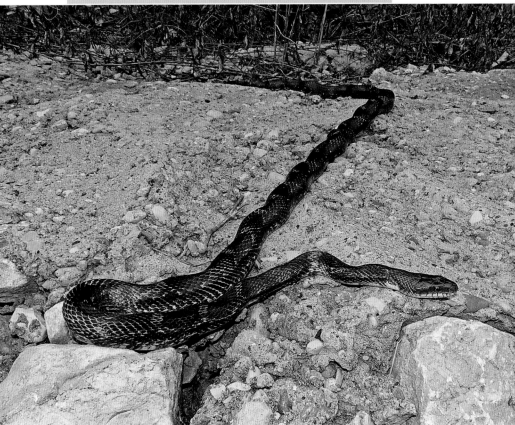

An eastern ratsnake (*Pantherophis alleganiensis*) displays a kinked appearance as it crosses an exposed space.

like a tree branch than a snake. By distorting the distinctive serpentine form, ratsnakes may be deceiving predatory birds.

Many herps, even those using crypsis, will take refuge in sheltered places to avoid predation. Terrestrial salamanders spend the daytime hours under rocks and logs or tucked into crevices. Frogs and toads often hide under the leaves of plants. Some herps may choose to thermoregulate from under cover rather than bask in the open, often using sheet metal, plywood, and other types of artificial cover. When they bask in the open, snakes and lizards often have a bolt hole or some other place of refuge close by. When threatened, rock-dwelling chuckwallas (*Sauromalus* spp.) wedge their bodies into crevices and inflate their lungs, making the large lizards nearly impossible to dislodge. Mud and rainbow snakes (*Farancia* spp.) often take refuge in floating vegetation and under logs and other objects that rest partially in the water; they can move to and from cover while submerged without exposing themselves on the surface.

Frogs have the ability to leap away from predators, and some can jump great distances. Some species can quickly change direction on each jump. Along the water's edge, frogs will leap into deeper water, but since predatory fish may be lurking there, they often swim right back to the safety of the shallows. Some snakes also exhibit this behavior and may travel parallel to the bank after making their U-turn back to safety.

Some lizards will shed parts of their bodies to escape predators. The tails of many skinks and glass lizards break easily, and some geckos have loose skin that can tear with very little pressure. Take care when handling lizards; while broken tails will partially regenerate, and torn skin eventually heals, the process uses energy that could be better spent on survival and reproduction.

Herps often avoid open areas illuminated by moonlight, when owls and other nocturnal predators are active. There are always exceptions to the rule, but in general herps seem to be more active on dark nights, with little or no moon present. Many field herpers are certain that road cruising is much more productive after full moons have passed and there is less ambient light.

Putting the Activity Model to Work

With a basic understanding of the Herp Activity Model, you're better prepared to find amphibians and reptiles in many different situations. Here are some suggestions for putting the model to work in the field.

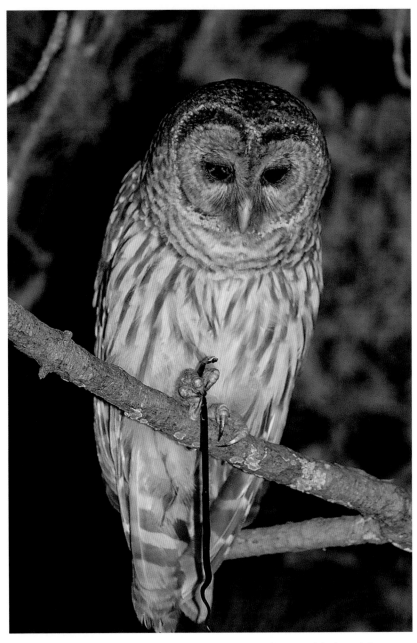

A barred owl grasps a ringneck snake (*Diadophis punctatus*) captured during a full moon. Bright moonlight can help snake predators see their quarry better, and this predatory pressure may inhibit snake movement.

MOON PHASES
AND SNAKE ACTIVITY

Since the inception of road cruising, there have been anecdotal observations about the impact the moon has on nocturnal snake activity. But over the past sixty years or so, the negative correlation between moon phase and snake activity has been relatively weak, and many studies are contradictory. I believe the primary reason for these contradictions stems from an incomplete understanding of moon phases in general. When I started my work with snake movement in South Carolina, it became obvious to me that in order to further the study I'd also have to understand the moon. What follows are some unpublished conclusions I've reached as part of my long-term study.

The short answer is that road cruising during large moons is bad, and road cruising during small moons is good. The longer answer is that road cruising during waxing moons leading up to a full moon is poor, but road cruising during the waning phases after the full moon, even if they are still large, are some of the best evenings to cruise. At first glance, this makes no sense, but while an 85 percent waning moon is still a very large moon, it won't rise until about three to four hours after sunset, providing several hours of darkness (the same level of darkness as during a new moon).

More details: small moons may have low levels of constant snake activity, such as one to two snakes per hour for the entire night. So if you cruise for eight hours, you could potentially find sixteen snakes, but on the per-hour scale, it's still only one to two snakes per hour. Often, during the waning phase of large moons, you will get a burst of activity during the hours of darkness before the moon rises, or until it gets roughly forty-five degrees above the horizon. During these bursts of activity, I've had upward of nine snakes per hour but only for a short period of time. Once the large-phase moon gets above the horizon and above the surrounding trees, activity drastically decreases.

So you're left with two general options: cruising for a short period of time with high snake activity or cruising for a long period of time with low snake activity. The long period of time ultimately produces more animals (sixteen versus nine), but most people don't want to road cruise for eight hours, especially if a budget is involved. This is of course the Cliff Notes version of my research, but that has been my general observation over the course of a nine-year road-cruising study. One caveat: my work has only been tested/applied in the eastern United States. I cannot say whether desert animals will respond in the same way. [Kevin Messenger]

A Mohave glossy snake (*Arizona elegans candida*) crossing a sand road on a moonless night.

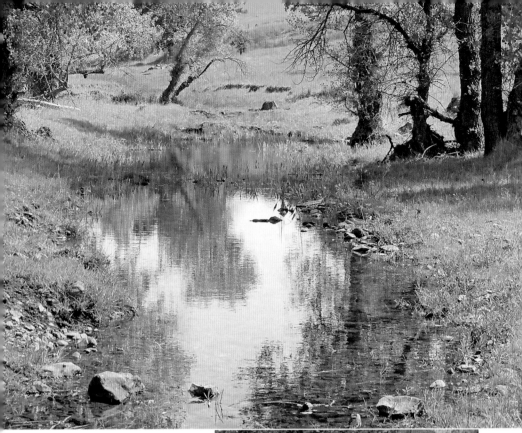

A small stream in the foothills of central California. Later in the summer, this trickle of water may dry up, but for now, it attracts a number of different herps.

A bullfrog (*Lithobates catesbeianus*) in ambush mode, waiting for flying insects to land on the log.

Water sources Home to many kinds of herps, water sources provide breeding grounds, moisture, refuge, and food. Wet places attract other herps in search of food and water, especially in drier climates or during the drier summer months. It is always worth your time and effort to check out the edges of ponds, lakes, creeks, and rivers, including nearby trees and other vegetation. Rain often stimulates herp activity and can provide opportunities for observing amphibian migrations, and to witness courtship and breeding at vernal pools and other bodies of water.

Basking spots Basking spots are places where reptiles can absorb heat directly from the sun or from surfaces heated by the sun. The best spots provide escape routes or a refuge from predators. Lizards often bask on rocks, trees, and logs, and aquatic turtles will crawl up on rocks and logs to sun bathe. Snakes will often bask at the mouths of animal burrows, on rock ledges, along fallen logs, and in bushes and trees. In forested areas, fallen trees often open up places for sunlight to reach the ground and are good places to check for basking reptiles. In dry climates, snakes and lizards may come out on roads at night to soak up heat.

Ambush spots Herps lie in wait for prey to come to them in ambush spots, often under cover that provides protection from predators. Check under bushes, along the length of logs, and at the base of trees for rattlesnakes and other pit vipers. Blending into their surroundings, frogs and toads remain motionless until insects or other prey come too close. Check for them under bushes, in leaf litter, and along the water's edge, both on the shore and in shallow water.

THE SECOND WARM DAY

In temperate climates, weather can be fickle in spring and fall, with cold snaps driving amphibians and reptiles back underground or under cover. Eventually, the sun comes out, warmer temperatures return, and the herps resume their activities. Experience has taught me that while some herps may be active on the first warm day after a cold spell, the second warm day is much more productive. Why the second day? Are herps sluggish to respond, are they being conservative with calories, or is it something else? I don't know the answer, but if I have to make a choice on which day to go herping after a cold snap, I'll take the second warm day, every time. If you're keeping notes on your field experiences, perhaps you'll make a similar observation; over time, you're likely to discover similar facts that will help inform you in the field. [Mike]

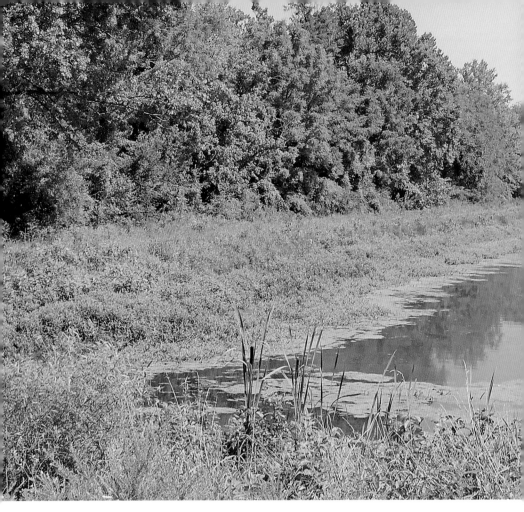

Edge habitat in parallel—forest, an open, sunny bank, and water. This area of successional habitat is home to many kinds of amphibians and reptiles.

Edge habitats Edge habitats often serve as corridors that channel movement and may also attract prey. Along with the water itself, the edges of rivers, streams, and lakes are often used as corridors, and they also serve as a destination for herps coming to breed, to lay eggs, or to drink. In drier climates, gullies, washes, and arroyos serve this purpose, as does flat ground along the bottom edges of steep slopes and bluffs. Forest edges serve as corridors for some herps, providing both cover and open places to bask and forage. Fallen trees also create edge habitat; the decaying wood holds invertebrate and rodent prey, and the logs often serve as "rodent highways." Artificial corridors include stone walls

below This old stone wall serves as a den for a small number of copperheads.

in fields, retaining walls and riprap, railroad embankments, roadside ditches, erosion fencing, culverts, and power line cuts.

Predator refuges Predator refuges provide places where herps can rest, bask, digest meals, shed their skin, and lay eggs or give birth without becoming some other creature's meal. Herps can take refuge under rocks and in crevices, under or inside logs, under bushes, and in thick brush. They may hide in leaf piles and in the nests and burrows of other animals, and some will burrow directly into sand or soil. Artificial cover such as old buildings, trash piles, boards, corrugated roofing, car hoods, and other discarded materials also provide refuge. Many predator refuges also serve as thermal refuges (see next section).

There's a lot of habitat to herp out there. Get to it!

Thermal refuges Herps can safely thermoregulate, brumate, and aestivate in thermal refuges. Artificial cover often serves as a thermal refuge, and flat metal objects like corrugated roofing, old signs, and car hoods are herp magnets. These objects absorb heat, even on cloudy days, and radiate some of that heat underneath. Using these refuges, snakes and lizards can safely raise their body temperatures without exposure, which is especially important for gravid females. Snake dens are perhaps the best-known example of natural thermal refuges; rocky hills and bluffs can provide places to brumate, and large numbers of snakes will often share the same crack or crevice. In the spring and fall, visiting dens on sunny days can be productive, as the snakes will often bask near the entrance. In more-urban settings, old foundations, stone walls, and stacked railroad ties are used as thermal refuges, and sunny days will reveal the resident serpents as they bask on the edges.

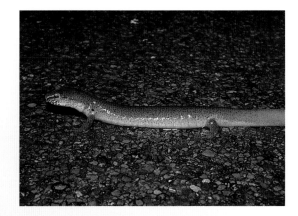

Location and altitude can affect herp movements. Spring salamanders (*Gyrinophilus porphyriti-cus*) may move year-round in the warmer Piedmont of North Carolina (~1,400 feet), but they may move only during the spring and summer months at higher elevations (>2,400 feet).

CHAPTER 3
FINDING HERPS

The first two chapters of this book contain a great deal of general information useful for finding herps in the field. This chapter provides more details specific to the different types of amphibians and reptiles, beginning with snakes and lizards. You may notice that some of the information is common to more than one type, since they often share the same kinds of habitat, microhabitats, and activity patterns.

Geography and Location

The North American continent features a wide range of climates and habitat types. Geography and location can determine the herps that can be found and the factors that drive herp activity. In some regions, temperature is the most im-

portant factor; in other places, moisture (or the lack of it) may play a dominant role. Altitude can also have an influence on which herps occur in an area, along with their periods of activity and other behaviors. Some amphibians and reptiles are generalists, utilizing many kinds of habitat across multiple regions, while others are specialists, appearing only in areas where certain conditions occur.

It's often said that herps don't read field guides, but field herpers should, and often. Along with identification keys and range maps, field guides also contain useful information about the kinds of habitat herps use, their periods of activity, and other bits of natural history. We recommend studying your state or regional field guide to get an understanding of how the herps function in your geographical area. If you plan to herp in another region or country, pick up an appropriate field guide and study it before you go.

Even in winter, water trickles in this small spring emerging from a crevice in the rock. The water helps buffer temperatures in both winter and summer and provides a stable microhabitat for salamanders, frogs, and other animals.

A Florida wormlizard (*Rhineura floridana*), the only amphisbaenian native to the United States.

Microhabitats

Microhabitats refer to a specialized habitat with environmental conditions different from the larger, surrounding habitat. A microhabitat can be quite small, such as a small spring seeping out of a limestone rock face or the underside of a flat rock. A series of sand dunes with sparse vegetation makes up a large microhabitat, within the overarching desert habitat. Microhabitats can be formed by combinations of geological features, plant communities, soil composition, water, altitude, and other factors. Some can exist for a long period of time, while others may last for only a season.

Microhabitats can be an important consideration in your search for amphibians and reptiles. Some herps may be adapted to the conditions within a microhabitat and spend their entire lives there. Other species may use one or more microhabitats on occasion, to find food, shelter, moisture, or refuge from predators.

Finding Snakes and Lizards

Snakes and lizards are grouped together in the order Squamata, along with amphisbaenian worm lizards. They are often referred to as *squamates*, from the Greek root word for "scales." Squamates occupy many kinds of habitat across much of the planet, due in no small part to their distinctive body plan. Their tough, scaly skin helps minimize water loss in hot climates and provides a good surface for absorbing heat.

Snakes and lizards are also bound together in a predator-prey relationship. While small snakes can be eaten by some lizards, snakes are the predominant predators, and many kinds of snakes prey on lizards. Anywhere lizards are found, more than likely snakes that eat them are also present.

FINDING HERPS
METHODS & RELATED JARGON

There are three common field herping methods for finding most species, and each has a bit of jargon to go with it. The first method is to simply encounter them in the field as they bask, hunt for food, or engage in other behaviors. Finding herps in this manner is often referred to as "walking them up" or "hiking them up," as it is usually the herper who is on the move, walking on a trail, wading in a creek, and so forth. A snake moving in the open is said to be "on the crawl," resulting in sentences like "we took the prairie trail and I walked up a hognose on the crawl."

Another method for finding amphibians and reptiles is *flipping*, the field herper term for looking under all objects where herps might be hiding. Since the herper code of ethics demands that all objects are gently returned to their exact position, *lifting* would be a more accurate term, but you'll never hear it used. While nothing is actually flipped, *flipping* is the accepted term: "We flipped some good-looking rocks on that hillside, but only found a single ringneck." A hillside where all the rocks were actually flipped over would be a terrible sight to a field herper, and no good for all the creatures living under those rocks. In addition to rocks and logs, herpers often target artificial cover for flipping, things like corrugated-steel roofing, boards, shingles, and the like. Any metal, regardless of its composition, is referred to as tin; this is a holdover from the olden days of

Lifting rocks in central Kansas.

Confined Spaces

Many kinds of squamates are *thigmotactic*—they prefer confined, covered spaces, and like to be in contact with the objects surrounding them. A rock crevice is one example of a confined space that protects the animal on nearly every side. This preference for tight spots is useful for finding many kinds of snakes and lizards. They will hide under rocks and logs; in tall grass, bushes, and leaf litter; underneath loose tree bark; in rock cracks and crevices and animal

Flipping tin in eastern Iowa.

field herping, when sheets of cheap metal roofing were actually coated with tin. Once on the ground, tin roofs are a gold mine for herps, and "flipping tin" could be the best part of a day in the field. Field herpers have always been secretive about the locations of their favorite "tin flips," and unfortunately, in the past decade or so, the rising price of scrap metal has led to nonherpers scouring the countryside clean of these precious herp hiding spots.

A third method is aptly called *road cruising*, since it involves driving on roads that pass through suitable herp habitat. The term has been in use for close to seventy years now and sounds much better than "road herping" or "car herping." Road cruising also spawned terms like *DOR* (dead on road) and *AOR* (alive on road): "The road was slow last night — we cruised up one AOR *atrox* after sundown, and a DOR kingsnake."

Most fields of interest have a rich layer of jargon and shorthand phrases, and field herping is no exception. Consider the following nuggets regarding rattlesnakes:

"Crotes" is derived from the genus *Crotalus* and refers to any kind of rattlesnake.

Western diamond-backed rattlesnakes (*Crotalus atrox*) are often called "atrox," but eastern diamond-backs (*Crotalus adamanteus*) are rarely called "adamanteus." More often, they are simply "eastern diamondbacks" or "EDBs."

Southwestern speckled rattlesnakes (*Crotalus pyrrhus*) are called "specks."

Happy hunting, and may all your herps be AORs! [*Mike*]

burrows; and under artificial cover. Along with a pile of boards or old metal roofing, herpers love the sight of a hillside covered with large flat rocks — rocks that are thin enough for snakes and lizards to wiggle or burrow under. They provide snug cover and can absorb heat on the top and then radiate it underneath. In some cases, flat rocks may rest on other flat rocks, and some squamates make use of the tight spaces in between them.

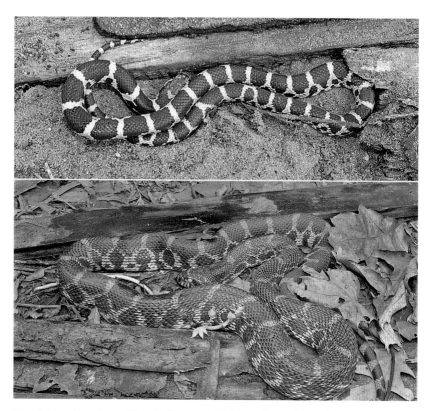

top A neonate eastern milksnake (*Lampropeltis triangulum*) taking refuge under a shingle pile in an Illinois sand prairie. Shingles provide tight cover, while absorbing and retaining heat.

bottom An opaque bullsnake (*Pituophis catenifer sayi*) uses a damp hiding spot under plywood to shed its skin.

While providing protection and cover from predators, confined spaces can also be refuges from extreme heat and cold. These spaces may also trap moisture, reducing evaporative loss and making skin shedding an easier process. Thigmotactic behaviors have also inspired some photographic techniques, covered in chapter 9.

Fossorial and Semi-fossorial Species

Fossorial species have adapted to burrowing in soil and sand. Fossorial species like threadsnakes (*Rena* spp.), wormsnakes (*Carphophis* spp.), and amphisbae-

nian wormlizards (*Bipes* spp. and *Rhineura floridana*) may spend much of their lives underground. Smooth scales and modified head shapes are common adaptations that make it easier for fossorial and semi-fossorial species to burrow in sand or soil. The legs of some lizards are reduced, such as those of the Florida sand skink (*Plestiodon reynoldsi*). Some have no external limbs at all, including the glass lizards (*Ophisaurus* spp.) of the eastern United States and the legless lizards (*Anniella* spp.) of the western United States and Mexico.

A number of small woodland snakes are considered semi-fossorial, such as smooth earthsnakes (*Virginia valeriae*), rough earthsnakes (*Haldea striatula*), and ring-necked snakes (*Diadophis punctatus*). These species and others will hunt for prey in the soil and aboveground in vegetation and leaf litter. Whether they live in soil or sand, fossorial and semi-fossorial species are attracted to the undersides of rocks, logs, and other objects, microhabitats that typically gather and hold more moisture than the surrounding soil. These hidden spaces are also home to prey such as earthworms, termites, slugs, spiders, and other invertebrates.

Rains heavy enough to flood the soil may force fossorial and semi-fossorial species to the surface and out in the open. Under these conditions, they can sometimes be found crossing paths and roads at night.

left A western slender glass lizard (*Ophisaurus attenuatus attenuatus*) from Kansas. Along with the absence of limbs, note the regenerated tail; glass lizards get their name from their habit of breaking off their tails when accosted by a predator (or picked up by a field herper).

middle Pine woods littersnakes (*Rhadinaea flavilata*) are semi-fossorial; their small bodies would lose moisture quickly in direct sun, and they would succumb to death by desiccation.

right This semi-fossorial mole kingsnake (*Lampropeltis rhombomaculata*) was found aboveground after a steady rain.

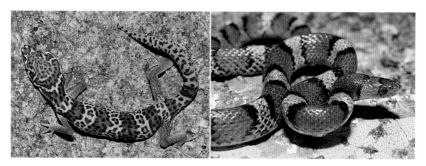

left A Texas banded gecko (*Coleonyx brevis*) observed in a boulder pile at night.

right Scarlet snakes (*Cemophora coccinea*) are often active at night.

Nocturnal Squamates

Nocturnal snakes and lizards are best found by walking or driving at night. The gray-banded kingsnake (*Lampropeltis alterna*) is a classic example. These snakes live in rocky desert habitat and are rarely seen during the day. Taking advantage of the heat radiating from their rocky surroundings, *alterna* emerge at night to hunt for lizards and rodents. They can be found by driving roads in rocky habitat and by walking along road cuts, using a flashlight to examine crevices and vertical surfaces.

Washes (or arroyos) are desert drainages carved out by water during heavy rains. When they are dry, "walking the washes" at night can produce rattlesnakes and other serpents, along with nocturnal lizards such as banded geckos (*Coleonyx* spp.) and night lizards (*Xantusia* spp.). Snakes tend to travel along barriers rather than crawl over them, making washes, ditches, rock walls, and other natural edges good places to check at night.

Road Cruising

One of the most popular methods of snake hunting is road cruising. While snakes cross roads as a natural occurrence, they also use the road surface to thermoregulate. Roads (paved roads especially) release accumulated heat at night, and as the air temperature drops, the surface becomes a thermally radiating object. Snakes and lizards can take advantage of these warm surfaces to keep their body temperatures elevated, but they also run the risk of predation, not to mention being flattened by passing vehicles. Often, nocturnal species will undergo a pulse of movement soon after dark, which some herpers call "the

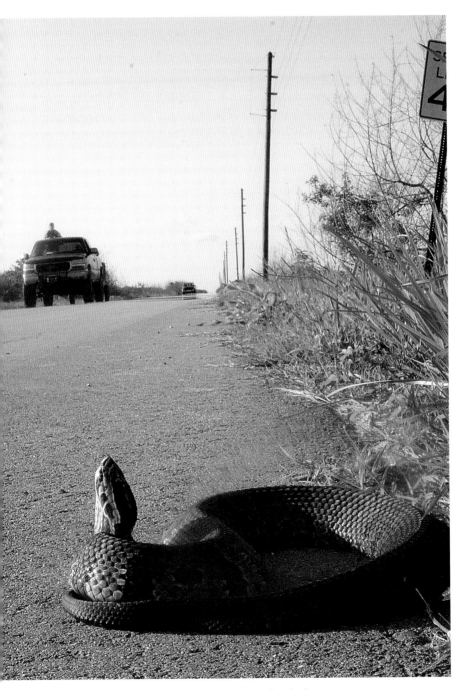

Roads provide opportunities to observe snakes as they bask or cross.

rush." It is common for most of an evening's snake finds to occur during this five-minute to one-hour-long period.

Road cruising is primarily done at night, but it can also be effective in the morning and again in the late afternoon, when crepuscular species are active. It is most effective in desert regions, where temperatures can drop quickly after sunset, and the warm roads attract and hold serpents. There are a few factors that may affect road-cruising success. Most field herpers agree that a full or nearly full moon inhibits nocturnal snake activity, as moonlight makes them more visible to predators. Light rain can stimulate activity, but heavy rains may cool roads to the point where they no longer radiate heat. In some places, high winds may also have a negative impact on reptile movement, although this may not be the case in areas where wind is a regular occurrence. Although road cruising is most often undertaken with cars, don't neglect other forms of transportation—bicycles, ATVs, and other vehicles can be invaluable in some situations. Bikes especially can allow you to cruise natural areas where the trails may be gated, and often it is easier to notice smaller snakes at the slower speeds a bike entails.

Basking Behaviors

It won't take much time in the field before keeping an eye out for basking spots (and basking herps) becomes second nature to you. Many kinds of snakes and lizards bask, relying on cryptic patterns and coloration, protective cover, or an adjacent hiding place to escape predators. Climate, season, weather, temperature, and time of day all affect when they bask and for how long, but in general, checking sunny spots near cover is always a good idea. Forest clearings, fallen trees, exposed embankments, wooden fences, and rock outcrops are all potential basking spots. Also of interest are places that absorb and then radiate heat, such as rock piles and ledges, stone walls, and open sandy areas near burrows or other cover. Nocturnal species also make use of substrate, rocks, and other objects that give off heat after the sun sets.

Squamates do not require full-body exposure to direct sunlight in order to thermoregulate. They often bask from concealment, under thick brush, branches, and thorny plants that offer some protection from predators, while letting enough sun through to raise their body temperature. As previously mentioned, snakes and lizards can also thermoregulate from underneath objects that absorb heat, making flat rocks, plywood, metal roofing, and other materials attractive hiding places. They also make use of basking spots in bushes and trees

THE DYNAMICS OF ROAD CRUISING

I've done my share of road cruising, driving on endless roads for countless hours in search of herps. Over the years, I've found some awesome animals, and I've also spent many long hours staring at white lines and asphalt surfaces with little to show for it. That's the essence of road cruising; when the herps are moving, it's exciting, and when they're not, well, the road goes on forever. It's good to have music or someone to talk with; I've had many awesome conversations while road cruising, some of which I wish I had recorded to hear again.

Herps are on the road for a number of reasons. They cross roads as a part of their regular activity, and you may be lucky enough to be there when they do. They may be on the road to absorb radiant heat, or moisture, or both. There may be no explanation for their appearance, like the six-foot crocodile I came upon, stretched across one lane of a dark Mexican highway. Daytime herps sometimes cross roads late at night, making me wonder what they're up to. And of course there are other interesting animals on the road, including owls, skunks, foxes, and coyotes.

Road cruising at night in desert habitat can be very productive. Many desert snakes and lizards are nocturnal, and they make use of the radiant heat that is released as night falls and the air cools. The typical scenario for desert cruising is to eat a late lunch or an early dinner during the heat of the afternoon, maybe nap a little, and then be ready to head out as the sun starts to sink in the west. Fill the gas tank, grab some caffeinated beverages and sugary snacks, and hit the road. You don't want to wait until dark because rattlesnakes don't wait — they begin to move as late afternoon turns into early evening (the "hour of the rattlesnake"). Diurnal and crepuscular species are often on the move at this time as well.

Nighttime road cruising isn't just for the desert. I've had good luck cruising up copperheads on hot summer nights in various places across their range. Roads running through the Everglades can be incredibly productive at night. Rainy nights can bring out toads, frogs, and salamanders that are taking advantage of the wet night to migrate or to absorb water from wet pavement. Mud and musk turtles also cross roads in the rain at night. Early morning cruising can be good for many kinds of

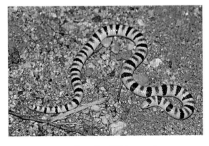

A shovel-nosed snake (*Chionactis occipitalis*) found on the road in San Diego County, California.

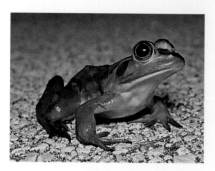

A pig frog (*Lithobates grylio*) on the road at night in Everglades National Park.

snakes, including racers, coachwhips, hognose snakes, and gartersnakes. Often the prime time for day cruising is just as the dew burns off the grass in the morning sun. Turtles may also be active in the morning, especially box turtles.

There is some disagreement among herpers about optimal cruising speed, and the arguments have been entertaining for many years. Some people prefer to drive fast — they cover more ground that way, they say. Others favor driving slower — they can stop faster and can spot the smaller snakes. It won't take you long to figure out what works best for you — my preference is somewhere between thirty and thirty-five miles per hour. (Josh clocks in at forty-five to fifty-five.)

Another arguable question concerns how long to cruise — till midnight? 2:00 a.m.? dawn? Often there is a pulse or rush of herps on the road just after sunset, and then things slow down for a while, and perhaps there's another flurry of activity later in the night. Is it worthwhile to cruise until 4:00 a.m. for one more night snake? Perhaps, if you've got nothing going on the following day. Do yourself one favor: don't continue road cruising until you're too tired to drive safely.

To conclude, here are a few things to remember:

Know the laws (some states have them) for road cruising and for handling or moving animals off the road.

Have your lights and hooks handy *before* you start road cruising.

Driving a rental? Figure out the door locks and the door handle locations *before* you find your first herp on the road.

When stopping for a herp, always put your car in park (there are many stories about anxious road cruisers failing to do this).

Pull off the road if you can, and turn on the hazard lights.

Don't stop your vehicle in the road near blind curves.

Road cruising can be a risky business. Take care and live to herp another day.

[*Mike*]

A Florida green watersnake (*Nerodia floridana*) takes advantage of a dry hummock in a cypress swamp to bask.

(see next section), especially in forested areas where sunlight is often blocked or filtered. In areas where pit vipers occur, take care to scan the vegetation around you, as rattlesnakes, copperheads, and cottonmouths all readily leave the ground to bask and to pursue prey.

Climbing Squamates

It's not enough to watch the ground; herpers also have to keep an eye on rocks, bushes, trees, and structures. Most snakes and lizards will climb, and some spend much of their time off the ground in vegetation or on vertical surfaces. Perhaps the most notable arboreal species in North America is the rough greensnake (*Opheodrys aestivus*), which lives its life well hidden among leafy greenery. Whipsnakes, coachwhips, and racers often climb, and when encountered on the ground, they may attempt to flee up into the nearest bush or tree. Watersnakes

These exotic Oustalet's chameleons (*Furcifer oustaleti*) spend nearly their whole life climbing in trees, only coming to the ground to lay eggs and move between trees.

A tree lizard (*Urosaurus ornatus*) blends in with the bark of a mesquite tree.

and crayfish snakes often occupy branches over the water and brush piles along the water's edge. Ratsnakes are powerful climbers, readily ascending tall trees and rock faces, and they are often found in the rafters of old buildings. Lyre-snakes (*Trimorphodon* spp.) are nocturnal specialists that hunt sleeping lizards in rock piles and on vertical rock faces.

Swifts and spiny lizards (*Sceloporus* spp.) make use of rock faces and trees and are often called "fence lizards" for good reason. In desert regions, look for tree lizards (*Urosaurus* spp.) in small shrubs and on the trunks and branches of mesquite and juniper trees. Alligator lizards (*Elgaria* spp. and *Gerrhonotus*

spp.) are known to forage and bask in bushes and brush piles. Subtropical regions have many types of arboreal lizards, including anoles (*Anolis* spp.), green iguanas (*Iguana iguana*), and spiny-tailed iguanas (*Ctenosaura* spp.).

While smooth-scaled toothy skinks (*Plestiodon* spp.) and ground skinks (*Scincella lateralis*) are often found under rocks, logs, and other objects, many are also very good climbers and can be observed basking and foraging above ground. In forest and forest-edge habitats, skinks and fence lizards may occupy the branches and trunks of standing and fallen trees, provided there is some exposure to direct sunlight.

Rock Features

Rock piles, boulder fields, talus slides, rocky washes, limestone bluffs, and even stand-alone rocks can all be great microhabitats for squamates. They provide food, shelter, territory, and boundaries, as well as places for thermoregulation, brumation, and aestivation. Chuckwallas make extensive use of rock piles and outcrops. Collared lizards (*Crotaphytus* spp.) and many other lizard species use rocks as elevated viewing platforms, to guard their territories and mates and to

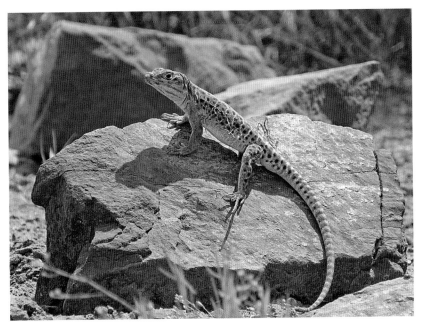

A long-nosed leopard lizard (*Gambelia wislizenii*) taking the high ground in western Colorado.

This eastern mudsnake (*Farancia abacura abacura*) was found foraging in the swampy area around a drainage ditch.

look for prey. Many kinds of rattlesnakes use rock piles as places of concealment from predators and as ambush spots for prey.

Water

All bodies of fresh water are good places to look for snakes. Some species eat fish, crayfish, salamanders, and eels, and semiaquatic prey such as frogs and toads. Snakes also prey on other animals that come to the water to drink or to eat. Aquatic species such as mud snakes, rainbow snakes, and swamp snakes spend much of their lives in the water and can sometimes be caught by passing a dip net among aquatic plants. They can also be found under logs and other objects lying along the bank or partially in the water and may be seen crossing wet roads day or night. Semiaquatic watersnakes, gartersnakes, ribbonsnakes, and crayfish snakes can often be observed basking on logs and log jams, brush piles, overhanging trees, and open sunny spots. Look for them in shallow water as well, as they hunt the riffles for minnows, tadpoles, and crayfish. The young of these species spend much of their time hidden under rocks, logs, and leaf piles along the bank. Food sources can indicate which species are present: lots of fish might point to mostly piscivorus (fish-eating) snakes such as the green watersnakes (*Nerodia cyclopion* and *N. floridana*), but snakes such as southern watersnakes (*Nerodia fasciata*) prefer more frog-rich environments. Most lizards are not adapted to an aquatic life, but some, such as skinks, anoles, and green iguanas, are often found along the water's edge.

Grassy embankments along ditches, streams, and lakes are good places to look for kingsnakes. Bridges are always worth checking under — the abutments usually have piles of rocks and boulders, which provide cover, basking spots, and winter dens. The undersides of bridges also provide places for birds to nest and bats to roost, attracting ratsnakes and other nonaquatic species. In arid climates,

Aquatic herps will often take refuge under cover if it is partially underwater. This black swampsnake (*Liodytes pygaea*) was found under this half-submerged piece of plywood.

A northern watersnake (*Nerodia sipedon sipedon*) foraging in a shallow stream.

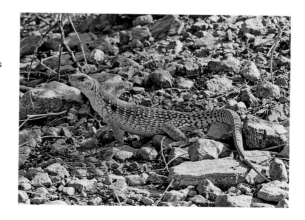

Desert iguanas (*Dipsosaurus dorsalis*) utilize open areas and dig burrows under bushes and in embankments.

permanent water sources can serve as concentrators for snakes and some lizards, as well as dry places that may contain water when it rains.

Open Areas and Sandy Soils

A number of fast-moving lizards make use of open areas interspersed with clumps of vegetation. The open spaces provide room to run, while plants and rocks provide hiding places. Sandy soil is often associated with open-area habitat, which is common in deserts and grasslands. Further east, open areas occur along riverbanks, floodplains, and in prairies and pine forests. Lizards using this habitat include whiptails and racerunners, zebra-tailed lizards (*Callisaurus draconoides*), and leopard lizards (*Gambelia* spp.). Slower-moving horned lizards (*Phrynosoma* spp.) also make use of open areas, but their presence is also tied to the availability of ants, their main food item. Find an ant nest, and you may find a horned lizard close by.

In open habitat, diurnal lizards are often on the move as they forage for food. Whiptails can be especially entertaining to observe as they patrol for insects, poking into bushes and shrubs, and randomly changing direction. Get too close, and they will dash away to the nearest vegetation that provides cover. Where lizards occur, so do the snakes that hunt them — whipsnakes, racers, and coachwhips can also be found foraging in open-area habitat.

Loose, sandy soil is usually a component of open areas, and there are a number of herp species that burrow into this substrate in search of prey and refuge, including the previously mentioned legless lizards. Desert iguanas (*Dipsosaurus dorsalis*) use rodent burrows or dig their own — watch for small openings on slopes and banks that are flat on the bottom and rounded on top. Some snake

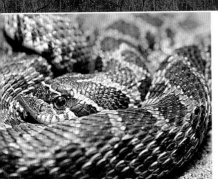

Loose, sandy-soiled areas like this sand prairie provide excellent habitat for burrowing species such as this dusty hognose snake (*Heterodon gloydi*).

species have modified snouts for burrowing into loose soil, including hognose snakes, leafnose snakes (*Phyllorhynchus* spp.), and the large group of pinesnakes, bullsnakes, and gophersnakes (*Pituophis* spp.). Sidewinders (*Crotalus cerastes*) prefer flat, sandy areas and use a modified means of locomotion to make their way across sand. Sidewinders and other snakes living in sandy areas are often nocturnal, and a good way to find them is to drive at night on roads that pass through suitable habitat.

Snakes also use burrows dug by animals as places of refuge and to hunt prey. The eastern diamond-backed rattlesnake (*Crotalus adamanteus*) and the eastern indigo snake (*Drymarchon couperi*) are classic examples; both make use of the sandy burrows excavated by the gopher tortoise (*Gopherus polyphemus*).

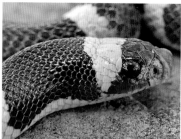
A close-up of a saddled leafnose snake (*Phyllorhynchus browni*). The enlarged and modified rostral scale is likely an aid in burrowing into sandy soil.

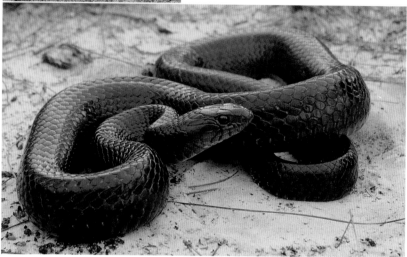
This eastern indigo snake (*Drymarchon couperi*) was found in an area with a high concentration of gopher tortoise burrows.

Finding Turtles and Tortoises

The shelled creatures (order Testudines) are found on every continent except Antarctica, occupy many different kinds of habitat, and come in an amazing variety of shapes and sizes. For herping purposes, we consider them in two groups — terrestrial tortoises and aquatic turtles.

Turtles, Roads, and Railroad Tracks

Turtles often cross roads in spring and summer, when males are looking for females, when females are looking for places to lay their eggs, and when hatchlings are looking for a water source. Of course, you will want to get any live turtle safely off the road, and there are some general guidelines for this. Make note of

LIZARDS BY NIGHT

Quite a few diurnal lizards can also be found at night, especially arboreal (tree-dwelling) lizards. In fact, some of my favorite lizards to look for are the introduced chameleon species of southern Florida. Hunting chameleons may seem like a chasing-of-the-wind to the uninitiated: if there's one thing cartoons and other popular culture have taught us, it's that chameleons camouflage very well with their surroundings. And they do. Except at night.

Chameleons are strictly diurnal; by the time twilight hits they are already fast asleep, and when they sleep their body color gets lighter. Chameleons and many other arboreal lizards, in fact, go from a well-suited camouflage to a light lime green at night. This makes them easy to see (to a trained eye, at least — there is a big learning curve to seeing them!), as well as easy to catch and photograph once found. Chameleons are not the only lizard to be a fun nighttime diversion; any walk through a tropical (and sometimes temperate) climate can reveal all sorts of species that may be much more difficult to find and catch during the day: anoles, iguanas, garden lizards, to name a few. Nighttime lizard hikes, in the right area, can be a great addition to your herping toolkit. [Josh]

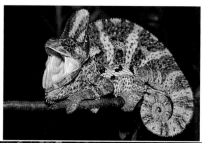

Veiled chameleons (*Chameleo calyptratus*) are remarkably difficult to find during the day in southern Florida. At night, on the other hand, they can be easily seen.

the direction the turtle was heading, move it in that direction as far as possible (you may need to cross the road), and then release it. Do not move the turtle to another location for release unless there is no safe habitat on either side of the road. Many species have established home ranges, and upon release they will attempt to return — again facing the risk of crossing roads. Snapping turtles (*Chelydra serpentina*) are one of the most commonly seen turtles on roads. With their sharp claws and a big bite, large snappers can be difficult to pick up and move — consider pulling them onto a car mat or blanket and then dragging them to the roadside.

Needless to say, please consider your own safety first. It's not always easy to pull off to the side and help a turtle across, especially in areas with heavy traffic and no road shoulders. Not every turtle can be safely rescued; play it safe so that you can rescue another turtle on another day.

Railroad tracks can be deadly traps for turtles. When a turtle encounters a rail, it may move along it in either direction, until it finds a low spot or a gap where it can squeeze underneath. Once trapped between the rails, turtles have a hard time finding a way out, and they often die of heat exposure, thirst, or contact with a train. Move any turtles you might find between the rails, and don't hesitate to move a turtle away from the rail bed, the same as you might do for a turtle on the side of the road.

Introduced Species

Occasionally you may be surprised by turtles that are far from home. Thanks to the pet trade, a number of species are established in places far outside their range, and municipal parks are common dumping grounds for turtles. Common "transplants" include snapping turtles, sliders (*Trachemys* spp.), and painted turtles (*Chrysemys* spp.). Box turtles are often picked up and brought home as pets. Some escape, and some are released, at times far from home.

A slider released in a city park's pond may not have much of an impact, but turtles released into wild ecosystems can be a potential disaster. The transplants can introduce exotic diseases and parasites and may compete with local turtles for resources. Out-of-place turtles should be documented and reported to the appropriate natural resources agency in your state or region.

Terrestrial Tortoises

The various species of North American box turtles (*Terrapene* spp.) and gopher tortoises (*Gopherus* spp.) make up this group in North America. Gopher tor-

below Be careful with large snapping turtles.
Their bites are painful, and they can easily
break the skin and ruin your day!

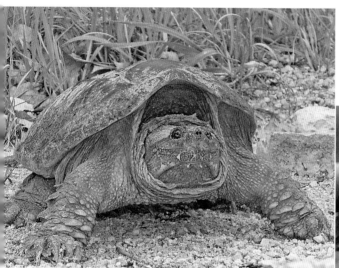

below A western
painted turtle
(*Chrysemys picta belli*)
rescued from between
the rails.

Red-eared sliders (*Trachemys scripta elegans*) basking
in a downtown park in Bangkok, Thailand.

A thornscrub tortoise (*Gopherus evgoodei*) outside the entrance to its burrow in southern Sonora, Mexico.

toises are associated with loose, sandy soil, and their burrows are an important component of their natural history, providing a thermal refuge, protection from predators, and reducing evaporative water loss. Many *Gopherus* dig their own burrows and scrapes, but some utilize burrows dug by other animals. Find an active burrow, and you may find a tortoise nearby — you'll know you've found an active burrow by the lack of vegetation and the newly disturbed sand "apron" at the entrance. In the Southwest, Mohave and Sonoran desert tortoises (*Gopherus agassizii* and *Gopherus morafkai*) often dig shallow burrows in the steep sides of gullies and arroyos, where they sleep at night and avoid the heat of the day. Found in south Texas and adjacent Mexico, Berlandier's tortoises (*Gopherus berlandieri*) may use animal burrows, but more often they construct a scrape (also called a form or pallet). The scrape is made by pushing away the top layer of soil and surface material, usually under a bush or other protective object.

In the southeastern United States, gopher tortoises (*Gopherus polyphemus*) excavate lengthy burrows that are often occupied by other animals. In fact, their burrows have been found to be used by hundreds of species, from insects and mammals to other reptiles. Some notable herp species, such as the gopher

frog (*Lithobates capito*) and the eastern indigo snake specialize in using their burrows. Indigo snakes are a tropical species that depends on gopher tortoise burrows as a refuge from cold weather; the burrows may have enabled them to range further north into the United States than otherwise possible.

Gopher tortoises are primarily vegetarians, and they forage around their burrows and scrapes for grasses, leaves, shoots, cactus, and cactus fruit. Don't be surprised, however, if you see one dining on carrion. In the spring, they can be active throughout the day; during the summer months, look for them in the early morning and late afternoon, as they often retreat to their burrows during the heat of the day. Rain will bring gopher tortoises out of their burrows to drink, and for desert species, rainfall is critical to restoring their internal water balance — drinking tortoises should not be disturbed. Gopher tortoises should not be picked up, since handling often forces them to urinate (and all species in the United States are protected by law). Giving up their water stores may mean a death sentence to these dry-weather specialists.

North American box turtles occupy many different types of habitats. The eastern box turtle (*Terrapene carolina*) can be found in forests, swamps, fields, and pastures. Ornate box turtles (*Terrapene ornata*) inhabit fields, prairies, and desert scrub. Typically, box turtles are "walked up" while passing through their habitat or are found crossing roads in the spring. In wooded areas, keep your ears open for *Terrapene* moving through leaf litter. During the heat of summer, eastern box turtles will dig a scrape into the leaf litter or hang out in shallow pools near water. Ornate box turtles often have scrapes under the shelter of bushes; after finding a few scrapes, you may develop a search image for them

Gopher frogs (*Lithobates capito*) are another habitat-specialist resident of gopher tortoise burrows.

above An in situ photo of an ornate box turtle (*Terrapene ornata*) hiding under a rock in Kansas.

right An eastern box turtle (*Terrapene carolina*) in a vulnerable moment on an Indiana road.

and for the turtles that make them. Juvenile and subadult *T. ornata* may also burrow underneath large flat rocks and may turn up under artificial cover.

As with gopher tortoises, rain leads to an increase in box turtle activity and movement. They forage for earthworms and other invertebrates that emerge after rainfall, and they look for puddles and pools from which to drink. Unfortunately, post-rain movement also brings *Terrapene* onto roads, where they must run the gauntlet of passing vehicles.

Box turtles are named for their ability to seal up their head, tail, and limbs within their shell. If you want to observe and photograph a box turtle, give it some space and resist the urge to pick it up, as it may close up entirely. A buttoned-up box turtle has more patience than humans do and may remain in that state long after you have moved on.

Aquatic Turtles

Across North America, aquatic turtles can be found in nearly every body of water. The good news is that many species bask on rocks and logs and are easy to observe; the bad news is that those same turtles are difficult to get in hand for a closer look. Observing turtles from a distance is a lot like bird-watching; a good pair of binoculars can bring them in close, and you can learn to identify species by their shape and profile and by the markings on their limbs, head, and neck.

Fishing lakes and lakes in municipal parks can be great places to get a closer look at aquatic turtles. Wild turtles are very wary of movement and loud noises, but turtles in these public areas are used to human activity, and often you can get close to them. Some lakes are encircled by roads, and turtles and other wildlife grow accustomed to vehicles; you can observe and photograph through an open window, but if you attempt to exit the vehicle, the turtles are likely to disappear into the water.

Bridges, dams, and spillways can serve as observation platforms that screen your movements as you peek over the side at basking turtles. Be sure to check

Red-eared sliders (*Trachemys scripta elegans*) and southern painted turtles (*Chrysemys dorsalis*) at a fishing lake in southern Missouri. The black-headed turtle is a red-ear; melanism is common among adult male *Trachemys*.

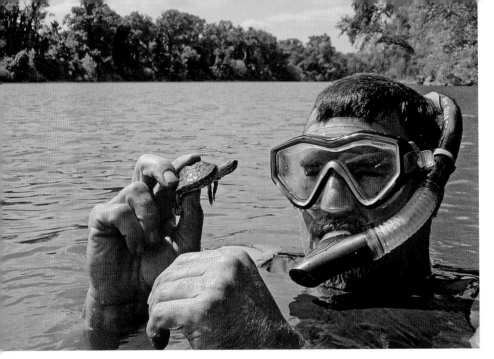

Snorkeling for small map turtles (*Graptemys* spp.) in Missouri's Current River.

the catchment basins below overflow spillways — turtles are sometimes swept over the edge into the basins below.

Aquatic turtles must leave the water to lay their eggs, providing an opportunity to observe them crossing roads and trails in search of a suitable nesting site. Typically, turtles will look for a sunny, sandy bank to dig a nest and deposit their eggs, but species such as snapping turtles and painted turtles will sometimes travel far away from water to lay their eggs. This habit disperses the next generation to other aquatic habitats, but it also means that neonate turtles are also on the move (and often crossing roads) after hatching, as they head for water.

Canoes and kayaks are great tools for getting closer to basking turtles. If you remain still and quiet, you can often float close by their basking platforms. Walking along shallow creeks and wading in small ponds can also be productive — if the water is clear, turtles can be spotted below the surface. Snorkeling in clear rivers and streams can also be a great way to observe turtles and occasionally get them in hand. Neonate turtles typically hide in shallow water, in places with thick vegetation to protect them from predators. They also hang out along the undersides of logs, root systems, and submerged trees and can be seen while snorkeling. Snorkeling is also a great way to observe sea turtles in shallow water habitats.

Rivers with sandy banks and sandbars may provide opportunities to observe softshells (e.g., *Apalone* spp.). Softshells often settle into the sand at the water's edge, where they can blend in, bask, and break for the water when alarmed. As you walk along the bank, keep alert for softshells foraging in shallow water, and for turtles dug in close to the water.

Mud and musk turtles (*Kinosternon* spp. and *Sternotherus* spp.) often forage at night, in shallow water near the shore. In some places, they can be easily found by hiking in shallow marshes and looking for their scrambling figures. They may also leave the water on nights with heavy rains, when they may be found crossing roads.

Semiaquatic turtles spend time in water and on land, including the spotted turtle (*Clemmys guttata*), the wood turtle (*Glyptemys insculpta*), the Blanding's turtle (*Emydoidea blandingii*), and the neotropical wood turtles (*Rhinoclemmys* spp.). While they can be observed in water and basking on logs and other objects, they can also be encountered on dry land, usually around a water source. During the egg-laying season (typically May or early June) they can be found crossing roads.

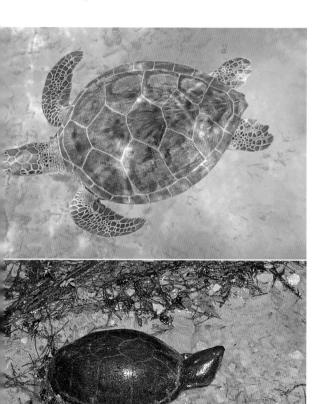

top A green sea turtle (*Chelonia mydas*) observed while snorkeling on the Yucatán Peninsula, in Mexico.

bottom An eastern musk turtle, or "stinkpot" (*Sternotherus odoratus*), observed crawling along a gravel road during a heavy rain.

TURTLES IN THE PARK

On a herp trip to Thailand a few years ago, I chose a hotel bordering a large municipal park in a Bangkok suburb. The park, I reasoned, likely had some turtles in its large lake, and my assumption proved to be correct. The lake was home to a number of species, including the yellow-headed temple turtle (*Heosemys annandalii*), the Malayan snail-eater (*Malayemys macrocephala*), and the Asian box turtle (*Cuora amboinensis*). The park was filled with people every day (Thai people use their parks!), and the turtles were accustomed to the constant activity. I was able to get very close to many turtles and even caught a few as they basked on the lakeshore. On a visit to Lumphini Park in the heart of downtown Bangkok, the situation was much the same: the turtles were approachable and catchable in some cases. (You can also get up close to some large water monitors [*Varanus salvator*] in Lumphini Park, but that's another story.) Later in the trip I saw wild examples of these turtles but mostly from a distance, so I was grateful for the opportunity that the parks provided.

While this experience drove the point home, I've always had good luck observing turtles in parks and fishing lakes. A pair of binoculars makes it even better, and there's something to be said for observing up close as a slider or a painted turtle crawls onto a log, looking around and blinking its eyes as it settles in for a bit of basking. [*Mike*]

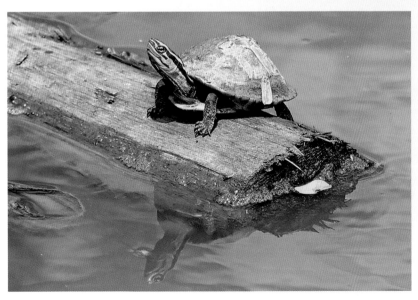

An Asian box turtle (*Cuora amboinensis*) basks in a city park in Lat Krabang, Thailand.

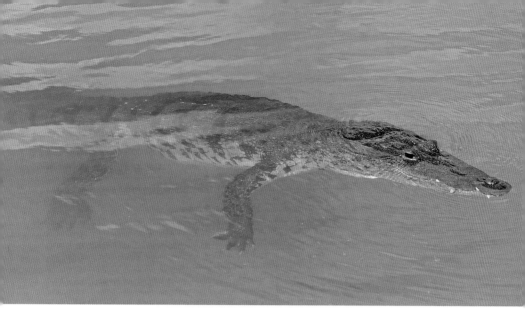

Morelet's crocodile (*Crocodylus moreletii*) in a lake near Coba, Yucatán, Mexico.

Finding Crocodilians

Five species within the order Crocodylia occur in North America; four of the five are restricted to the subtropical regions of the United States, Mexico, and the Caribbean. One is an introduced species from South America; the spectacled caiman (*Caiman crocodilus*) is established in canals and other waterways around Miami in southern Florida. In Cuba, field herpers may have opportunities to view the critically endangered Cuban crocodile (*Crocodylus rhombifer*). Morelet's crocodile (*Crocodylus moreletii*) is found in the Yucatán Peninsula of Mexico and in Guatemala.

The most accessible crocodilian in North America is the American alligator (*Alligator mississippiensis*). More cold-tolerant than other crocodilians, alligators can be found in suitable freshwater habitat across the southeastern United States, including swamps, lakes, marshes, rivers, and canals. They are sometimes found in residential lakes and in ponds on golf courses. Wildlife refuges, parks, and other natural areas are excellent places to observe alligators, including the Everglades in southern Florida and the Okefenokee Swamp in southern Georgia.

The alligator and the American crocodile (*Crocodylus acutus*) receive both federal and state protections within the United States. American crocodiles are found in coastal areas in southern Florida, Mexico, and the Caribbean, and they

American alligators
are often abundant in
appropriate habitat
within their range.

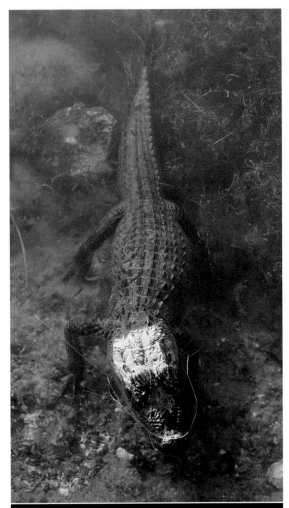

American crocodiles
are common in the
mangrove swamps
of extreme southern
Florida.

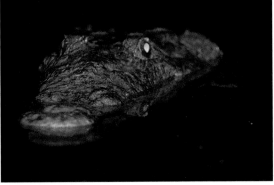

are restricted to salt and brackish water. Hunting and habitat loss have reduced their populations, but under protection they are making a slow recovery in southern Florida. A number of crocs have taken up residence around the boat docks near the Flamingo visitor's center at the southern end of the Everglades, and many field herpers get their first look at *Crocodylus acutus* there.

The best opportunity to observe crocodilians is while they bask along the water's edge. Large crocodilians must haul themselves onto the bank, while smaller ones can also use logs, branches, and other objects as basking platforms. When they bask and for how long depend on the season, cloud cover, air temperature, and water temperature. In general, crocodilians tend to bask more on sunny days in the spring and fall. Like turtles, wild crocodilians may hit the water if you try to approach them — binoculars are handy tools for spotting and observing them. In areas with frequent human activity, they may allow you to get closer, but remember that large crocodilians have the potential to inflict serious injury or even death. Watch out for nest mounds that alligators construct using mud, sand, grasses, and other vegetation; female alligators guard their nests and the eggs incubating within. Adult females will also keep watch over their babies for a few weeks after they hatch; if you see a neonate, keep an eye out for the mother, who may be nearby.

Finding Frogs and Toads

Within the class Amphibia, frogs and toads make up the order Anura ("without tails") and are often referred to as anurans. One thing that sets anurans apart from other herps is the significant amount of noise they make. The calls and trills of male frogs and toads are intended for females, and field herpers can take advantage of these come-hither vocalizations to witness their rituals of courtship and mating. Outside their normal breeding season, anurans may vocalize when it rains or when a low-pressure front moves in — squirrel treefrogs (*Hyla squirella*) are often called "rain frogs" for this reason.

Frogs and toads are found across most of North America, and finding some species is simply a matter of visiting any kind of fresh water. But anurans have adapted to live in many different habitats, including dry plains and deserts, and finding these habitat specialists requires paying attention to weather and understanding their natural history.

Anurans are tied to the water, thanks to their permeable skins and method of reproduction. While the thick, rough skin of toads allows them to wander

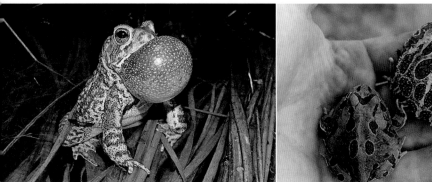

left A male Woodhouse's toad (*Anaxyrus woodhousii*) calls from a shallow pond in south-central Kansas.

right These horned frogs (*Chacophrys pierottii*, left, and *Ceratophrys cranwelli*, right) are specialists from the semiarid Chaco region in Paraguay, Argentina, and Bolivia. They are rarely seen except during rain, when they may come to the surface in high numbers.

further away from water, they still suffer from evaporative loss. Toads, treefrogs, and other anurans that spend time away from water have water-absorbing patches of skin in the pelvic area and in some cases on the hind limbs. Within these pelvic patches, the skin is often granular, allowing greater contact with moist or wet surfaces. Once water is absorbed through the skin, it is stored in the urinary bladder to be used as needed. Driving roads after a rain, you may see frogs and toads with their bellies pressed flat against the wet road surface, absorbing water through their pelvic and leg patches.

Breeding Season

Across North America, frogs and toads reproduce at different times, depending on location, climate, and species. In temperate regions, breeding season begins with the early spring rains; further south, anurans may breed during the winter. Desert species tend to breed during the monsoon rains of late summer. No matter where you live, the anuran breeding season is worth witnessing. If enough rain has fallen to fill ditches, ponds, and ephemeral pools, participation is easy; just take a nighttime walk or drive to places with standing water, and listen. The calls and trills of male frogs and toads will show you the way.

The classic scene of a croaking frog on a lily pad is a rare occurrence. Most anurans (especially smaller species) prefer to call from under vegetation to avoid predation. It can be difficult to locate a calling frog or toad, and you may need to move several feet in one direction or another to get a fix on its location.

In temperate climates, where ice and snow give way to spring rains, some species breed as soon as possible. Choruses of spring peepers (*Pseudacris crucifer*) and wood frogs (*Lithobates sylvaticus*) are often the first evidence of the coming spring in much of the eastern United States and north into Canada. As the weeks pass and spring advances, other anurans will join in and provide field herpers with more opportunities to observe their courtship and mating.

The Water's Edge

For many people, their first encounter with a frog or a toad takes place along the edge of a pond, lake, swamp, or other body of water. Typical water's-edge species include various types of "true frogs" (family Ranidae), including cricket frogs (*Acris* spp.), bullfrogs, green frogs, and leopard frogs (*Lithobates* spp.). They make use of cover, including vegetation along the bank, water plants, and overhanging trees and bushes. Frogs living on the water's edge must be wary of aquatic, aerial, and terrestrial predators, and a leap from land to water might be an escape from one danger, only to face another threat from large fish or turtles.

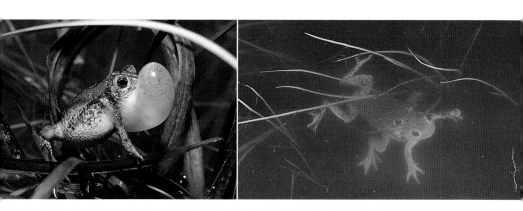

Breeding season may make a number of species both visible and audible. These two species, the oak toad (*Anaxyrus quercicus*) and the barking treefrog (*Hyla gratiosa*) (right), may be found at many sites in the southeastern United States during the breeding season.

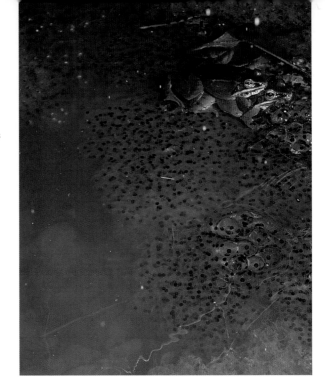

Wood frogs are among the most cold hardy of any amphibian and are the only herp species to range into Alaska.

Wanderers Afield

Don't be surprised if you find frogs that seem out of place or far from their watery home, especially during rainy weather. Vegetation tends to retain moisture from rain and dew, allowing frogs to forage far afield. Leopard frogs often hunt for insects in fields and meadows, and chorus frogs often occupy the fields and forests surrounding their water source.

Treefrogs

Long limbs and grasping, sticky toes allow treefrogs to utilize habitat from ground level up into the trees. Most treefrogs stay fairly close to the ground; a few (such as gray treefrogs *Hyla versicolor* and *H. chrysocelis*) may occupy the tops of tall trees. Many species sleep during the day and are active at night. During the day, examine cattails, bushes, and small trees close to water for sleeping treefrogs tucked under leaves or loose bark, on shaded branches, or in tree hollows. After dark, the same vegetation will hold active, alert treefrogs looking for insect prey. Look for treefrogs at night on the sides of buildings with lights (houses, gas stations, park buildings, campground headquarters, etc.). The frogs gather there to feed on the swarms of insects attracted to the lights.

Day or night, rain can trigger activity, and some treefrogs may call during the pressure drop in advance of any rainfall. During breeding season, they may call from the ground or water or from low bushes and plants.

Desert Anurans

In dry regions, frogs and toads use habitats where water occurs, where rainfall collects, and where moisture persists. Frogs such as California chorus frogs (*Pseudacris cadaverina*) and canyon treefrogs (*Hyla arenicolor*) make use of permanent and semipermanent streams flowing down from mountains and foothills into the desert. When water is present, they can usually be found close by; during drier periods, they will seek out remaining pools of water, or they may retreat into cracks and crevices where moisture is still present.

The tough, warty skin of toads helps slow evaporative water loss, and a number of species are found in desert habitat, including red-spotted toads (*Anaxyrus punctatus*), arroyo toads (*A. californicus*), and western toads (*A. boreas*). While they occur around permanent or semipermanent water, toads can also be found in places where water runs or collects when it rains, such as arroyos and gullies. They also take advantage of cattle tanks, retention basins, and irrigation ditches.

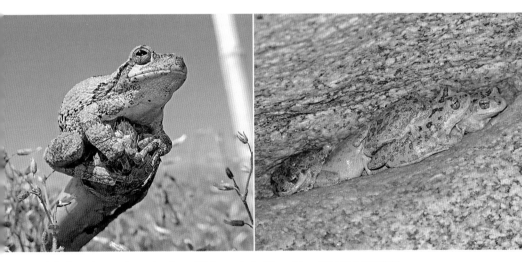

left One of several gray treefrogs (*Hyla versicolor*) found in a Missouri cornfield on an early morning in May. They likely came down to the field during the night to feed on insects.

right California treefrogs (*Pseudacris cadaverina*) in a crevice above a desert stream, San Diego County, California.

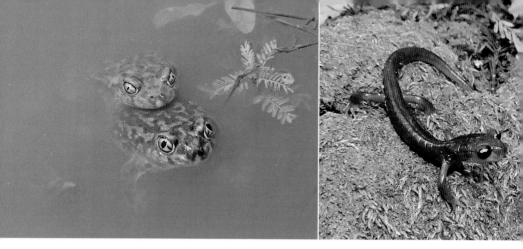

left Couch's spadefoot toads (*Scaphiopus couchii*) amplexing in a rain pool in Baja Sur, Mexico.

right Yellow-eyed ensatina (*Ensatina eschscholtzii xanthoptica*) from central California.

Spadefoot toads (*Scaphiopus* spp. and *Spea* spp.) survive desert heat and dry seasons by burrowing underground, where they wait until the next rain event. When there is significant rainfall, as in the late-summer monsoon season, spadefoots emerge from the soil to breed in the resulting pools of water. During their active season, they are out at night, attempting to eat as much as possible, and they will remain active as long as moisture persists. During the rainy period, spadefoots also absorb water through their pelvic patches, refilling their bladders in readiness for the coming long months underground.

Many desert anurans are nocturnal, avoiding the sun to minimize evaporative loss. Because frogs and toads come out on the roads to soak up moisture, road cruising after rain (even light rain) can be very worthwhile.

Finding Salamanders

Within the class Amphibia, the order Caudata ("with tails") contains the salamanders, often referred to as *caudates*. There are more than seven hundred species of salamanders, and approximately a third of those are found in North America. Some species are completely aquatic, others are semiaquatic, and some salamanders live a terrestrial life. As amphibians, all salamanders are dependent on moisture to varying degrees.

For the purposes of this chapter, we set aside taxonomy and consider finding salamanders based on terrestrial, semiaquatic, and aquatic lifestyles.

Terrestrial Salamanders

This group includes mole salamanders (family Ambystomatidae) and many of the lungless salamanders (family Plethodontidae). When moisture is present, they can be found under logs, rocks, bark, and artificial cover. During dry conditions, they burrow into the earth in search of moisture, or they may move closer to water. In desert and plains habitat, terrestrial salamanders stay close to water sources such as streams, gullies, and cattle tanks, where the soil may remain moist. In hilly and mountainous areas, salamanders often prefer cool and moist northern slopes.

Mole salamanders inhabit forests, swamps, marshes, and grasslands. Most breed during winter or spring, but a few species such as the marbled salamander (*Ambystoma opacum*) breed in the fall. They are best observed during breeding season, when they move to fishless ponds and temporary pools to breed. The migration typically takes place on rainy nights; with a headlamp or flashlight, rain gear, and rubber boots, you can observe salamanders on the move and their courtship and reproduction once they reach their breeding pool.

Ambystomatids and other salamanders often intersect roads on rainy nights, providing another opportunity to witness their migration; unfortunately, many are often flattened by vehicles. If you can do so safely, please consider moving salamanders off the road and in the direction they were heading.

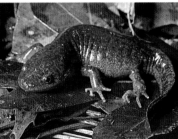

left Some ambystomatids like this eastern tiger salamander (*Ambystoma tigrinum*) spend much of the year underground and are usually found at the surface only during winter or early spring rains.

middle The mole salamander (*Ambystoma talpoideum*), on the other hand, is less picky and may be found during rains or near ponds year-round at some locations.

right Streamside salamanders (*Ambystoma barbouri*) do not typically breed in calm, fishless pools like many other mole salamanders but instead breed in fast-flowing temporary streams.

above Cave salamanders (*Eurycea lucifuga*) emerge from hiding places at night to hunt invertebrate prey.

right A larval red salamander (*Pseudotriton ruber*), from the leaf litter alongside a seepage pond.

Terrestrial plethodontids include woodland salamanders (*Plethodon* spp.), ensatinas (*Ensatina* spp.), and slender salamanders (*Batrachoseps* spp.). While they may be found close to water, these salamanders do not require a permanent water source; their typical habitats receive rain, snow, or both, and they are usually found under objects that retain moisture, such as rocks, logs, stumps, layers of fallen leaves, and moss.

Some species of terrestrial salamanders specialize in using cracks and crevices in rock faces, caves, seeps, and springs. This group includes cave salamanders (*Eurycea lucifuga*), web-toed salamanders (*Hydromantes* spp.), and climbing salamanders (*Aneides* spp.). Some *Aneides* are also arboreal and have been recorded in tall trees at heights over a hundred feet.

Semiaquatic Salamanders

Quite a few salamanders live in and along the edges of small streams, swamps, bogs, springs, and seeps. Stream dwellers include brook salamanders (*Eurycea* spp.), dusky salamanders (*Desmognathus* spp.), torrent salamanders (*Rhyacotriton* spp.), and Pacific giant salamanders (*Dicamptodon* spp.). During the day, they are typically hidden under rocks, logs, and other cover near the water. At night, they emerge from hiding to feed on their invertebrate prey. Some dusky salamanders may be active during the day, including the blackbellied salamander (*Desmognathus quadramaculatus*). Muddy areas below small seeps and springs are good places to look for red and mud salamanders (*Pseudotriton ruber* and *P. montanus*) as well as spring salamanders (*Gyrinophilus porphyriticus*). These species can also be found in and around small streams.

The newts of North America deserve special mention, as some species can be both terrestrial and aquatic. Pacific newts (*Taricha* spp.) are rough skinned, much like toads are, and can be found away from water, in forest and field habitat. They return to ponds, lakes, and streams to breed and can be found both in the water and along the bank. The larvae of eastern newts (*Notophthalmus*

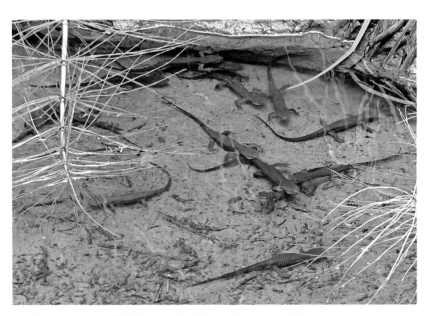

Rough-skinned newts (*Taricha granulosa*) in a quiet pool of a shallow stream, Santa Cruz County, California.

viridescens) transform into an eft stage, developing a rough, water-retaining skin that allows them to spend several years on land. Eventually they return to the water to breed and transform again into their aquatic adult form. Look for efts under rocks and logs in moist habitat; aquatic newts can be caught with a dip net or a minnow trap.

Please note that newts are poisonous (not venomous): their bodies contain varying amounts of tetrodotoxin, which serves as a deterrent to predators. The rough-skinned newt (*Taricha granulosa*) of the Pacific Northwest has the highest known amount of tetrodotoxin. Eating rough-skinned newts or ingesting even a small part of one can be fatal to many animals, including humans.

Aquatic Salamanders

North America has an impressive array of large aquatic salamanders, arranged in four families: hellbenders (Cryptobranchidae), waterdogs (Proteidae), amphiumas (Amphiumidae), and sirens (Sirenidae). All are completely aquatic, although you may see sirens and amphiumas wriggling across roads on rainy nights. Aquatic salamanders can be a challenge to observe, but some can be caught with a dip net or a minnow trap, and snorkeling for them in clear water can be effective. All of them are active at night and remain largely hidden during the day. All the aquatic salamanders are capable of delivering a painful bite.

Hellbenders (*Cryptobranchus alleganiensis*) are perhaps the most notable species, and thanks to habitat degradation, they are also the most vulnerable and endangered of the aquatics. Hellbenders receive both federal and state protection and should not be captured or handled. A creature of clear flowing rivers and streams, hellbenders can sometimes be observed in shallow water. Like other aquatic salamanders, they are primarily active at night, but they may also forage along the bottom on overcast days. Hellbenders lay eggs on the underside of large rocks in the summer and fall, so take care not to disturb them.

Mudpuppies and waterdogs (*Necturus* spp.) are large aquatic salamanders with paddle tails and external gills. They inhabit a number of aquatic habitats but are most easily found in clear, shallow water, under rocks, logs, and root systems. They are occasionally caught on fishing lines and may show up in minnow traps. They can be found in appropriate habitat under rocks and by running a dip net through leaf litter.

The four-legged amphiumas (*Amphiuma* spp.) and two-legged sirens and dwarf sirens (*Siren* spp. and *Pseudobranchus* spp.) are perhaps the easiest aquatic salamanders to find and observe on the southeastern coastal plain. They live

A fully aquatic greater siren
(*Siren lacertina*).

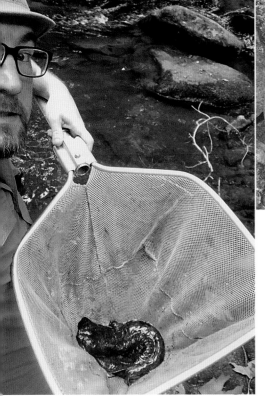

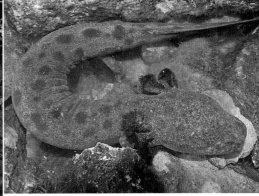

A mudpuppy (*Necturus maculosus*)
from a creek in Indiana. Note the
feathery external gills, which help
distinguish it from a hellbender.

Josh with a hellbender (*Cryptobranchus
alleganiensis*) found during his research.

"I THINK WE NEED A BIGGER NET"

The leafy, sandy-bottomed creeks in the Apalachicola National Forest are filled with all sorts of interesting herp species, if only one can get to them. I had been told by a friend of a good spot to dip for an as-yet-undescribed species of mudpuppy, as well as an undescribed species of siren. Armed with a dip net and the burning desire for a new and interesting lifer salamander or two, Jake Scott, Daniel Dye, Michael Dye, and I embarked on an excavation of the leaf packs along the edge of the creek, hoping to see the wiggle of a 'mander or two. We dipped and dipped, but nothing was presenting itself except the occasional dragonfly naiad, predacious diving beetle, or terrifying giant water bug (they don't earn their colloquial name "toe-biter" for nothing!). After nearly an hour, we were drenched, muddy, and mudpuppy-less.

We decided to call in the big guns and asked Nathanael Herrera and Ken Wray to help us. The two had mastered Apalachicola, amphibian-wise — at least, as much as anyone else — and mudpuppies and sirens

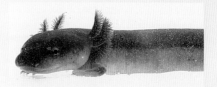

A dwarf waterdog (*Necturus punctatus*) found in many pounds of leaf litter in a sandhill creek.

were a dime a dozen for them. We met later at the same creek, and almost immediately I realized our error. I had a modest dip net that could perhaps slog five pounds of leaf pack on a good day. Nathanael and Ken had monster dip nets that could haul fifty pounds, equipped with handlebars for hauling the stuff out of the water and a heavy steel frame. Within five minutes, we had found several mudpuppies in the creek and were beginning a photo session, having learned the lesson: persistence pays in herps, but sometimes proper equipment trumps time and energy. [*Josh*]

Disclaimer When you dip net leaf packs, return them to the water afterward, and be sure to leave some intact — they provide important habitat!

Josh's daughter searches through the detritus brought up by his heavy-duty dip net.

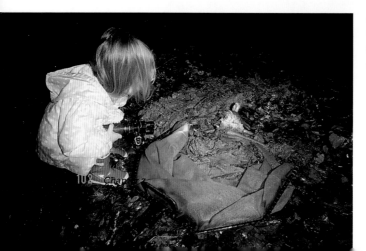

in swamps, bayous, oxbows, canals, and other kinds of shallow, murky water. Roadside ditches are great places for amphiumas and sirens; their narrow confines make it easier to catch them, either with a dip net or a minnow trap.

Finally, some terrestrial salamanders may remain aquatic throughout their lives if water levels remain high — the axolotls (*Ambystoma mexicanum*) of Mexico are famous for this, but a number of species, including other mole salamanders, may retain their gills and aquatic lifestyle into adulthood. Such salamanders are said to be *neotenic* or *paedomorphic*.

Identifying these dusky salamanders would be a challenge without picking them up.

CHAPTER 4
CATCHING AND HANDLING HERPS

Field herping is a hands-on activity, and while at times it is inappropriate to handle some herps, there are also many good reasons to catch and hold them. Many amphibians and reptiles will flee as soon as they realize they are being watched or approached. Catching them gives you the opportunity for a tactile experience and for a prolonged and up-close look instead of a brief glimpse. Handling some herps may be the only way to see the features that distinguish them from other species. Salamanders are an excellent example, as many species may be identified only by features like toe shape, tail shape, number of costal grooves, and so on. Finally, while in situ ("in place") pictures are a wonderful way to showcase a herp, getting a good in situ shot is not always possible. A carefully posed shot can show off the animal's coloration, patterning, and body to the greatest effect.

For observers of other types of wildlife, catching and handling are difficult

or impossible because their target animals are too big, fast, or dangerous or because handling them may cause unnecessary stress that may lead to death. For the most part, field herpers do not have this problem; with a little experience and common sense, you can safely handle most herps without putting too much stress on them. Despite the popularity of snake hooks and tongs, most terrestrial herps are best caught by hand. When discovered they may move quickly, and so must you if you want to catch them!

This chapter provides some specific, time-tested catching and handling methods, but that does not mean that all herps should be caught and handled. Crocodilians, venomous snakes, and venomous lizards are dangerous and should not be handled without a very good reason. When catching harmless herps, remember that they are wild animals and capable of biting, scratching, and otherwise causing injury, so handle at your own risk! During capture and detention, remember that you and the animal are having a completely different experience: you're excited, while the herp may think it is being preyed upon. Also keep in mind that it isn't necessary to catch and handle every herp you see — there is also satisfaction to be gained from hands-off observations. Respect for animals is part of the field herping experience, and other field herpers will expect it from you.

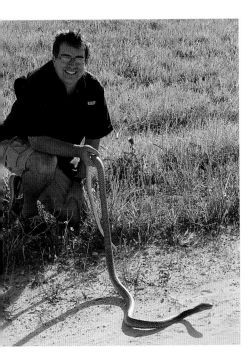

Harmless snakes are characterized as nonvenomous and unable to kill a human by constriction. Few would say this eight-foot, six-inch coachwhip (*Masticophis flagellum*) is truly harmless; its bite is painful but not a medical emergency.

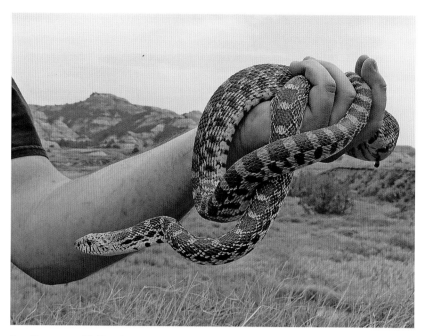

A well-supported bullsnake is briefly examined and admired in the badlands of North Dakota.

Harmless Snakes

Before picking up a snake, you need to make sure it is harmless. This may seem like a no-brainer, and it is for most snakes, but some harmless snakes look like venomous species and vice versa. Conditions may make instant identification difficult; for example, trying to identify a snake at dusk in the light of a vehicle's headlights can be a problem. Study the venomous snakes in your area and know what they look like and what their harmless mimics look like. If you're not sure about the species of a snake, treat it as a venomous animal until proven otherwise.

Harmless snakes are best picked up at mid-body and not by the tail. We use the term *picked up* rather than *grabbed* because the less force that is used, the less likely it is that the snake will bite, defecate, musk, or regurgitate a food item. While biting, pooping, and musking are common consequences of handling snakes and to be expected, the last thing you want is for a snake to regurgitate and lose a hard-won meal that it likely can't replace. Any snake with an obvious

food bulge should not be handled. Many snakes are fast, and to catch them, you may have no choice but to make a quick grab. Once you have it, use both hands to support the snake from underneath and keep your movements slow and steady. Snakes often mirror the handler's temperament — remain calm and deliberate, and chances are the snake will too. Use one hand to gently but firmly restrain the snake, and your other hand and arm can serve as a support — to the snake, they are nothing more than a supporting branch. Snakes may sometimes strike at a handler's free hand, face, or another person, but they usually ignore the hand and arm that supports them.

A small snake can rest on the palm of your hand, while you gently restrain its body with your thumb. If necessary, long, heavy serpents can be held by the back third of the body, with the front half of the snake remaining on the ground. Snakes should not be grabbed or held by the tail (the area below the vent), as it may be damaged, or even break off, as the snake tries to escape. Snakes that are obviously gravid or have a distended abdomen due to a large meal should be handled as little as possible or (preferably) not at all.

The occasional bite from a harmless snake is part of the field herping experi-

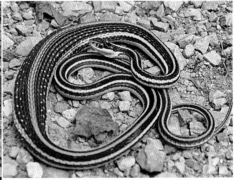

left A calm, supportive hold on a very bitey Yucateca bird snake (*Phrynonax poecilonotus*).

above Snakes with enormous food bulges like this orange-striped ribbonsnake (*Thamnophis proximus proximus*) should not be handled.

Even harmless snakes can deliver painful bites. Use caution for yourself and show respect for the snake.

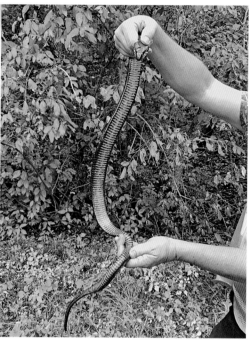

A plain-bellied watersnake (*Nerodia erythrogaster*) is being readied for a PIT tag implant and a DNA sample. The head and neck are firmly supported, as is the tail to prevent any thrashing.

ence. Most of the smaller species almost never bite, larger kinds are occasional biters, and some, like the aquatic *Nerodia*, are notorious for biting a lot. While bites often result in just a few shallow scratches, the shock of getting bitten can intensify the experience. It may take some time to get over the apprehension of a bite, but try to keep the experience in perspective: picking up an uncooperative domestic cat may result in worse wounds than a snake's bite. With practice, you can avoid most bites by handling the snake properly in a calm manner. Under no circumstances should a snake be antagonized into striking or biting; it may injure itself, it can lose teeth, and it is unnecessarily stressful (and disrespectful) to the animal.

Holding a snake behind the head is advisable only when it must be held immobile for measurement, scale counts, and such. When the snake is restrained in that manner, its interpretation of events is that it is being preyed upon, and it will do its best to get free. If held improperly, the snake can suffer injuries if

BROADSIDES FROM THE OTHER END

The business end of a snake, AKA the bitey end, gets a lot of attention and reasonably so. But snakes can also musk you, and poop on you as well. There you are, calmly holding a gorgeous kingsnake, and all of a sudden it raises its tail and smears a liquid mixture of dark brown stuff (feces) and white stuff (uric acid) all over your arm. The smell is awful, and seemingly more awful than it should be. That extra-smelly slap on your nose is snake musk, a complex cocktail of organic compounds, which is made and stored in glands on either side of the snake's cloaca. The feces and uric acid effectively distribute the musk further than it could get on its own.

Snake musk largely serves as a predator deterrent. In studies done on musk, it appears that molecules within the odoriferous substance can trigger warnings within the predator's olfactory system, thereby distracting it. During the breeding season,

Diadophis punctatus receives many votes for the most potent musk.

male snakes make use of musk to deter other males while they mate, and some female snakes can take advantage of male musk for the same reason. The pungent perfume certainly has an effect on humans, who can't think of much else during the moment they are musked, which may prove the greater point. Determining any physiological effects of snake musk on humans (elevated heart rate, thoughts of taking up stamp collecting) may be a fertile field for research.

Musk and poop are a part of field herping. Despite your best intentions and calm, respectful handling, sooner or later, you're gonna get it. A pack of baby wipes can help remove the worst of it, and soap and water can finish the job. Clean up the stinky mess before handling another snake, which may otherwise react to the musky molecules clinging to you. It can make a difference for your companions too; four herpers in a closed car, each with his or her own pungent paint job, is a scenario not for the faint of heart. Musking is so embedded in field herping culture that there are arguments over which species have the worst-smelling musk, and whether the human nose can tell one species from another (we can). Top contenders for the title of Most Awful Musk include ringneck snakes, gartersnakes, ribbonsnakes, and watersnakes. Pythons receive honorable mention for sheer volume of projectile musk. We'll let you reach your own conclusions.

[Mike and Josh]

it slips from your grasp and thrashes its body. The best grip to use is much like holding a garden hose: the snake in your closed hand, with its neck supported by all your fingers and your thumb resting on the head. The body of the snake is firmly supported with your other hand. Avoid using only a thumb and index finger to circle the neck or even a three-fingered pinch of the head and neck — use all your fingers to prevent the snake from writhing.

Venomous Snakes

Observing venomous snakes is an exciting part of field herping. The authors hope that you have many encounters with these fascinating animals, but we strongly recommend against catching and physically handling them. In North America, many cases of venomous snakebite result from attempts to catch the snake or from purposeful handling. You can observe and enjoy venomous snakes in the field without putting yourself and others in harm's way, and you can keep your chances of being bitten extremely small, simply by leaving them alone. See the next chapter for more details on venomous snakebite.

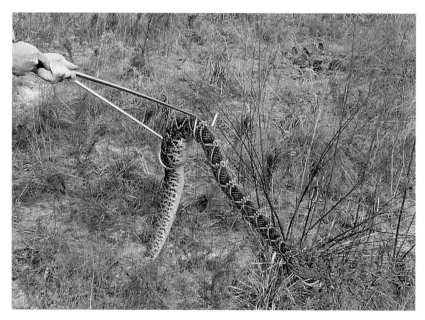

This large eastern diamondback attempted to flee upon discovery. Snake hooks are being used to "detain" the snake, rather than capture it. The snake is part of a research project, and data was taken before allowing it to move on.

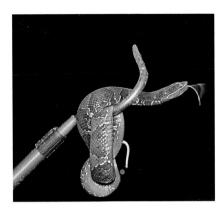

Small pit vipers like this Mexican moccasin (*Agkistrodon russeolus*) will often coil and hang from a hook. The high angle is for photographic purposes and is not recommended.

At times you may need to manipulate a venomous snake without catching it, such as when moving it out of harm's way (off a road, for example) or posing it for photographs. This is where your snake hook comes into play, although a strong branch can be used if no hook is available. The hook should be long enough to keep your torso and limbs safely out of reach. To move a venomous snake, slide the hook under it near mid-body and lift the animal just off the ground. Smaller snakes may coil around the hook end as if it were a tree branch. Try to keep the hook at an angle close to horizontal — too high and you can lose control of the animal, and it may come down the shaft of your hook. A high drop may injure the snake as well. When moving a venomous snake suspended from a hook, keep an eye on your path to avoid tripping over objects, and other people should stay out of your way. It isn't always necessary to lift a snake to move it out of the way; often a soft nudge with a stick is enough to start the animal moving in the opposite direction.

Getting an in situ photograph of a venomous snake is always desirable; the animal is not disturbed, and the photographer remains a safe distance away. But photographs can be difficult if the snake is moving or is obscured by vegetation. Sometimes a snake at rest can be lifted with a hook and moved to a more open area, or the blocking vegetation can be moved aside. Getting a moving snake to stop can sometimes be a problem. When threatened, most snakes, including venomous types, react by moving away in another direction; they may stand their ground and adopt a defensive posture only if they can see no path of escape. Sometimes a moving snake can be stopped by stepping in front of it at a safe distance. This tactic works better when more than one person is present.

A key point to remember when observing or manipulating venomous snakes

WHAT ABOUT
REAR-FANGED SNAKES?

Venomous snakes are typically divided into three groups, based on their fang structures, and all three groups occur in North America. This section of the chapter focuses on the viper and elapid groups, but the rear-fanged snakes deserve some mention too, since you're likely to find and safely handle some of the more common species.

The *solenoglyphous* group is composed of vipers and pit vipers. Located at the front of the mouth, their fangs are large and are attached to the jaw by a hinge. The hinge allows the fangs to be folded up against the roof of the mouth when not in use, which also means that the fangs can be larger than the fixed fangs of the other two groups. The *proteroglyphous* group includes the elapids (mambas, cobras, coralsnakes, seasnakes, etc.) Their fangs are rigidly fixed to the jaw at the front of the mouth, which means they are much smaller than viper fangs, but on the other hand, they are always in position to deliver a bite. *Opisthoglyphous* snakes are part of the Colubridae, the largest family

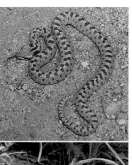

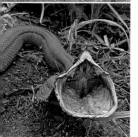

of snakes. They are usually referred to as "rear-fanged" snakes; their fangs are located further back in the mouth, making it more difficult for them to envenomate their prey. While vipers and elapids can bite, deliver their venom, and then release and withdraw, rear-fanged snakes must bite, hang on, and chew to bring their fangs into play. It may seem clumsy in the context of biting humans, but for snakes that eat lizards, frogs, and other small vertebrates, it is an effective method. Rear-fanged mechanisms have evolved independently more than once among colubrid snakes.

Some rear-fanged snakes, such as the African boomslang (*Dispholidus typus*), are dangerous to humans. Rear-fanged snakes in North America are harmless to humans; most are small, with tiny fangs and weak venom that seems to have little effect on mammals. They rarely attempt to bite and can be safely handled. If a rear-fanged snake does bite, and you allow it to hang on and chew, then you may get a localized reaction (pain and swelling) from the weak venom. This issue is of little concern, as it is easy enough to avoid letting a rear-fanged snake chew on you. Common rear-fanged species in North America include hognose snakes, lyresnakes, nightsnakes, and ringneck snakes. You may handle and enjoy them without worry. *[Josh and Mike]*

top A harmless Mesa Verde nightsnake (*Hypsiglena chlorophaea loreala*) flattens its head in an attempt to mimic a pit viper.

bottom A harmless eastern hognose snake (*Heterodon platirhinos*) using an open-mouth threat display. Two small fangs (sometimes called "toad-poppers") are clearly visible. To the uninitiated, this bluffing behavior can seem like a sinister threat.

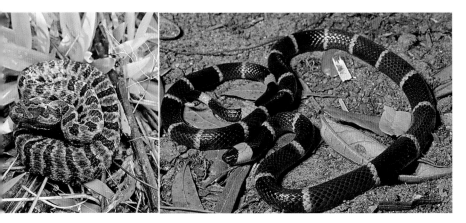

left An in situ photograph of a neonate Carolina pygmy rattlesnake (*Sistrurus miliarius miliarius*) basking in the open along the edge of a canal.

right Eastern coralsnake (*Micrurus fulvius*).

is that their behavior is unpredictable. A rattlesnake may remain quietly coiled as you observe and take photos, but that does not mean the next rattler will behave in the same way. Elapids such as coralsnakes are notoriously unpredictable; when encountered, they may attempt to rapidly crawl away or hide under objects, or they may thrash their bodies in a violent manner. Occasionally corals may remain in place, while waving their raised and flattened tails, and they sometimes attempt to bite by swinging the front part of their bodies sideways, with their mouths open. Other field herpers may tell you about their experiences with corals and other venomous snakes, but keep in mind that their experiences shouldn't be taken as gospel on how the snake in front of you might behave. Respect the animal, maintain a safe distance, and always expect unexpected behavior.

Researchers, snake relocators, and other professionals use a number of tools and techniques to capture venomous snakes. While we mention some of them in the next few paragraphs, they are not part of field herping as a recreational activity and should not be attempted by anyone without formal training or experience and a very good reason to use them.

Researchers who work with venomous snakes often use clear plastic tubes to immobilize the "business end" while they draw blood, take a DNA sample, and so forth. Success depends on getting the snake to crawl into the tube far enough to be safely handled. One hand holds the end of the tube and the snake's body,

COMPLACENCY
AND ASSUMPTIONS
A DANGEROUS DUO

A common thought when observing, photographing, or moving a venomous snake is "how close can I get and remain safe?" which often relates to how far and how fast the snake may be able to strike. Back in 2007, I had a pretty good year finding timber rattlesnakes (*Crotalus horridus*). I spent a little time helping to radio-track timbers in Indiana, and that experience really tuned me in — for the rest of the herping season, I was finding timbers all over the place. In late fall of that year, I visited a favorite rattlesnake den in southern Illinois, and right away I spotted a large female *horridus* on the edge of a rock ledge. The snake was close to four feet in length and at about waist height to me on the ledge. It looked like a perfect photo opportunity; I pulled out my camera and moved to within

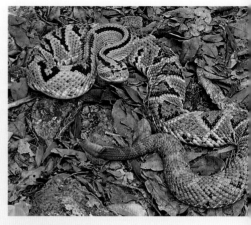

The unpredictable
Tzabcan rattlesnake.

a yard or so of the snake. Without warning, without rattling or coiling in a defensive posture, the snake struck at me, and with so much force that it slid off the ledge and landed at my feet. Needless to say, I scrambled in retreat to put some distance between me and the rattler. What surprised me the most was how much of its body the snake was able to launch in my direction, and with enough force to

effectively preventing it from backing out of the tube. There is a risk with this technique, and while researchers have a legitimate need to put a snake in a tube, field herpers do not.

Snake tongs ("clamp sticks") are nearly as iconic as snake hooks, and work best on snakes of moderate size. Tongs are useful for grabbing a snake near mid-body and lifting it into a nearby container or moving it a short distance. Closing the tongs on the snake's body requires applying an appropriate amount of pressure on the handle, which means there is a potential for injury — too

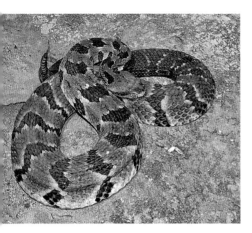

This timber rattlesnake had quite a lunging strike.

the rattlesnake. I forgot that snakes are capable of explosive action. Dumb Mistake Number Three: I hiked to the den alone, and it was a long hour's walk to reach it. If I had been bitten, or even if I had injured myself on the hike, I would have been in big trouble.

Fast forward ten years: I'm in the Yucatán, and we're photographing a Tzabcan rattlesnake (*Crotalus tzab-can*), a big five-footer we had found crossing the road. It was coiled and rattling on the roadside, and when I moved directly in front of it to take a picture, it struck at me. Later, I was able to estimate the reach of its strike at around thirty inches; the snake had launched at least half of its length at me. While I was a safe distance away, it was still a startling experience, and it brought my *horridus* moment to mind. My advice is to avoid dumb mistakes by never underestimating a snake's reach and never assuming you know what the snake will do based on what the last one did. [*Mike*]

carry the whole snake forward and off the ledge. I was lucky, but it was an afternoon filled with dumb mistakes on my part. Dumb Mistake Number One: I assumed this female would behave like most of the other *horridus* I had seen that year; most had given me no more notice than a flick of the tongue and maybe a cock of the head. Dumb Mistake Number Two: I assumed I was at a safe distance from

much force, and ribs or vertebrae can be broken. Grabbing a snake at the neck can also result in injury, as the animal thrashes about in an attempt to escape. Tongs do not work well with small snakes, which can be easily injured, if they can be grabbed at all. The way tongs are constructed means they also don't work well on snakes with a body shape that is triangular in cross-section, such as neotropical rattlesnakes (*Crotalus durissus*) and bushmasters (*Lachesis* spp.). Tongs have little practical use in field herping, and a snake hook is a much better tool for manipulating venomous snakes.

The hook-and-tail technique is sometimes used for capturing or moving venomous snakes. One hand holds the hook, to lift and support the front third of the snake's body, and the tail is grabbed with the other hand and held higher than the front end of the snake. The snake is kept stretched out to prevent the front end from doubling back toward the tail. This technique works only with snakes of a certain size; too short, and the head is always too close to the tail. Long snakes can be heavy, and arms quickly tire; there is also risk of injury to vertebrae and ribs from suspending the snake's full weight from two small areas. This technique is not recommended; much can go wrong, and it isn't necessary for field herping.

Finally, there is an "old school" method of catching venomous snakes that involves pinning the snake's head to the ground with a hook and then using a three-fingered pinch to hold it by the neck, with the index finger pressing down on the snake's head. This method is very stressful to the snake, and injuries can result from the pinning process and from the snake's efforts to get loose. It is also extremely dangerous because, like all snakes, venomous snakes can move the two halves of their top jaw independently of each other. This means that a snake can sometimes manage to stick a fang into the handler even if the person thinks he or she has a good grip on it. Things can also go wrong during the pinning and grabbing process. The only situation where this technique is necessary is venom extraction, and again, it has no place in field herping.

The allure of venomous snakes can be very powerful, and it can be very tempting to handle them. Please keep in mind the consequences to yourself and your family that come with the ordeal of venomous snakebite. Respect the animal, maintain a safe distance, and always expect unexpected behavior.

Lizards

Some lizards can be easily caught by hand, while others are too fast and wary, requiring other methods of capture. For hand catching, a "slapping" technique is commonly used, where one hand is brought down on top of the lizard (quick as a slap), pressing it between the hand and the substrate. Speed is the key with this technique, rather than force — slapping down too hard may injure the lizard. You can hand-catch small to medium-sized lizards using distraction: approaching slowly and avoiding direct eye contact, wave one hand slowly to hold the lizard's attention, until your other hand is close enough to slap over it. Take care

LARGE CONSTRICTOR HANDLING

Handling very large snakes is a whole other ball game from handling either small or medium-sized snakes or even handling captive giants. Thanks to the invasive Burmese pythons and boa constrictors in south Florida, some North American herpers can have the chance to interact with these otherwise-tropical species. Pythons and boas are constrictors: they wrap coils around their prey and squeeze tightly, so proper handling technique is important to avoid having that happen to you. As a general rule of thumb, the average adult can wrangle a python or a boa of up to ten feet in length; we do not recommend handling a larger constrictor without help, so think twice if you're alone.

There are two common methods for handling sub-ten-foot constrictors. First, one may grab them by the tail and proceed either to dodge their bites until they wear out (I call this "the Python Waltz") or to handle the front end with a snake hook. This method is obviously less than ideal because the animal is forced into undue physical exertion, and it should be avoided if possible. Alternatively, most pythons are encountered crossing roadways, and doing so they often use rectilinear movement (moving in a straight line without kinks or bends in their body). When moving like this, they are "uncocked," so to speak; they cannot strike a far distance and often can be easily grabbed behind the head. For the fainter of heart, large constrictors can generally be pinned with the butt end of a snake hook or with a boot (firmly but gently), and their neck is then grabbed. Because large constrictors are less delicate than smaller snakes, pinning and holding behind the head is an acceptable means of handling them, though it should be done with care

Handling pythons larger than ten feet in length requires a friend or two (or more).

The Python Waltz.

not to harm the animal. Once a grab is made behind the head, the other hand should grab the tail or as far down the body as possible — the key to safe constrictor handling is to have both ends of the snake under control to prevent it from getting a coil around you. Even with constrictors under ten feet, you should not drape them around your neck as is common with captive constrictors: wild specimens are much more powerful and unpredictable.

Constrictors over ten feet long may be captured the same way, except that another person is required to assist in handling and controlling the snake's body. It is important to maintain control of both ends and prevent the snake from getting a coil around any of the handlers' body parts. For constrictors over twelve feet, having three handlers is best, two at each end and one in the middle. The often-asked question when handling such a large constrictor is, "Do you want the sharp end, the end that defecates all over you, or the part that squeezes you to death?" Choose wisely. *[Josh]*

Disclaimer Obviously, large constrictors can be dangerous and harmful animals, especially if provoked. Use caution and remember to observe the laws governing large constrictor possession.

left This Isla Santa Catalina leaf-toed gecko (*Phyllodactylus bugastrolepis*) has both a regenerated tail and a small skin tear above the hind leg.

right A pair of eastern collared lizards (*Crotaphytus collaris*) hunkered down for the night under a flat rock in central Kansas.

with skinks and other types of lizards that drop their tails to escape predation; the whole body must be grabbed and held.

If you have no reason to catch tail-dropping species, consider leaving them alone — growing a new tail takes a lot of energy resources that could be better used for reproduction or foraging. Day geckos (*Phelsuma* spp.), leaf-toed geckos (*Phyllodactylus* spp.), and other gecko species have loose skin that tears easily. This is an escape mechanism; a predator grabbing hold can end up with just a mouthful of torn skin. These geckos should be handled gently; like tail-droppers, forcing them to grow a new patch of skin for no reason is a waste of precious resources.

For lizards that take refuge under rocks, logs, or artificial cover, you have the element of surprise on your side, and often you can slap a hand over them before they can escape. Lizards that are blazing fast at noon are more easily caught under objects at night or on cool mornings, when they are sluggish and slow to react. Lizards that climb on trees, power poles, and similar objects can be caught by coordinating with an observer, sneaking up on the opposite side, and reaching around to grab the unsuspecting lizard.

Noosing can be a useful technique for securing energetic lizards, who may

This collared lizard was noosed with an aluminum tent pole and a little dental floss.

A green iguana can bite, sink its claws into you, and leave a serious wound with its abrasive tail.

A six-lined racerunner (*Aspidoscelis sexlineatus*) is held by the front and back limbs for a photograph.

not view a stick and a string as much of a threat. Slender branches, dowel rods, and fishing poles are often used, and string, fish line, or even dental floss can be used for the line. The noose should be a slipknot, and the line must be long enough to keep the stick above and away from the lizard. The stick and noose are slowly swung over the animal and then lowered; when the loop settles over the lizard's head, the stick is jerked slightly to tighten the knot, using the lizard's body weight to keep it secure until the lizard is in hand. It takes a little practice to get the technique right, and care must be taken not to jerk the stick too hard or too far, which has the potential to injure the lizard. Noosing works best in open areas where vegetation and other objects won't get in the way and even better for species that perch on rocks and boulders, such as collared lizards.

Most lizards bite, but few can do more than deliver a sharp pinch. Larger species can break the skin when they bite and have other defensive weapons at their disposal. Green iguanas and spiny-tailed iguanas have a painful bite, their toes have sharp nails that can leave gouges and puncture wounds, and their abrasive tails can cause serious lacerations when they choose to whip. Large lizards like these are best held with two hands, one at the neck, and the other at the base of the tail. Avoid supporting the body with your forearm, as large lizards will bring their sharp claws into play. Smaller lizards can be held and supported in your palm, with a front or hind limb secured between thumb and index finger, and the other fingers holding the body in place. For examination and photos, both limbs closest to the hand can be held, leaving a clear side view of the lizard.

North America is home to two species of venomous lizards — the Gila monster (*Heloderma suspectum*) and the beaded lizard (*Heloderma horridum*). Large and robust, these lizards produce venom in the lower jaw, which is delivered to the prey animal (or careless human) by biting and chewing. They are caught by a quick hand to the neck and held by the neck and the base of the tail, but as

The business end of a Gila monster (*Heloderma suspectum*) from Sonora, Mexico.

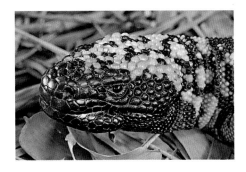

with venomous snakes, the authors recommend not handling them at all. While fatalities from *Heloderma* bites are rare, they require medical attention and are excruciatingly painful. These lizards do not just bite and release — they hold on, and on occasion their jaws have to be pried loose from the victim. Additionally, *Heloderma* are protected across their range in the United States and Mexico, and in the United States there are substantial penalties for collecting, detaining, or harassing them.

Turtles

On land, turtles are the easiest of herps to catch and handle; in the water, they are among the most difficult. Sometimes you can jump in and make a grab if the turtle is swimming nearby, but basking turtles are very wary, and it is nearly impossible to catch them. A dip net can make catching turtles much easier, especially if you are in a kayak or canoe. Slide the net under a swimming or basking turtle and lift up to make the catch. Dip nets also work well from docks and boardwalks and in ponds and other smaller bodies of water, especially if you don't mind getting wet. Snorkeling with a dip net is also effective, especially in clearer water.

Minnow traps are another method for catching mud and musk turtles and also juvenile turtles. The traps are baited with a can of tuna or sardines (punch a few holes in the can). The traps should be deployed in shallow water, and care must be taken to make sure the top of the traps remain above water, so that

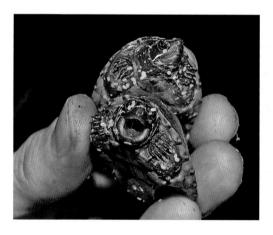

Two small stinkpots that were caught in a minnow trap.

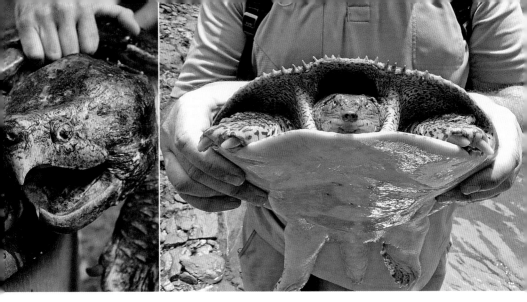

left Alligator snappers are best handled with one hand gripping the carapace, just behind the head (hand is safely out of reach).

right Large softshells can be held on both sides at mid-body.

the turtles and other creatures entering the trap have air to breathe. The trap can be anchored with sticks or stakes to make sure it doesn't move into deeper water.

Once captured, most turtles can be safely held with two hands at mid-body, in the same way you would hold a large hamburger to take a bite. While they are by no means aggressive animals, most turtles will bite in self-defense, and some are equipped with a strong set of jaws capable of breaking the skin. Snapping turtles, alligator snappers, and softshells are strong, long necked, and can deliver a powerful defensive bite. Large adults of any of these species require different handling methods. In land or on water, snappers can be detained by grabbing their tail, but they should not be picked up that way. The weight of the turtle can separate tail vertebrae and cause tissue damage, and the larger the turtle, the more severe are the injuries. Holding adult snappers and softshells at mid-body for any length of time can be problematic, as their hind legs are strong, and the feet have large claws that can rake your hands. A common method is to hook one hand under the front edge of the carapace, just behind the head, while the other hand holds the back end of the shell, or a foot. If properly done, this position will prevent the turtle from being able to reach any digits for a bite, but remain wary; no hold is foolproof.

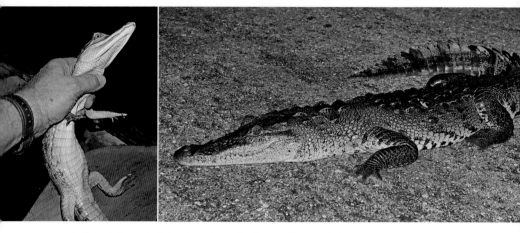

left A small spectacled caiman is grabbed and held for a photo.

right This six-foot Morelet's crocodile is too large to handle safely.

Crocodilians

Crocodilians are fascinating animals with an ancient lineage, and it is natural to want to get your hands on one, to examine it closely and have the tactile experience. In this section, we cover techniques for catching and handling small crocodilians under three feet in length. Adult crocodilians are dangerous animals, and we strongly recommend not catching or physically handling them — leave them to the experts. Also, bear in mind that in the United States, the American alligator and the American crocodile are protected by law and may not be collected, detained, or harassed. You may still have a chance to handle and examine small specimens of these two species if you link up with a research project, an outreach program, and such, and you also may have opportunities to handle crocodilians in other parts of the world.

Small crocodilians can be caught by hand or with a dip net, and they are much easier to find at night using a boat or canoe. The eyes of alligators and crocodiles reflect back red light ("eye shine") when hit with a flashlight beam. From the size and spacing of the glowing red eyes, you can easily tell adults from juveniles. When making a grab, one hand should target the neck, as close behind the head as possible, and the other hand should be ready to quickly grab the tail to prevent thrashing. For neonates, a one-handed grab will suffice. Once the animal is captured, you can maintain this hold or move the hand holding

the tail to underneath the body and support the body with your arm (remember that crocodilians have sharp claws).

It should come as no surprise that crocodilians will bite to defend themselves. Neonates have small teeth, but they have *many* small teeth and can leave a lot of little puncture wounds. A meter-long crocodilian can inflict severe wounds, and a bite is often accompanied by a severe thrashing of the head and tail. It goes without saying that if you don't have a good reason to catch a crocodilian, consider leaving it alone.

How big is too big to catch? If you cannot encircle more than half the neck with your hand, the animal is too large for anyone but an expert to handle. Always be aware of your surroundings when dealing with crocodilians of any size, and remember that young individuals may be in close proximity to their larger mothers, who have a maternal instinct to defend their offspring for weeks after hatching. Additionally, some species are stronger and more vigorous than others. For instance, holding a three-foot spectacled caiman is far more difficult than holding an alligator of similar size.

Frogs and Toads

Most toads scuttle and hop and are easy to catch. Frogs, with their powerful legs and ability to change direction after every leap, can be more difficult. The technique for hand-catching lizards can also be used on frogs and toads; one hand is wiggled to distract the animal, and a lightning grab is made with the other, while avoiding direct eye contact. As with lizards, it is more of a "slap" than a grab: quickly press the anuran against the substrate and then close your fingers around it. Frogs can also be caught with dip nets and landing nets, but that method isn't nearly as much fun as grabbing them by hand. Frogs are also easier to catch at night, as the beam from a flashlight can temporarily disorient them.

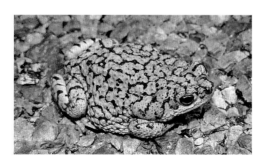

A western green toad
(*Anaxyrus debilis
insidior*) on a dark road
in New Mexico.

FROG JUICE IN THE EYES

It happened at the end of a good day of herping in North Carolina. Hiking around a small lake, we had found a melanistic eastern hognose, a pair of black racers, and a host of other amphibians and reptiles. Walking up the dirt road to our vehicle, I got something in my right eye, and I instinctively rubbed it with my index finger. Immediately I felt an intense pain, as if someone was slashing at my eyeball with a piece of broken glass. I had no idea one could actually feel that sort of pain on the surface of the eye.

About an hour earlier, we had found a Cope's gray treefrog (*Hyla chrysoscelis*), and I had posed it for photos in a small tree. I didn't wash my hands after handling the frog, and now I was paying for it. Despite a flood of tears and frequent dousing from my water bottle, the intense pain persisted for twenty minutes or more, and my eye was irritated and swollen for the remainder of the day. Since then, I've heard similar stories from other herpers, and like me, it was an experience they would rather not repeat. I keep a package of hand wipes or diaper wipes in my field pack, and I make sure to clean my hands after handling frogs, toads, and salamanders.

There are times when your exploits can be an inspiration, and then there are other times when you can only serve as a warning to others. Consider yourself warned! [*Mike*]

Anurans may not bite, but they do have another defense: skin toxins. Many toads have a pair of parotid glands on the top of their heads, which produce powerful bufotoxins designed to poison any animal that tries to eat them. Many frogs have small poison glands in the skin that are uniformly distributed over their bodies. If you handle frogs and toads, small amounts of these toxins will be passed to your hands. With a few notable exceptions (such as the toxins produced by *Phyllobates terribilis*, the golden poison frog from Colombia), these substances are harmless to humans, but they can be a source of irritation to the eyes and nasal cavities. Wash your hands after handling anurans or bring a package of wet wipes in the field with you. Be sure to clean your hands each time you handle a frog or toad, especially if more than one species is involved. For example, the skin toxins of the pickerel frog (*Lithobates palustris*) can be lethal to other kinds of frogs. When possible, handle amphibians of all kinds

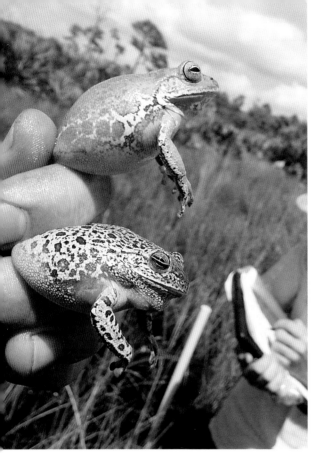

Barking treefrogs are held securely around their waists during data collection.

with moist or wet hands to minimize the transfer of toxins and to avoid pulling moisture away from the animal's skin. Consider wetting down any frog you have handled to restore moisture, but be careful not to use chlorinated water, as chlorine compounds can be toxic to amphibians.

Large frogs can be secured with your hand firmly around the waist, while small frogs can be held by the back legs. Toads lack the leaping ability of frogs and the landing skills as well; take care to restrain them firmly to avoid any falls, which can be fatal. Both frogs and toads may urinate when handled, so it is important to refrain from handling them in dry habitats. Desert anurans retain urine to slow the evaporative process; if they pee when captured, they may have a hard time replacing that moisture if no rain falls or if no water source is available to refill their bladder.

left Slimy salamanders make for sticky hands.

right An eastern redbacked salamander (*Plethodon cinereus*) is retained in a plastic plant saucer.

Using a dip net to pull newts from a small fishless pond in early spring.

Salamanders and Newts

Most terrestrial caudates are fairly easy to catch with a simple grab or by using the "slap hands" technique. Stream-dwellers such as dusky salamanders and some of the brook salamanders can be quick to react and make their escape via water or by burrowing down into the substrate; you'll have to be just as quick to get your hands on them. The same cautions given for frogs and toads apply to salamanders and newts as well: handle them with moist hands, wet them down after handling, avoid using bug spray on your hands, and be careful to wash your hands after handling because many species produce skin toxins. Some species like the northern slimy salamander (*Plethodon glutinosus*) also produce a thick, sticky slime that may take several washings to remove.

Once captured, many terrestrial salamanders will attempt to wriggle away and have to be restrained with hand and fingers, but you can let some of the slower forms walk on your hand or arm. Larger species can be restrained by encircling the neck with your thumb and index finger or by gently holding one or more limbs. Plant saucers and other shallow containers used for photo covers (see chapter 9) work well to hold small wrigglers, making it easier to examine them and wash dirt or mud off them.

To catch aquatic salamanders, dip nets and minnow traps come into play. For newts, sirens, and other aquatics, the net is pulled across the bottom on a low angle and then brought up to the surface. Along with any salamanders, the net will also contain invertebrates, leaves, mud, and other detritus from the bottom. Use a hand below the net to push materials around to search for salamanders and then return the materials and any living creatures back to the water. Be gentle and sparing with your dip net; on the bottoms of ponds, swamps, and streams, "leaf packs" are important habitats for a number of creatures, including salamanders. Be sure to leave some areas with leaf packs undisturbed.

Minnow traps can also be utilized as not only an easy way to catch salamanders but also an even easier method for handling them. Newts and other aquatic salamanders will end up in the traps as a result of their foraging movements. The traps should be deployed in shallow water, and care must be taken to make sure the top of the traps remain above water so that any captured animals have air to breathe. The trap can be anchored with sticks or stakes to make sure it doesn't move into deeper water. Once you catch salamanders, they can be easily observed in the trap without worrying about them wriggling away.

Waterdogs and some other aquatic salamanders have external gills that are

A couple of aquatic trap sets. Different trap styles can yield different finds.

AQUATIC TRAPPING

Aquatic environments provide an interesting challenge for herping. Sometimes they can easily be sampled by road cruising along the edges, and a herper might also have luck hiking to find basking animals or cover objects to flip. But often the aquatic environment conceals some wonderful critters that shy away from basking or road crossing, and aquatic trapping can be a good tool in the herpers' toolkit to see them. *As with every herping method, it is*

Some of the fruits of a few aquatic traps: a couple of greater sirens (*Siren cf. lacertina*), a Florida watersnake (*Nerodia fasciata pictiventris*), an eastern newt (*Notophthalmus viridescens*), and some fish.

vitally important to make sure that trapping is legal to undertake in your state or municipality. Many states have laws restricting aquatic trapping to those with a fishing license or similar permit, so take care to obey the law. It can also be beneficial to trap in areas where only you have special permission to be: trapping in well-known public spots can lead to stolen and vandalized traps.

When placing traps, it is essential to ensure that at least a part of the trap is exposed to the air so that air-breathing herps can surface and breathe. If trapping in coastal areas, consider tidal fluctuations; traps placed at low tide may drown herps at high tide. Keep this in mind, too, in areas prone to flash flooding. Check your traps no less than once a day, and in areas with venomous snakes, use a hook or other tool to lift traps. Traps are often most successful when placed along fallen logs or other natural barriers — herps are lazy and will often move along the log straight into your trap! [Josh]

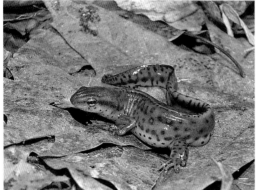

An eastern newt (*Notophthalmus viridescens*) dip-netted from a pond in early spring.

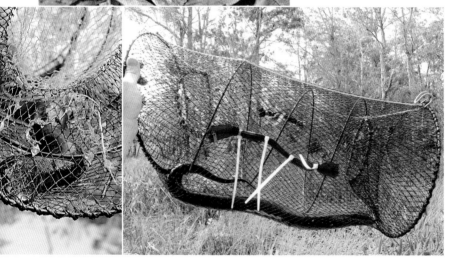

A couple of large two-toed amphiumas (*Amphiuma means*) in a twenty-four-inch collapsible trap.

delicate and easily damaged; try to handle them as little as possible and with extra care. Hellbenders are among the larger aquatic salamanders; given their widespread population declines and protected status, we cannot recommend catching or handling them.

While terrestrial salamanders are capable of biting, only a few species are known for it. Some of the larger dusky salamanders may occasionally bite but without much force. Pacific giant salamanders have sharp teeth and strong jaws and can easily puncture the skin; their bites are known for being painful and bloody. Many aquatic salamanders can bite, and the larger species of sirens and

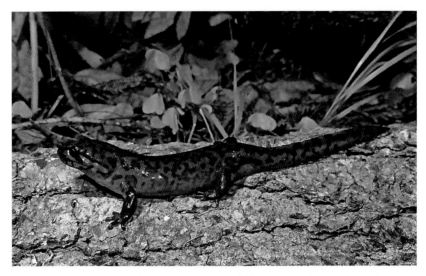

California giant salamander (*Dicamptodon ensatus*). These strong-jawed salamanders can deliver a forceful bite.

amphiumas are capable of breaking the skin. Extra caution is recommended for handling amphiumas — they have strong, razor-like teeth for crunching up aquatic invertebrates such as crayfish, and they can do significant damage to a thumb or hand. Aquatics can be held by the neck, and larger specimens should be held with both hands — though good luck actually restraining them in any way! Placing them in clear plastic bags or dip nets is often the best way to observe aquatic salamanders.

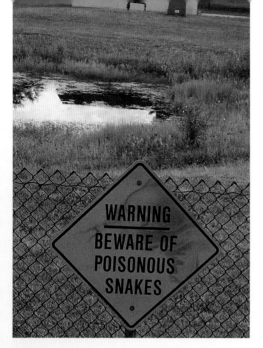

Outdated terminology
but an important message.

SAFETY IN THE FIELD

Like all other outdoor activities, field herping carries a certain amount of risk. Among other things, you might suffer a broken bone, have your car broken into, or get bitten by a venomous snake, although most of those perils are rare. In this chapter we'll touch on some commonsense practices to help avoid trouble in the field and deal with safety issues when they occur.

Personal Safety

Nearly everyone has a cell phone, which is the most important survival tool you can take into the field. If you're herping alone, let others know your plan of action, your location, and your timetable; if you don't report in, someone will at least have a general idea of where you might be. On solo trips, consider the

Herping in remote areas can leave you in a pickle if you don't take precautions.

actions you will need to take in case of injury, venomous snakebite, and other situations, and it never hurts to know where the nearest hospital is. Of course, getting out in the field with friends is a good way to avoid many potential problems that come with herping alone.

Remote places can be great for herps, but they may also harbor criminal activities. Be on the lookout for drug labs, cannabis fields, and other activities that may lead to trouble if you remain in the area. If something doesn't look or feel right, don't hesitate — turn around and leave quickly. Vehicles can be targets for thieves, and outdoor enthusiasts of all sorts are at risk, especially since cars may be left parked in remote areas for hours or days at a time. Don't leave anything in your car that you can't afford to lose.

Roads and Roadsides

The ideal roads for cruising at night are straight rather than curving and have little traffic. Straight roads allow other drivers to see your stopped vehicle in time to slow down or go around you. It is very difficult to safely road-cruise on a busy road. Driving slow and stopping in the middle of the road for a herp can

be very dangerous: at best, you may receive a ticket; at worst, someone could be injured or killed. Whatever the traffic conditions, be safe and pull your vehicle off to the side of the road. Curving roads with no shoulders are also recipes for disaster, and if you're alone, you may need to let the herp go if you can't find a safe place to pull off. If you have someone else in the vehicle, you can let that person out to pursue the herp and then find a safe place to park. Road shoulders can also be dangerous places to walk — if you're the passenger who jumps out for a snake, keep an eye on traffic as you go and consider wearing reflective clothing.

Keep in mind that what seems like just ordinary road cruising to you may look like suspicious or reckless behavior to law enforcement (often referred to as LE). Slow driving, abrupt stops, and U-turns are bound to attract LE's attention. Getting pulled over by LE is part of the road-cruising experience, and the officers may not be familiar with field herping, necessitating lengthy explanations. If you see a parked law enforcement or Border Patrol vehicle, it never hurts to approach it first and have a conversation with the officer. Let him or her know ahead of time that you are looking for snakes on the road, and that you may be driving back and forth a number of times. Doing this may save you from getting pulled over later during road-cruising prime time.

A long, straight stretch of highway in Yucatán, Mexico, provides ample lines of sight and plenty of room on the shoulder for vehicles. The snake is an adult tropical ratsnake (*Pseudelaphe flavirufa*).

There may be herps in this field, but ticks and chiggers are also likely to be present.

Assaults from the Plant and Animal Kingdoms

Like anyone else spending time outdoors, you are likely to have problems with some of the plants and animals you encounter. Poison oak, poison ivy, nettles, cactus spines, fire ants, chiggers, scorpions, bees, and wasps can all have it in for you. Alternatively, you may find yourself backing slowly away from bears, mountain lions, moose, javelina, and other megafauna. Even domestic cattle can be testy. Encounters and incidents are all a part of field herping, and everyone has at least one good story to tell. Know the risks when you're herping in a new area; do your homework on which dangerous animals are there and consider asking local inhabitants (you're likely to hear some interesting stories). As scary as some of these encounters may sound, field herping is no more dangerous than a morning commute to work or a walk in the park.

Ticks

Classified as small, blood-sucking arachnids, ticks are a serious issue for field herpers and anyone else engaged in outdoor activities. Found in many places around the world, these ectoparasites carry a number of serious diseases that are passed to their hosts. The U.S. Center for Disease Control (CDC) estimates that three hundred thousand people are diagnosed with tick-borne Lyme disease each year, with the majority of cases coming from the eastern and midwestern portions of the United States. Lyme disease gets a lot of attention, but ticks are carriers of many other diseases such as Rocky Mountain spotted fever and tick paralysis. Many tick-borne diseases can be physically disabling or even fatal if not treated quickly. Prevent ticks from attaching to you by using insect repellents containing DEET or permethrin, wearing long-sleeved shirts and trousers, and tucking pant legs into your socks. Some repellents can be sprayed on clothes around the ankles, waist, and sleeves. Lice and bedding spray (.05 percent permethrin), carried by pharmacies and pet-supply stores, is a very effective choice for spraying clothing. Keep in mind that pesticides can be fatal to amphibians that come in contact with them.

Check yourself for ticks while in the field, before getting in your vehicle, and after you return home. Along with attached ticks, keep an eye out for bite marks such as red rashes, red "bulls-eye" circles around a bite, or dark purplish bruising. If detected early, tick-borne diseases can often be quickly addressed with antibiotics, so contact your physician immediately if you think you have any signs or symptoms.

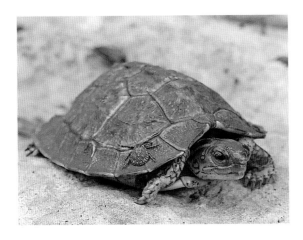

Herps are also susceptible to parasites. This furrowed wood turtle (*Rhinoclemmys aerolata*) from Mexico has several large ticks attached.

On a related note, the steps you take to prevent ticks can also help reduce chigger bites. Chiggers are a group of tiny trombiculid mites that are not bloodsuckers like ticks; instead, they harvest layers of skin cells and leave behind a small hole, a raised red bump, and an itchy rash. To date, there are no known chigger-borne diseases in North America.

Venomous Snakebite

The CDC estimates that in the United States alone, between seven thousand and eight thousand people are bitten by venomous snakes every year, and that five or six of those people will die. Statistically, you are ten times more likely to die from a lightning strike or from the stings of hornets, bees, and wasps. All the same, snakebite can happen to anyone, even careful, experienced field herpers.

The realities of snakebite In the United States, most people receive some kind of medical treatment if they suffer a venomous snakebite. This keeps the death rate much lower than in other parts of the world, but a bite from a venomous snake should never be trivialized — while you may stand a good chance of surviving, there are other costs involved, both to you and your family. Treatment, including antivenin, can cost tens of thousands of dollars or more, and you may be out of work for a significant period of time. Depending on the type of snake and the severity of the bite, you may suffer severe physical trauma, and permanent physical disabilities and amputations are a possibility. Also, bites

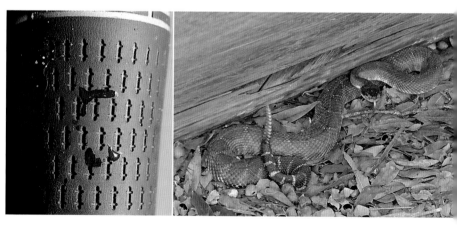

left Cautionary photo: a timber rattlesnake delivered its venom payload into the handle of this snake hook when the photographer was trying to manipulate the snake.
right Northern Pacific rattlesnake (*Crotalus oreganus oreganus*) under a sheet of plywood.

SNAKEBITE STATISTICS

Dennis Wasko and Stephan Bullard analyzed snakebites that were covered by the media over a three-year period and compiled some interesting statistics. In a study of 307 bites, 68 percent were "legitimate," that is, the persons bitten were unaware of the snake; 32 percent were "illegitimate," bites that resulted from deliberate handling, manipulation, or attempts to kill the snake. Your chances of snakebite in the field are already small, and these statistics support our contention that you can make the odds even greater by not handling venomous snakes without a very good reason.

This study also found that of legitimate bites, 65 percent were to the lower extremities (ankles, legs, feet), while 90 percent of illegitimate bites were to the hands and fingers. Maintaining "situational awareness" can reduce the chances of a bite to the extremities; watch where you put your hands and your feet, examine the ground around you before crouching or kneeling, and stay a safe distance away when photographing a venomous animal.

For more on the statistics gathered by Wasko and Bullard, see Dennis K. Wasko and Stephan G. Bullard, "An Analysis of Media-Reported Venomous Snakebites in the United States, 2011–2013," *Wilderness and Environmental Medicine* 27 (2016): 219–26. [*Mike and Josh*]

invariably end up in the news, and you may not like the publicity or the sensational headlines with your name on them.

Preventative measures It is said that fortune favors the prepared mind: educate yourself on the complex subject of venomous snakebite (the Wikipedia entry for "snakebite" is a good place to start). Before your next field trip, take a few minutes to get the answers for questions you don't want to waste time on after getting bit: Where is the nearest hospital? What is the phone number? Is 911 or another emergency service available?

Many bites occur because people insist on handling venomous snakes. It follows then that the most effective method to dramatically reduce your chances of snakebite is to leave them alone. It's that simple: if you have no good reason to handle a venomous snake, then all that remain are bad reasons. Bites can result from all sorts of scenarios including the following:

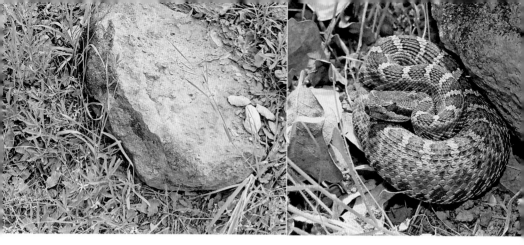

Take care where you put your hands when flipping in areas with venomous snakes. This juvenile northern Pacific rattlesnake was tucked in and well hidden along one edge of the rock.

- Attempting to pin a snake by the head to pick it up
- Free-handling venomous snakes (sometimes fueled by alcohol, or by misconceptions of snake behavior, or both)
- Getting too close while taking photographs, and paying more attention to the camera's LCD screen than the snake itself (see chapter 9 for more info on photographing venomous herps)
- Grabbing the tail of a snake crawling into a hole or crevice (usually the business end of the snake is already turned around and facing the entrance)

Proper footwear is important. In the field, boots can help reduce the risk of a bite, especially taller types that cover the ankles. Rubber boots are very effective at protecting the legs below the knee. Snake gaiters are made of Kevlar or similar materials and are strapped to the legs below the knee. Gaiters can be uncomfortable to hike in, but they provide effective protection for the lower legs in brushy, dense areas.

Cryptic species like copperheads can be nearly invisible in leaf litter. There are plenty of stories about people who were completely unaware of a copperhead coiled just inches away from them, and more than a few field herpers have been bitten by snakes they never saw. Be aware of your surroundings: watch where you step, where you kneel or sit, and where you place your hands.

Complacency has led to a bite on more than one occasion. Snakes can seem to be predictable in their behavior, until you meet one that breaks all the rules.

Avoid making assumptions about behavior based on experiences with other snakes. To keep on your toes, do an Internet search for "snakebite" every once in a while. There's nothing like images of swollen, blackened limbs, necrotic tissue, and amputations to keep things in proper perspective. Keep in mind that reckless behavior with hot (venomous) snakes will not win you any points within the field herping community. Respect the snake, respect yourself, and stay out of the news.

If you are bitten The immediate first step after being bitten is to avoid a second bite by moving away from the snake. The next step is to seek medical treatment. It is important to remain calm; acute stress increases blood flow and quickens the distribution of venom. Walk, don't run, and don't walk unless you have to. If you've done your homework, you know that both symptoms and treatment can vary, depending on the species of snake involved. It is also possible that you have received a "dry bite," where little or no venom was injected, but even so, a trip to the hospital is always advisable following a bite from a venomous snake — waiting around and hoping for a dry bite might prove fatal.

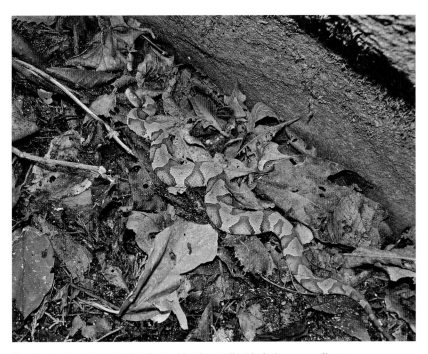

Cryptic species like copperheads can blend in well with their surroundings.

Treatment before transport: First aid Prescribed first-aid treatment for venomous snakebite has changed often over the years, and some previously recommended treatments often did more harm than good. In this matter, we defer to the U.S. Center for Disease Control and its recommendations for first aid:

- Seek medical attention as soon as possible (dial 911 or call local emergency medical services). Inform others of your situation as necessary.
- If you don't know what kind of snake bit you, try to remember its color and shape, which can help with treatment of the snakebite.
- Keep still and calm. This can slow down the spread of venom.
- Apply first aid if you cannot get to the hospital right away:
 - *Lie or sit down with the bite below the level of the heart.*
 - *Wash the bite with soap and water.*
 - *Cover the bite with a clean, dry dressing.*
- Do NOT do any of the following:
 - *Do not pick up the snake or try to trap or kill it.*
 - *Do not wait for symptoms to appear if bitten. Seek immediate medical attention.*
 - *Do not apply a tourniquet.*
 - *Do not slash the wound with a knife.*
 - *Do not suck out the venom.*
 - *Do not apply ice or immerse the wound in water.*
 - *Do not drink alcohol as a painkiller.*
 - *Do not drink caffeinated beverages.*

Snakebite symptoms Pit-viper bites are usually immediately painful and may be accompanied by bleeding at the wound. Symptoms include blurred vision, difficulty breathing, nausea and vomiting, paralysis, swelling around the bite, and weakness, but most of these symptoms may not begin for thirty minutes or more. Bites from coralsnakes or other elapids may not be painful at first, and the onset of symptoms may be variable. Symptoms include abdominal pain, blurred vision, difficulty breathing, drowsiness, nausea and vomiting, numbness, paralysis, slurred speech, swallowing difficulty, swelling of the tongue and throat, and general physical weakness.

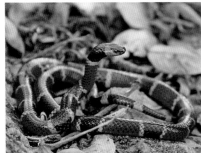

Yucatán variable coralsnake (*Micrurus diastema alienus*).

Be careful out there!

At the hospital When you arrive at the hospital or treatment center, your symptoms will be evaluated to determine the need for antivenin and other treatments. Bites are generally rated as mild, moderate, or severe, with antivenin administered for moderate or severe cases. Swelling and other symptoms will be monitored over time. Because the neurotoxic effects of an elapid bite may develop without warning, antivenin may be administered regardless of symptoms. Patients are monitored for signs of breathing difficulty and paralysis.

One last word Venomous snakebite is a serious matter, but the occurrence of bites in the field herping community is very low, and almost exclusively restricted to those who purposely handle venomous snakes. Many herpers have spent decades in the field without being bitten (including both of the authors). Staying aware of your surroundings, respecting the serpent, and avoiding unnecessary handling will drastically reduce your risk of a bite.

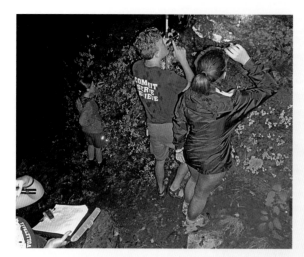

This seepage is on public land. It is important to respect the habitat, the organisms that live there, and the other people that enjoy it.

CHAPTER 6
ETHICS AND ETIQUETTE, RIGHTS AND RESPONSIBILITIES

Like many other pursuits, field herping comes with a set of ethical principles and a layer of social etiquette. Ethics and etiquette are framed by some basic relationships:

- Our relationship with amphibians and reptiles and other living organisms we encounter
- Our relationship with the land and those who own or maintain it
- Our relationship with other field herpers and with nonherpers encountered while herping

The ability to capture and handle amphibians and reptiles sets field herping apart from many other wildlife-related activities, and it comes with additional

GOOD AND BAD REPUTATIONS

Here's an all-too-familiar scenario: on a fine day in late spring, you visit a rocky hillside where you've had many great herp encounters over the years. But on this occasion, it is a scene of devastation; every flat rock has been flipped over and left upside down, and the ground is covered with dark, bare spots where the rocks once were. As you toil to repair the damage, returning the rocks to where they once were, you wonder who would do such a thing. Did they collect the herps living here? Was it someone you brought here, or did one of your friends tell someone about this hillside? The seeds of mistrust are sown, and you vow to never share another herping spot or bring anyone to your favorite places again.

There are "good guys" and "bad guys" in perhaps every aspect of the human condition, and field herping is no exception. Some of the problems with the "bad guys" are rooted in the past. Back in the pre-Internet days of the last century, field herpers were thin on the ground. The term *field herper* wasn't even in use; many people thought of themselves as "snake hunters" who went "snake hunting." Much like today, there was a core of field herpers out to enjoy amphibians and reptiles, others who collected herps for captive breeding, and others who were out to make money. Often, the lines were very blurry between these groups, and while known hot spots for certain species were plundered of their animals, the overall impact of snake hunters was far lighter than it would be today. There simply weren't that many field herpers back then, communication was more difficult, and there was less information to share. Reputations, either good or bad, were not a major issue.

Fast-forward to today, when there are tens of thousands of field herpers,

Among field herpers, "put the rock back" is a familiar phrase.

both with in-the-field and online presences. As with other groups of humans, most are upstanding, friendly people who want to be a part of the community. As a group, they are in close contact with one another, they can share finds on social media in real time, and for good or bad, they have access to a great deal of free-flowing information. In this environment, the lines between recreational field herpers, bulk collectors (those who collect every herp they can find), and market hunters (those who collect highly prized herps that bring a lot of money) are much more distinct; the latter two groups are looked on with distaste by many in the field-herping community. There is also a small subset of people who simply don't care about ethics or responsibilities; while they may not collect herps, they will break any law, exploit confidential information, tear up habitat, and use others to see the herps they want to see. Unfortunately, it is easy for the bad guys to blend in with other field herpers, and they have become experts at harvesting information, befriending themselves with less-than-wary people, and even creating false online identities to work behind. As a result, established field herpers are very wary of others, and it can take some time for newcomers to establish themselves as trustworthy.

It isn't necessary to participate in the online herper community — it can be full of loud characters and drama, and it's not everyone's cup of tea. If you do join in, you'll find that it pays to be polite and respectful to others. The extreme "connectedness" of online communities means that your words and actions are under scrutiny, and reports of misbehavior in the field can also end up in social media.

Building and keeping a good reputation is important if you want to participate in the field herping community, be invited on trips, and become friends with other herpers. How you behave in the field and in social media, and how you treat herps and other herpers, will determine what kind of reputation you acquire. It can be a long and difficult process to overcome a bad reputation.
[Josh and Mike]

ethical principles and responsibilities. The social aspects of field herping also must be considered. If you're new to field herping, building relationships in the field and on social media can be tricky without knowing some herper etiquette. In this chapter we cover some ethical issues first and then examine social etiquette for herpers.

Treatment of Herps and Other Wildlife

If you choose to catch and handle a herp, keep in mind that improper technique can lead to undue stress, injury, or death of the animal. Chapter 4 has detailed information about capturing and handling different kinds of amphibians and reptiles. If you have no pressing need to capture an animal, please consider leaving it untouched and enjoy the creature in situ. Typically, the desire to get your hands on herps tends to diminish as you spend more time in the field.

It may be necessary on occasion to "detain" a herp for a short time, for photographs, to collect data, to make an identification, or to show your find to others. Snake bags, plastic containers, and plastic bags can be used for this purpose. Containers should be clean before you place animals in them and should be thoroughly cleaned again before holding another herp, to prevent the spread of disease and to avoid reactions to musk or skin secretions. Plastic containers should have air holes, and plastic bags can be discarded after a single use. Bread bags or tropical fish bags work better than flat zip-seal bags, as they can be tied off with a volume of air inside. For amphibians, plastic bags or containers work best, and a few leaves and a small amount of water can be added to retain moisture, but keep in mind that plastic bags should be used only as temporary containers. Herps in any type of container should be kept out of direct sunlight and out of hot, closed vehicles or backpacks.

Many amphibians and reptiles have home ranges, and some rely on specific microhabitats; detained herps should be released at their point of capture and not some distance away. If you found them under a rock, log, or other object,

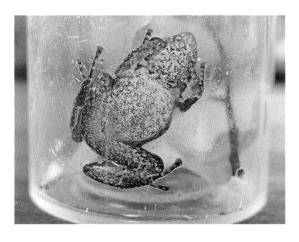

A variable rain frog (*Pristimantis variabilis*) is detained while its identification is determined. Clear plastic containers make examination of small herps easier, while removing the stress of handling.

left Returning a herp to the correct microhabitat is extremely important. Species like this coastal dunes crowned snake (*Tantilla relicta pamlica*) will desiccate easily if left in the sun.

middle Keep in mind that many other creatures share the underside of cover objects with herps. They deserve respect too, and some for more obvious reasons.

right California mountain kingsnakes (*Lampropeltis zonata*) are highly coveted, and some collectors will destroy their habitat in order to find them.

avoid any potential squishing by placing them at the edge of the object and allowing them to crawl underneath. Herps should not be taken home and then later returned to the wild. The animal could potentially acquire an unfamiliar disease or parasite and then infect other animals upon release. The possibility of disease transfer is even greater if you have captive herps in your home.

The undersides of rocks, logs, and other objects are microhabitats for herps and all sorts of other small creatures. Those microhabitats can be destroyed when the cover objects are not returned to their original location. "Flipping" is really the action of lifting or rolling an object to see the creatures that lie beneath; any herps should be moved out to avoid being squished when the cover is put back in place and then allowed to crawl back underneath. Allow rodents and large invertebrates to clear out before replacing a heavy object, and keep in mind that small invertebrates can be squished if heavy rocks and logs are allowed to fall back. Take a few extra seconds to ease cover objects down and to make sure they are returned to their original position.

Along with replacing cover objects and preserving microhabitats, there are other considerations. Habitat should not be destroyed in search of the herps that use it. This includes actions like stripping the bark from dead trees, tearing apart living plants or tree stumps, or using a pry bar to split rocks apart. These are typically the actions of bulk collectors and have no place in field herping.

Herps in dry climates have some additional considerations related to mois-

ture. Many herps drink deeply when the rains come; try not to disturb them, as it may be a long time before they can drink again. This practice extends to frogs, toads, and salamanders that may soak up water from road surfaces, although you may need to move them to the shoulder to save them from being squished by passing vehicles. Keep in mind that desert anurans retain water in their bladders to slow evaporation, and if they pee when handled, you may be putting them at risk of dehydration.

In dry climates, rocks and other objects may have a moist microclimate underneath. There may be just a trace of dampness, but it can be important to herps and other creatures. Often the substrate around the edges helps form a seal that slows evaporation; lifting the object breaks that seal and releases the moisture trapped underneath. Consider sprinkling some drinking water underneath the object before replacing it and adding more to the substrate around the edge to reseal the moisture barrier.

Preventing the spread of disease among wild herp populations is vitally important. Be sure to sanitize your gear between trips and locations (see the sanitation sidebar in this chapter for more details). Personal hygiene is also important. Clean your hands between handling herps, and while washing with soap and

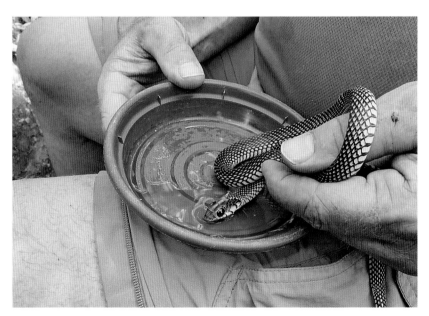

After a photo session on a hot day in the Yucatán Peninsula, this speckled racer (*Drymobius margaritiferus*) is given a drink before being released at its point of capture.

water is preferable, it is rarely practical in the field. As a substitute, keep baby wipes and alcohol wipes in your gear bag. If you have captive herps at home, do not use any associated equipment for field herping. Even if your captive animals are maintained to the highest standards, there is always a potential for spreading disease to wild populations (or vice versa).

Collecting Herps

It is difficult to find a field herper who hasn't felt the urge to take a herp home. The human desire to prolong and repeat an experience with an animal is very powerful, and like most things involving people, it is a complicated issue. While some people are opposed to collecting herps, others support the idea if it is done in a legal and responsible manner. Many field herpers maintain herps at home, although most keep only captive-bred individuals, and not animals collected from the wild. They view their captive herps and field herping as two separate activities.

It is legal to collect common herps in some states and provinces, although a hunting or fishing license is usually required. Other places prohibit the collection of all amphibians and reptiles, and of course, threatened and endangered herps cannot be collected or harassed in any way. Most field herpers are fierce protectors of herps and their habitat, and while they may grudgingly agree that a

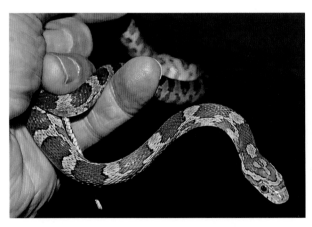

A beautiful cornsnake (*Pantherophis guttatus*) from south Florida. It's easy to see why people like to keep cornsnakes in captivity, and fortunately, there are plenty of captive-bred animals available.

GEAR SANITATION

Chytrid fungus, ranavirus, and SFD (snake fungal disease) have had a terrible impact on wild herp populations, and field herpers must take care to avoid being vectors for disease. Because field herping often involves traveling to more than one site, there can be a significant risk of spreading pathogens and the diseases they cause from one site to another. It is a good practice to disinfect your equipment between visits to different sites. This is especially important for boots and dip nets but should also include anything that touches the ground or the herps themselves. Disinfection starts with washing away mud and dirt with soap and water, then spraying gear with a disinfectant, and allowing contact for at least one minute before rinsing or drying. Nolvasan (a 2 percent solution of chlorhexidine, available through online retailers) is an excellent and commonly used disinfectant. If chlorhexidine is unavailable, a 6 percent solution of chlorine bleach (such as Clorox) or 70 percent ethyl alcohol (commonly sold as "rubbing alcohol") are also effective disinfectants. Use a plastic spray bottle, with the contents clearly marked. Please note that chlorine bleach can damage fabric and metals, and rubbing alcohol will dissolve rubber, so use them judiciously.

Washing snake bags after every use is also advisable, and for amphibians, any plastic containers should be disinfected and thoroughly rinsed before the next use. If plastic bags are used to detain amphibians, they should be discarded after one use. See appendix 1 on amphibian and reptile diseases for more information on these ailments. [Josh]

common herp can be collected, they will not hesitate to turn in anyone involved in illegal collecting.

The urge to collect can be strong in new field herpers, but with experience, it tends to fade over time. You may notice that some old hands are vocally against collecting in a "do as I say and not as I did" manner. While they have a different perspective that comes with experience, this bit of hypocrisy is another reason why collecting is a complicated and contentious issue.

There are a few things to consider before collecting a herp from the field. They may seem like scare tactics to dissuade you from collecting, but we feel that the decision requires some sober thought. First and foremost, an animal's fate takes an unexpected turn when it is collected. Because of the real and credible risk of spreading disease, it cannot be returned to the wild, and as a result, it can no longer contribute to the gene pool of its species. Removing an

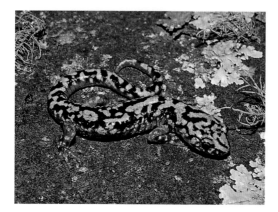

Green salamanders (*Aneides aeneus*) are an awesome find in the field but are difficult to maintain in captivity.

animal from a breeding population is the ecological equivalent of killing it. While taking a single animal may not make much difference to the species as a whole, these consequences should be considered out of respect for the animal and its kin.

Are you ready to take personal responsibility for the care and well-being of this animal, for the rest of its natural life? What are the captive care requirements, and are they something you can manage? A cornsnake may be relatively easy to care for, but a woodland salamander is much more difficult, and collecting it may likely be a death sentence. Something else to consider: captive-bred specimens of the herp you're interested in may be available, and these typically do better than wild-caught animals and do not drain wild populations. Examine your reasons for wanting to keep the herp, and use common sense to decide if you can care for it properly.

Market Hunting and Bulk Collecting

While the urge to collect herps for personal enjoyment is understandable, collecting them to sell to others is considered selfish and reprehensible by most people in the field herping community. Along with wildlife smuggling, bulk collecting and market hunting have no place in field herping. Most people in the field herping community are on the lookout for such activities and will report them to the proper authorities. Many coveted herps on the black market are not only protected but are also sensitive to depletions in their population. Collecting a dozen gartersnakes may not have much impact, but the removal of a dozen wood turtles (*Glyptemys insculpta*) would be devastating to a breeding

THE POWERFUL URGE
TO POSSESS

I have a large seashell collection
which I keep scattered on the beaches
all over the world. Maybe you've
seen it. [Steven Wright]

On my first trip to Baja Sur, we found
a number of Baja ratsnakes (*Boger-
tophis rosaliae*). Along with several
adults, we turned up a handful of
neonates while cruising mountain
roads at night. These young-of-
the-year *rosaliae* were over a foot in
length and beautiful — pale oranges
and pinks, with thin yellow bands.
After the sixth neonate appeared
on the road late one night, I began
thinking about how cool it would be
to start a breeding group with the
half-dozen gorgeous youngsters,
who would eventually turn into
handsome reddish-brown adults . . .

and of course, that wasn't going to
happen. We never had the six neo-
nates together at one time, I would
never have attempted to smuggle
them from Mexico into the United
States, and I have neither the time
nor the energy to devote to such a
breeding project. But all the same,
some portion of my mind was busy
thinking about how to prolong my
all-too-brief encounter with the
beautiful *Bogertophis rosaliae*.

I get it. I understand the urge to
keep nature in a bottle, to surround
yourself with the things you love.
And I have collected a few herps over
the years, but none for quite a while,
now that I've adapted Steven Wright's
approach; I can visit my global herp
collection any time I wish. With a
little vacation time and a plane ticket,
I can go back to Baja Sur and see
some pretty little ratsnakes (and I
have). [Mike]

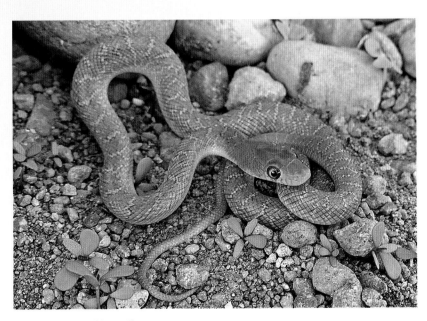

Neonate *Bogertophis rosaliae*.

population. Animals that are collected and sold can have a short and miserable life, especially those that end up with reptile wholesalers, who typically provide very little care for their animals. Aside from the obvious moral and ecological issues, it makes little economic sense; few collectors make more than beer money. For-profit collectors are a big reason why many field herpers do not share herp locations and why they mistrust people they don't know.

Protected Species

Across North America, there are laws at various levels of government that prohibit the collection, export, and exploitation of amphibians and reptiles. There are also laws that protect particularly sensitive species, usually by designating them "threatened" or "endangered." Under these classifications, protected species usually cannot be collected, handled, or detained without a permit. Penalties include fines, court appearances, and even time in prison.

When it comes to protected species or wildlife refuges and other areas where herps are designated as "hands-off," field herpers who practice CPR (catch, photograph, and release) are limited to observation and photography. Ignorance of the law will not save you from receiving a citation, so we recommend becoming familiar with the protected species in your area and in places that you plan to visit. Most states and provinces list all their protected flora and fauna online, along with specific rules and regulations. Keep in mind that most rules and regulations are in place to protect species, rather than to penalize field herpers and others who enjoy wildlife. While they may be hands-off herps, you still have the right to observe and photograph any protected species that you encounter.

In some cases, the laws protecting herps can seem nonsensical and contradictory; in some states, for example, you can receive a citation for handling a protected species, but there may be no penalty for running over it with your vehicle. A few laws are on the books because field herpers have caused problems on public roads. Such regulations are controversial within the herper community, leading to endless discussions on whether herpers are having their rights infringed upon, questions about responsibility, and how to get the laws changed. As field herping continues to grow in popularity, so does the risk of more legislation aimed specifically at herpers. On the other hand, there are also opportunities to work with legislators toward sensible change.

left This tentacled snake (*Erpeton tentaculum*) was found in south Florida, on a city block close to a wildlife importer's shop. It was undoubtedly a wild-caught individual, collected from its home in Southeast Asia and shipped to the United States, only to escape or be discarded. When it was found it was emaciated, possibly diseased, and nearly dead.

right The eastern indigo snake is federally protected in the United States. This individual was examined, photographed, and had data collected before release. This animal was handled under a research permit.

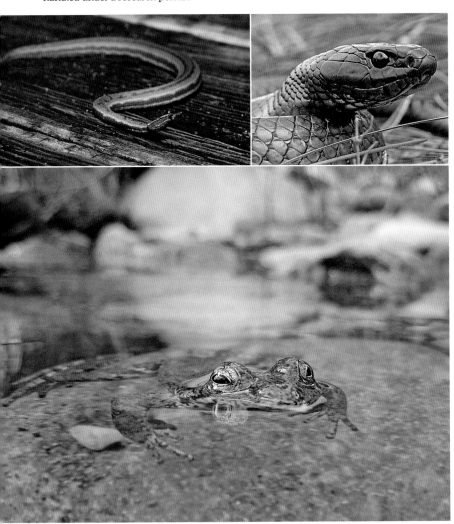

A foothill yellow-legged frog (*Rana boylii*), photographed in a quiet pool of a mountain stream. *Rana boylii* is listed as a "Species of Special Concern" by the California Department of Fish and Wildlife.

Herps and other wildlife are hands-off within the Everglades National Park.

An old barn, absolutely worth asking permission.

Public Lands and Private Property

Across North America, federal, state, and local governments hold millions of acres of land for public use. Much of it is designated for mixed-use activities such as hunting, fishing, and hiking. Wilderness areas, wildlife refuges, and biosphere preserves protect flora, fauna, and habitat on a larger scale. Herps are largely protected on public land to varying degrees; most prohibit the collection of amphibians and reptiles, while observation and photography are allowed. See appendix 2 for more information on public lands in the United States.

Any herper who has spent time in the field is familiar with the disappointment of a sign reading "NO TRESPASSING." Most landowners use them to keep unwanted hunters off their property. Along with posting signs, some landowners mark rocks and trees along their property lines with purple paint, and in some states, the paint is the legal equivalent of a no-trespassing sign. It is a good idea to respect the private property of others; otherwise you may have a confrontation with an angry (and possibly armed) landowner and perhaps receive a ticket from law enforcement. Additionally, chances are good that no herper will ever be able to set foot on the property again.

All is not lost with posted property; you can often get access simply by asking the landowner for permission. If you're not sure who owns the land, stop at the nearest house and ask. Be friendly, be polite, and tell the truth about why you want access to the property. People will often be surprised at your request, but in the end, you're more likely than not to receive permission, although you may have to listen to some stories about encounters with snakes and other herps. You might be able to answer some questions and provide a little herp education, but try to avoid contradicting people on what they consider to be factual. After all, what's more important, getting to herp around some cool new property, or winning an argument?

Etiquette in the Field

In general, the field herping community is open, friendly, and helpful to newcomers. Many new herpers may still find it frustrating when other herpers are reluctant to share information or to invite them to participate. Given the potential for misuse (see the first sidebar in this chapter), this is only natural and to be expected. It can take some time for other herpers to get to know you well enough to establish trust (social media can be a big help). Try to remember that

SUCCESSFULLY NAVIGATING ENCOUNTERS WITH LAW ENFORCEMENT

If you spend any time field herping, chances are you will be stopped and questioned by law enforcement (LE). Even if you are doing everything within the limits of the law, some aspects of field herping (looking around abandoned buildings, driving slow at night, walking around with flashlights) may look suspicious because of their possible connection to illegal activities. Keep this in mind during encounters with LE; the best approach is to be open and friendly and explain exactly what it is you are doing. Knowing the local laws that pertain to herping will help you to (politely) explain your activities. Showing officers some pictures of the herps you've seen can go a long way to break the ice and change the tone of a conversation. Many herpers are very concerned with their rights when talking with LE. Rights are certainly important and we should know what they are, but in being concerned about our rights, we should not lose our concern for others. Law enforcement officers are men and women just like the rest of us, and they have a job to do. Being pleasant, courteous, and well informed can make for quick and painless encounters with almost all LE. Additionally, carefully choosing your words can speed up the process: for example, if you are in a wildlife refuge or other protected area, it might be wiser to say that you are "photographing snakes and other wildlife," instead of "looking for snakes." Both statements are true, but the latter response will certainly lead to more time-consuming questions. [Josh]

they take this approach for practical reasons, and it isn't intended as a personal affront to you. Most herpers are open to herping with newcomers on "neutral ground" — public lands such as parks and wildlife refuges, where no private spots are at stake, and everyone is subject to the same rules.

Along with respect for herps, field etiquette includes respect for the land and for other herpers. This etiquette includes actions like packing out all your trash and replacing rocks and logs in their original location. It also means being courteous during photo sessions and sharing your finds with others. Field trips can be incredible bonding experiences for people, or they can be disasters that lead to vows of "never again."

When people take you along to one of their herping spots or provide you with some locality information, show them some respect and appreciation. Consider that they may have worked hard to find the spot, and they probably have good

Snake Road in southern Illinois. Bordering the Shawnee National Forest, this road lies within a research natural area. As a result, the flora and fauna here receive special protection. Snake Road is a famous attraction for field herpers, and many visit each year.

memories from the place and an emotional attachment to it. Thank them for the opportunity, and ask if you can return some other time. If they are agreeable, be sure to contact them before you go, just to let them know, and follow up with a report of what you found (they'll be interested to know). Make sure to leave the place as you found it and that all cover objects are restored to their original position. This kind of respect is appreciated and helps build relationships within the field herping community. You may find that a "secret spot" someone shared with you is actually well known to others. This happens frequently, but don't let it lessen your appreciation of the person who shared it with you (and you might consider making him or her aware that others know about it).

FIELD HERPING TRIGGER POINTS ON SOCIAL MEDIA

There are a number of common phrases, questions, and actions that often trigger negative comments and spark unwanted discussion on social media, and you may have a hard time living them down. Here are some common pitfalls to avoid:

"Where did you find that?" Unless someone completely omits all locality information, this question is inappropriate. If someone posts a photo and provides the state and county, that's all you need to know, and that's all the person wants you to know.

"Did you find that at X?" By guessing at the locality, you just gave away a locality and made some herpers angry. Never play the guessing game in public.

"ID please." Nothing says, "I can't be bothered to do a little research or buy a field guide" like this rude demand. Exhaust your own resources before politely asking for help.

Making fun of "noobs." Everyone was a newbie at some point. There is little to be gained by making fun of people because of their newness or their lack of knowledge.

Inappropriate comments regarding race, ethnicity, gender, sexuality, religion, or politics. As a whole, field herpers are a tolerant and inclusive bunch. Most herpers aren't concerned about the race, religion, gender, or political affiliations of the people they herp with, and you shouldn't be either.

"Trash herps." A phrase often used in fun these days, but there are still a few people who put great value on some herps while dismissing others as worthless.

Inappropriate photos. Free-handling venomous animals. Incorrect handling that may cause injury. Needless exploitation (making herps bite, strike, etc.).

Photos of questionable legality. If the Gila monster you are holding in a photo was handled under a research permit, say so; otherwise, people will call you on it. Another common occurrence is posting photos of people holding herps in a protected area — other herpers will be quick to point out the problem with that.

Photos of herps in containers. You may be detaining the herp only for pictures or to take data, but your audience won't know that unless you say so. It's best to avoid posting any container shots because despite your explanations, some people will still get the wrong idea about you.

Photos of questionable origin. Tell the truth. If you make stuff up, more than likely someone will catch on. Once that happens, it will be nearly impossible to regain any credibility.

Consider context. Words can explain the context in a photo, but words and photos often become separated. There you are, holding a federally protected indigo snake, and the words that mention your research permit are long gone. Meanwhile, the photo floats around the Internet forever, and herpers everywhere are wondering what you're up to with that protected *Drymarchon.* [Mike]

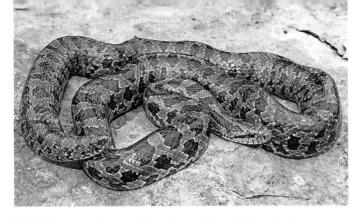
Prairie kingsnake (*Lampropeltis calligaster*) from Elk County, Kansas.

Social Media Etiquette

Many newcomers to field herping have their interest kindled on social media platforms. Facebook, Instagram, and old-school forums like Field Herp Forum are great places to build relationships, showcase your finds in the field, and learn more about herps and field herping in general. People like to share photos of their herp finds with others and maybe to show off a little. It is human nature to want to show off, but remember to respect the experiences and expertise of others. Most people who post photos are open to any reasonable questions you might have, giving you the opportunity to learn and to make a connection. If you appreciate a photo or the herp in the photo, take a little time to let the poster know. Social media has a lot of built-in give-and-take, and it's important not to forget the "give" part.

When posting to social media, keep in mind that in most cases, your words and images are open to the public, and they may be around for many years to come. When posting photos of herps, be somewhat vague with locality data. Avoid anything more specific than county level ("Prairie kingsnake from Elk County, Kansas"). Remember, too, that in some cases, county-level information may be too specific if the county is very small or if there is very little remaining habitat. Another thing to keep in mind is that some cameras include GPS locations in the image's EXIF data; while most social media platforms strip EXIF data from photos, this is not the case for any photos you directly share with someone.

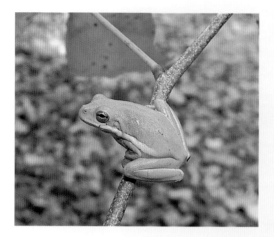

Green treefrog
(*Hyla cinerea*).

CHAPTER 7
CLASSIFICATION, TAXONOMY, AND SPECIES IDENTIFICATION

Scientific Names

In chapter 1, we touched briefly on how identification is a fundamental part of field herping. It is human nature to want to know the names of the flora and fauna surrounding us, and at a basic level, identification is about discovering an organism's name. Many amphibians and reptiles have a common name (like "green treefrog," for example) and a scientific name (*Hyla cinerea*) that is composed of the genus (*Hyla*) and the species (*cinerea*). Common names can be confusing; there are a number of "green treefrogs" around the world, but only one has the scientific name of *Hyla cinerea*. Whether they have a common name or not, every organism that is known to science has been given a unique scientific name (also referred to as a "species name" or "Latin name"). Once we know the scientific name, a whole world of information opens up, and we can learn all that is known about the organism bearing that name. If you use the scientific

name *Hyla cinerea* when communicating with others, then they know exactly which "green treefrog" you are talking about. Scientific names can change, and if that happens to *Hyla cinerea*, then the old name is still attached to the frog in a historical sense, like the tail on a kite.

Learning scientific names can seem like a daunting task, but it isn't necessary to learn all of them. You can start with the common species in your area. You're likely to pick up more in conversations with other field herpers, and if you think of the scientific name as the organism's "real name," learning it may be easier. Consider using the scientific name along with the common name whenever possible, and don't worry too much about mispronunciations; you'll find any number of opinions in the field herping community about how certain names are pronounced. Scientific names are often a mixture of Latin, Ancient Greek, and other languages, so there's not much consensus about "correct" pronunciation.

Classification and Taxonomy

Humans classify *everything* as part of how our brains process sensory information. We group things together and in many different ways. Think about the way your grocery store is organized; it is no accident that all the condiments are in one aisle, and that salty snacks have their own section. Consider apples and apple pie; both can be included in the "Food" group, but each might be placed in different subgroups, each smaller than the previous group. Apples might be classified as "Food-Fruit-Apples-Red," while apple pie might be "Food-Desserts-Baked-Pie-Apple." We do the same with herps and every other living organism — we assign them to groups and to subgroups. Classification and taxonomy help us identify herps and provide the framework that helps us understand the relationships between organisms. They help us understand that the barking treefrog (*Hyla gratiosa*) is a close relative of *Hyla cinerea*, and that Fowler's toad (*Anaxyrus fowleri*) is a distant cousin.

Taxonomy is the scientific classification system used to name and define groups of organisms, based on shared characteristics. It features a hierarchical arrangement, much like an upside-down pyramid, with very broad and inclusive classifications at the top that get smaller and more exclusive at each level. From the top down, the order is domain, kingdom, phylum, class, order, family, genus, and species. Herps are sorted into either class Amphibia or class Reptilia, and generally we are most concerned with the lower groups of order, family, genus, species, and in some cases, subspecies. There is a great deal of argument among

CALIFORNIA RED-SIDED GARTER SNAKE
(*Thamnophis sirtalis infernalis*)

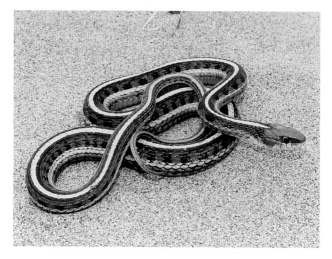

KINGDOM:
Animalia

PHYLUM:
Chordata

CLASS:
Reptilia

ORDER:
Squamata

FAMILY:
Colubridae

GENUS:
Thamnophis

SPECIES:
sirtalis

SUBSPECIES:
infernalis

A simple classification of *Thamnophis sirtalis infernalis*.

biologists and taxonomists about the validity of subspecies, but since field herpers use them and aren't likely to stop, we use them here in the *Guide*.

Taxonomic Syntax

It isn't necessary to become a taxonomic expert, but it is useful to know some of the basic syntax associated with scientific names. As an example, here is a breakdown of the common gartersnake, or *Thamnophis sirtalis* (Linnaeus 1758). *Thamnophis* is the generic name and refers to the genus. The word *sirtalis* is the specific epithet and refers to a particular species. The generic name and the specific epithet form the species name, *Thamnophis sirtalis*. Because the species name is formed from two words, it is often referred to as a binomial. The species name is italicized (or underlined when handwritten), wherever possible. The generic name is always capitalized, and the specific epithet is always lowercase. This name is designed to be unique; no two types of animals can have the same species name, and while names can change, no animal can have more than one valid species name at any given point. Taxonomy uses the grammatical forms of Latin; while many names are derived from Latin words, other names come from other languages (*Thamnophis* comes from two Greek words, while *sirtalis* is

derived from Latin). When you don't know the exact species, an "sp." (not italicized) after the generic name — for example, *Thamnophis* sp. — will indicate this.

The species name is followed by the describer. Linnaeus was the first person to describe the species in question here, in the year 1758. The parentheses around the describer and the date indicate that the species was first described under a different name (in this case, *Coluber sirtalis*). You'll notice that parentheses are quite common, especially with species that were described long before the structure and rules of taxonomy were standardized. These days, species are described in scientific publications, using a formal species description, providing all the details that distinguish the organism and make it unique.

A genus with a single species is monotypic, while a genus with multiple species is polytypic. Along with *sirtalis*, the polytypic genus *Thamnophis* contains a number of other species, including *T. couchii*, *T. validus*, and *T. proximus* (note that abbreviations of the generic name are appropriate, as it is clear we are referring to *Thamnophis*). If we want to refer to multiple species in the same genus, we can also include a "spp." behind the generic name — *Thamnophis* spp., in this case. The common gartersnake also has a number of described subspecies, such as the following:

Thamnophis sirtalis sirtalis (Linnaeus 1758) — eastern gartersnake

Thamnophis sirtalis fitchi Fox 1951 — valley gartersnake

Note the addition of the subspecific epithet (*sirtalis* and *fitchi*). The three-part name is sometimes referred to as a trinomial. There are always at least two

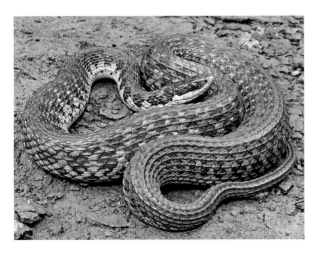

Kirtland's snake (*Clonophis kirtlandi*) is a small serpent that frequents marshes and other wet habitat across the eastern United States. *Clonophis* is an example of a monotypic genus.

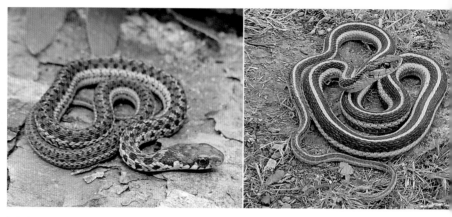

left An eastern gartersnake from North Carolina. Even within the subspecies, *Thamnophis sirtalis sirtalis* shows a remarkable degree of variation in colors and patterns.

right Valley gartersnake (*Thamnophis sirtalis fitchi*) from Calaveras County, California.

subspecies, and the originally described species is one of them and is known as the nominate form. To distinguish the nominate form, the specific epithet is repeated as the subspecific epithet (*sirtalis sirtalis* in this case). When you see a double epithet, you know that the subspecies was the originally described species, before any subspecies were described.

Subspecies are considered to be geographically separate populations of a species that exhibit recognizable differences (sometimes referred to as "local variants"). The eastern gartersnake and the valley gartersnake are two subspecies that are separated by half a continent; they are different enough to be considered separate subspecies but alike enough to both be considered part of *Thamnophis sirtalis*.

The rules and syntax of taxonomy may seem tedious, but they allow people who may not share a common language to understand precisely which organism is being referred to. If someone refers to *Thamnophis sirtalis*, you can be fairly sure he or she means the common gartersnake and all its subspecies, occurring from the Atlantic to the Pacific and from Canada south into Mexico. If *Thamnophis sirtalis sirtalis* is discussed, that name refers to the eastern gartersnake, a single subspecies of the common garter. For field notes, many biologists will abbreviate herp names by making an acronym of the first two (or sometimes three) letters of the genus and species — in the case of *Thamnophis sirtalis*: ThSi or ThaSir.

DNA, GENETICS, AND THE NEW TAXONOMY

To paraphrase Charles Dickens, it is "the best of times, and the worst of times" for taxonomy. It is the best of times because technologies for synthesizing and analyzing DNA have improved dramatically and continue to do so. By analyzing segments of DNA code, scientists are able to build a picture of how groups of animals are related and which species may share a common ancestry. Prior to the emergence of DNA analysis, herps and other organisms were classified solely by physical appearance features such as size, patterns, and color and by anatomical characteristics such as the structure of skulls, teeth, and scales. In many cases, physical analysis was enough to sort organisms into orders, families, genera, and species and to make inferences about which species might be closely (or distantly) related.

While DNA analysis has confirmed some of the relationships inferred from physical characteristics, it has also brought plenty of surprises, and more are certain to come. Some species that look very different from each other are actually closely related. Analysis has also revealed "cryptic" species, organisms that are physically identical to the rest of the population but are genetically distinct. In 2014, for example, DNA and physical analysis of alligator snapping turtles (*Macrochelys temminckii*) revealed the presence of a second species (*M. suwanniensis*) and possibly a third, each inhabiting a different drainage system in the southeastern United States.

Which brings us around to the "worst of times." DNA analysis has led to a great deal of taxonomic change in a short amount of time, as researchers adjust their hypotheses to accommodate the new data. The names of some long-standing genera have changed; change the genus name, and the species names in that genus may change too. Species have been "sunk" (removed) or moved to other genera, and in some cases, new species have been described, and new genera erected. For many field herpers, these changes

An eastern black kingsnake (*Lampropeltis nigra*) from southern Indiana. There are endless discussions and arguments among field herpers about kingsnake taxonomy, a species continuum that stretches from ocean to ocean.

An Iowa specimen of a western foxsnake (*Pantherophis ramspotti*), formerly known as *Scotophis vulpinus*, *Pantherophis vulpinus*, and. *Elaphe vulpina*

have been hard to follow and, in some cases, hard to swallow. Veteran field herpers were present when the North American ratsnakes were moved from *Elaphe* into *Pantherophis* and then later witnessed some seemingly crazy and logic-defying changes to the species within that genus. Several decades have passed since those changes, and some people are still angry about the mess. Genetics, taxonomy, and evolutionary biology are tough subjects for many of us, and we can't see DNA, so we have to take a lot of the changes and proposed changes on faith. As we mentioned earlier, humans classify everything with their senses, and for the first time ever, we have to take someone else's word for it. Unfortunately, not all biologists and taxonomists are sensitive to that fact. It also doesn't help that scientists don't all agree on how DNA should be interpreted and applied to taxonomic relationships, and that they're still working the kinks out of this new science.

How do we as field herpers cope with all of this? First of all, understand that some confusion on your part is OK — many of us are confused by taxonomic change. Second, and just as important, there is no need to immediately accept and incorporate taxonomic changes, and you are under no obligation to do so. It's good to remember that these are *proposed* changes, and some of them will not stand the test of time or academic scrutiny. If you are still referring to North American green treefrogs as *Hyla cinerea* instead of immediately jumping on the *Dryophytes cinereus* bandwagon (yes, that happened while this book was being written), don't worry. Most other herpers will know what you are talking about. You're likely to notice other herpers using old terms, such as referring to *Bufo* instead of *Anaxyrus* when talking about North American true toads, and that's OK too.

While we favor a slow adaptation to taxonomic change, we do realize that change is inevitable, and that there are big changes still to come. Some will make sense, others will leave us scratching our heads, but all of it is bound to be interesting. Fasten your seat belts! *[Josh and Mike]*

Species Identification

Even nonherpers are pretty good at sorting herps into the basic groups of frogs, toads, salamanders, turtles, crocodilians, snakes, and lizards, based on appearances alone. Identifying animals to a finer degree (family, genus, species) may require examination of "field marks": anatomical details such as colors and patterns, scale configurations and appearance, numbers of toes and their shape, pupil shapes and other characteristics of the eye, and so forth. For some herps, identification to the species level depends on their genes and on the genetic researchers who develop genetic profiles of organisms — you may be sure of their identity only if your location falls within their known range or habitat.

While some species have distinctive field marks that are an easy "tell," others are more of a challenge. Dusky salamanders are a good example: colors and dorsal patterns can vary from one individual to the next and from one location to the next. With these salamanders, identification starts with tail shape — their tails can be round in cross section or flat and knife-shaped, or they can be both round at the base *and* knife-shaped at the tip. Once you've established the tail shape, you can then focus on other details like spots, patterns, belly color, shape of the mouth line, toe-tip cornifications, and so forth. A quicker solution is "elimination by range"; pull your field guide out of your pack and use it to elim-

left Two neonates: a smooth softshell (*Apalone mutica*) on top, with a spiny softshell (*Apalone spinifera*) underneath. Differences between the two species are slight but evident, including length and curve of the nose, face and neck stripes, shape of the nostrils in cross section, and the presence or absence of spines on the front edge of the carapace.

right Seal salamanders (*Desmognathus monticola*) have a tail that starts out round at the base. It changes to be laterally compressed and keeled for the posterior two-thirds of the tail.

SALTMARSH SNAKES
A CLUSTER OF TAXONOMIC &
MORPHOLOGICAL CONFUSION

We often stereotype creatures in the herp world. It's easy for us to say, "This herp looks like this, and that makes it different from this other herp that looks like that," and this stereotyping often works well for us. For example, California kingsnakes (*Lampropeltis californiae*) have black and white bands and are pretty easy to distinguish from western diamond-backed rattlesnakes (*Crotalus atrox*). But sometimes the lines get blurred — take the saltmarsh snake (*Nerodia clarkii*), for example. Saltmarsh snakes are separated into three subspecies: the Gulf saltmarsh snake (*Nerodia clarkii clarkii*), the mangrove saltmarsh snake (*N. c. compressicauda*), and the Atlantic saltmarsh snake (*N. c. taeniata*). I have had the pleasure of working with this species in the field for several years. I've found all three subspecies in a number of counties, some in places where they seldom (or never) have been documented before.

Some of the natural variation in the mangrove saltmarsh snake (*Nerodia clarkii compressicauda*).

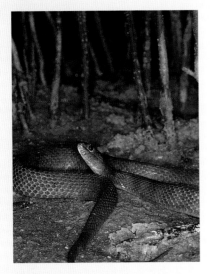

They are found throughout the Gulf States but are best known (and most variable) in Florida.

Because saltmarsh snakes prefer different habitats in different Florida counties, I often ask the locals if they've seen any to narrow my search. There are only three morphological traits that the layperson seems to grasp: size, which is often exaggerated wildly; pattern; and color. When I'm asked what saltmarsh snakes look like, I answer candidly: "They can have stripes, bands, or no pattern at all, or some variation thereof. They are often a slate gray in some localities, but it's just as common to find ones that are tan, light green, blood-red, orange, black, salt-and-pepper, and yellow. I've never seen a blue one, but I know someone who has. . . ."

This is the moment that I typically lose the local I'm talking to, and then I just ask him if he's seen any snakes near the salt water.

If my description seems weird, just wait — the snakes themselves get weirder. One would expect that even if the species were somewhat variable physically, genetic analysis would clear things up. Unfortunately, this is not the case for saltmarsh snakes. The genetics of the species vary significantly across their range, likely due to populations being isolated and reintroduced a number of times over Florida's history through the Ice Age. Cycles of sea-level rise and fall have left *Nerodia clarkii* genetically confused — in fact, Jason Hickson, a biologist who studied these snakes for his (yet-unpublished) thesis research at the University of Central Florida, has found evidence suggesting that saltmarsh snakes at a given location are genetically more similar to banded watersnakes (*Nerodia fasciata*) found nearby than they are to members of their own species in farther-flung areas. That's right: a saltmarsh snake may be genetically closer to a different species than it is to a member of its own species. If ever you despair over the dysfunctionality of your own family, remember the saltmarsh snake. [Josh]

inate all the species that don't occur in your location and then check tail shapes and field marks on the remaining candidates.

Field guides are indispensable tools for identification, especially if you're new to field herping and are learning as you go. Along with pictures, most guides include range maps for each species, along with their distinguishing field marks. Some feature dichotomous keys that ask questions with yes/no answers; eventually you arrive at an identification by process of elimination. While we encourage you to thoroughly read your field guide at home, don't leave it there; take it with you. Most guides are designed to be carried in the field, and chances are you're going to need yours.

Sometimes you will run across a herp that you can't identify, even with the use of a field guide. It even happens to experienced herpers, on occasion. If you have the herp in hand, this is where your camera comes in handy: you can take a series of photos and do research later or ask others for assistance. Take photos of the head and the body from the top, from the sides, and from underneath. For snakes, make sure to photograph the ventral scales, including the anal plate at the venter — some snakes have a single anal plate, while others have a divided anal plate. For turtles, take photos of the plastron and the carapace. Toads can often be identified by the shape of their cranial crests and paratoid glands, so take a photo of the top of the head. A side shot of frogs that shows the tympanum and any dorsolateral fold can be useful for identification, as will a shot of the toes and the webbing between the toes.

Identification gets easier with every herp you examine, and after a while, you'll find that you can recognize a species even from a brief glimpse. One word of warning: don't make assumptions about snakes, especially if the identification is unclear and there is a possibility that it is venomous. Aberrant patterns and colors do occur on occasion, and if you're not sure, it's best to be cautious.

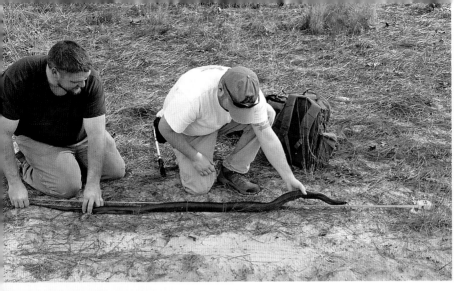

Gathering physical data from an eastern indigo snake during an Orianne Society field trip.

CHAPTER 8
CITIZEN SCIENCE AND DATA COLLECTION

According to the *Oxford English Dictionary* (OED), citizen science is defined as "scientific work undertaken by members of the general public, often in collaboration with or under the direction of professional scientists and scientific institutions." While the term was only added to the OED in 2014, in practice, citizen science has been around a long time. Prior to the twentieth century, when scientific research shifted largely to universities, science was a pursuit largely undertaken by amateurs. In the early days of herpetology and other life sciences, significant contributions to taxonomy, ecology, behavior, and natural history were made by "natural philosophers" (the word *scientist* was not coined until 1833). Since then, amateur herpetologists have continued to make contributions to herpetology, such as documenting range extensions and aspects of natural history, discovering new species and subspecies, and mak-

ing behavioral observations. In this chapter, we'll discuss how you can help make contributions, along with some citizen-science projects that welcome your participation.

The Value of Field Observations

Today, under the umbrella of citizen science, there are opportunities for amateurs — including newcomers to field herping — to make contributions to science. Each year field herpers will spend tens of thousands of hours in the field, observing untold numbers of amphibians and reptiles. Why not put those observations to good use? Chances are you're already documenting field observations for your own purposes; by sharing them with appropriate institutions and research groups, you can contribute in a number of ways. First of all, your observations can help document "presence," which helps land managers understand which herps are present and where. This allows them to more effectively use funds and human effort (both of which are always in short supply) to manage and protect both herps and their habitat.

Documenting presence can be helpful in many other ways. While it can assist in understanding which herps are found in a given area, on a larger scale it may also help establish the current range of a species (which may be different from the historical range). You may even document a "range extension"; the whereabouts of some species are poorly known, and others may be expanding outside their established ranges. Some herps have been introduced to areas outside their natural range; the American bullfrog, for example, has been introduced in many places west of the Rocky Mountains. Recording observations of introduced species can help keep tabs on their populations and may document their presence in new areas.

Documenting the presence of common species is important, although they often get overlooked ("just another toad"). Rare and endangered species receive a lot of attention, and deservedly so, but it is also important that we "keep common species common," and to do that, we need to know where they are and how many there are, so that funds and efforts can be effectively used in protecting them and their habitat.

Your observations can also contribute to phenology research. Phenology is the study of biological events and how they are influenced by changes in season or climate. Phenological events for herps include emergence from brumation, courtship and breeding, aestivation, and migration. If you visit vernal pools in

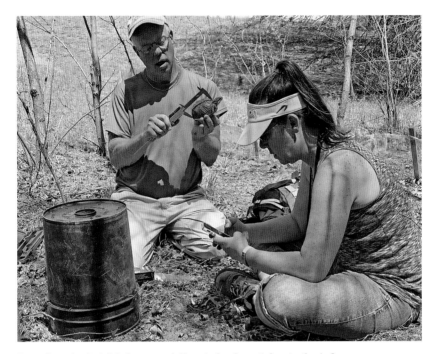

Recording physical data for a population study of ornate box turtles in Iowa.

the spring, you have the perfect opportunity to document emergence, courtship, and breeding for salamanders, toads, and frogs.

Opportunities for Participation

Along with making contributions to herpetology and herp conservation (and seeing more herps), participation in citizen-science projects can have some personal benefits as well. You can add to your field herping knowledge, sharpen your observation skills, and make new friends. You can rub elbows with biologists and learn about their research, and participation can lead to other opportunities in the field.

Bioblitzes

First held in 1996, bioblitzes are organized events where scientists, naturalists, and other volunteers participate in a biological survey of a designated area. They are often held in parks, nature preserves, and on other types of public and

TEMPORARY WETLANDS
DIAMONDS IN THE ROUGH

Animal life can be sparse in terrestrial habitat, but one place where the organisms really congregate is in and around temporary wetlands. By definition, temporary wetlands are wet areas — ponds, pools, marshes, and swamps — that dry up on a regular basis, usually every year or every other year. Many of these wetlands have few or no populations of fish — they are either too small, too far from lakes and rivers, or dry up completely. Even roadside ditches in rural areas can serve as temporary wetlands. The lack of voracious predatory fish makes them a precious resource for other organisms, including countless species of invertebrates. Frogs and toads, salamanders, snakes, and turtles will flock to temporary wetlands during their breeding season, many to breed and some to feed on other animals.

But temporary wetlands face many problems. Because of their often-small size, their importance is frequently overlooked, they are more likely to be destroyed for human habitation, and they are more vulnerable to pollutants. But they are important! My work with temporary pools in Florida revealed that they had eight to nine more resident herp species, on average, than more permanent wetlands. Often in conservation, we don't *really* know how important something is until it is too late; this is where herp-centric citizen

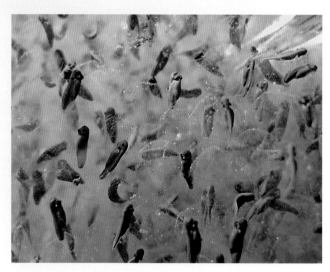

Small though they may be, temporary wetlands are of utmost importance to herps. A bathtub-sized pool in northern Alabama provided a good location for the deposition of hundreds of salamander eggs.

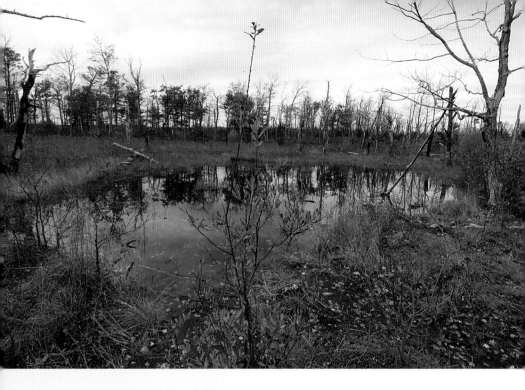

scientists like you can help! Many local and even state parks are only vaguely aware of how important their temporary wetlands are to amphibians and reptiles. This is a problem, but it can become an opportunity for you to educate others and do some herping while you're at it! Offering to do a survey can be a good way to see which species are using your local temporary wetlands, and because they are easy to do, surveys can be a great way to get people of all ages involved with herps. By watching and surveying our temporary wetlands, we can gather long-term data that indicate when they are facing threats, how restoration programs are working, and a number of other important bits of information to keep herp diversity in our backyard, long into the future. *[Josh]*

private land. Bioblitzes are brief events, typically spanning twenty-four hours or perhaps a weekend, with the purpose of recording as many types of flora and fauna as possible and also their numbers. Volunteers can be assigned one or more types of organisms to survey, and usually some people are needed to log amphibians and reptiles. Although it is helpful, no experience is required, and bioblitzes are usually open to the public and are kid-friendly. By their nature,

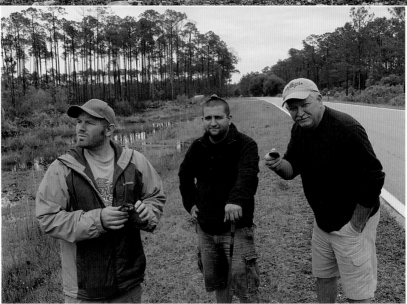

top Herp survey, central Kansas.

bottom Wildlife meetups can be a great place to make new herping friends. Some participants in "Team Aquatica" showing their turtle finds during a North American Field Herping Association field trip.

bioblitzes have a built-in focus on biodiversity, which can help participants realize its importance on a local level. Aside from being a lot of fun, bioblitzes also provide opportunities to talk with biologists and other "subject-matter experts." Many are hosted annually, and a simple Internet search may reveal those near you. Even if you end up counting birds and oak trees, you're likely to have a good time, meet some interesting people, and learn something new.

Field Trips and Herp Surveys

Many state and regional herpetological societies hold annual or semiannual field trips. Some (such as the South Florida Herpetological Society) host members-only group outings, intended for fun and to introduce newcomers to field herping and to other field herpers, while others host field trips that are intended as herp surveys. The Kansas Herpetological Society's semiannual field trips are perhaps the best-known herp surveys; they are open to the public, and each trip is held in a different area of Kansas. Participants scatter across a designated area in search of herps and record any they find.

Some regional chapters of PARC (Partners in Amphibian and Reptile Conservation) also sponsor herp surveys — the Colorado chapter (COPARC), for example, holds semiannual herp surveys. The Orianne Society holds an annual "Places You've Never Herped" field trip for members. Space is limited, but PYNH is an opportunity to participate in herp surveys with Orianne staff, in underappreciated locations. "Indigo Days" is another Orianne event that takes place in early winter, when members can help search for eastern indigo snakes and other herps. The North American Field Herping Association (NAFHA) hosts field trips in varied locations on a semiregular basis.

FrogWatch

If you have a zoo or aquarium near you, chances are it hosts a local chapter of FrogWatch. In the United States, the FrogWatch project is hosted by the Association of Zoos and Aquariums (AZA); in Canada, it is hosted by Nature Canada and Environment Canada. FrogWatch is a volunteer-driven program that monitors frog and toad populations by listening for their choruses. Volunteers submit their observations to an online database. By participating, FrogWatch volunteers help monitor anuran populations across a wide area. For field herpers, it is also a good way to learn the calls of local frogs and toads and where populations are located, while taking advantage of opportunities to observe them. An Internet

search of "FrogWatch" will provide the necessary information on chapters in your area.

Herpetological Databases

All your field observations, even those of common species, can be extremely useful data when added to a herpetological database. Typically, such databases are used by conservation organizations, state agencies, and researchers to understand species distributions and population dynamics. These databases support the conservation of herps and their habitat, and the data helps optimize effort and funding, to protect both threatened and common species.

State Herp Atlases A number of states have herp atlas projects, and as this book goes to press, more are in the works. These atlases are designed to gather observations, map herp distributions, and monitor populations, and while their goals and scope vary from state to state, most provide methods for the general public to submit observations. An Internet search will reveal atlas projects for states in your area.

HerpMapper HerpMapper (www.herpmapper.org) is a nonprofit, cooperative citizen-science project designed to gather information about amphibian and reptile observations across the planet and then share that data with research and conservation organizations. Contributors can enter records of their herp observations using a web browser, or they can create real-time records in the field using HerpMapper's mobile app. Records consist of a voucher photo, a time stamp, species identification, and some basic information about the herp. Collected data is made available to HerpMapper's partners: accredited organizations and science teams that use the data for research, conservation, and preservation purposes. By participating, contributors agree to make all the records they enter available to HerpMapper data partners.

Since HerpMapper's primary goal is to assist in the conservation of herpetofauna on a global scale, it does not share specific locality data with the general public. Contributors have full access to all the records they create, which makes HerpMapper a handy tool for keeping track of your herp finds. HerpMapper contributors can also keep track of their finds in their account profiles, which lists the numbers of records, number of species observed, and other data. HerpMapper also automatically builds and updates a life list for each contributor, based on his or her recorded observations.

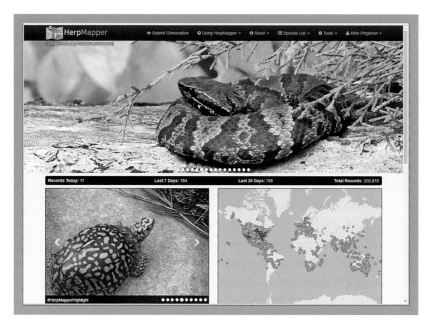

HerpMapper home page at www.herpmapper.org.

The HerpMapper mobile app uses the native GPS on your mobile device, which means that you can create records in the field without needing a cellular or wireless connection. Records can be synced with the HerpMapper database later, when you have connectivity. If you're participating in bioblitzes and herp surveys, HerpMapper can be a force multiplier for data collection, opening the door for even more research teams and conservation programs to make use of your observations. A number of state atlas projects use the HerpMapper database, and your iNaturalist observation data (see next section) can also be imported into HerpMapper.

There is also a social component for HerpMapper participants. The project has a support and discussion group on Facebook and is @herpmapper on Twitter. As records are created, they are streamed on the HerpMapper website, with specific locality data removed. If you can't be out in the field yourself, you can at least see what other field herpers across the planet are finding.

iNaturalist iNaturalist is "a crowdsourced species identification system and an organism occurrence recording tool" that people can use to record and share

VOLUNTEERING

OPENING DOORS AND MINDS

When I started hanging around the local nature center (I'm self-employed and often have free time during the day), I think I knew more than the average person about herps but nowhere near as much as I thought I did. I would talk to Jenny and the other staff in the nature center from time to time, and at one point, I was insisting that the hognose snake I had found was in fact a western and not an eastern . . . it was an eastern. To this day, I am not sure if my now-friend Jenny just happened to be the only person who shared my interest in herps, or if there was a secret meeting to address the crazy guy who kept coming to the park, and she was elected to be my handler.

When kids came to the nature center on field trips, I started to show them some of the herps I was finding in the park. At some point, people must have decided that I knew what I was talking about because Jenny asked me to give a talk to a group of naturalists. Despite having only two days to prepare and my nervous fast-talking, the talk did go well, and it led to my doing many other programs at the nature center and also in schools around my area.

Thanks to these experiences, I fell down the rabbit hole of educating the public, which led me to other paths and opportunities I couldn't have imagined. I eventually got a permit from the Iowa DNR allowing me to keep many native species to be used to educate the public. I believe my biggest crowd so far was 168 people during a weekend program, but the best programs are the random ones where I see some kids at the center, and I can enjoy their excitement when they spot a frog or a

observations of any and all living organisms. iNat also describes itself as "an on-line social network of people sharing biodiversity information to help each other learn about nature." Users can upload observations via browser, or they can use the iNat mobile app to create records in the field. They can get identification help from the iNat community, and maps, calendars, lists, journals, and other tools are available to help users keep track of their observations.

A secondary goal of iNaturalist is to provide biodiversity data to researchers and land managers, and the ability to create projects is a common way to pool observation data. Projects can also be created for individual events, such as bioblitzes. iNaturalist is used by field herpers and is very useful for herp surveys. Please note that the project shares and displays locality information — herpers should exercise caution when it comes to threatened, endangered, or sensitive

turtle, and I can join them to show them more.

Around the same time, Jenny and I started marking the Blanding's turtles in the park, which in turn led to my doing other projects to inventory the herp species in all the county parks. Each project grew into something new. Helping to track box turtles and inventorying Linn County properties eventually led me to a small nondescript piece of property that used to be home to a population of ornate box turtles, but the sandy habitat had become choked with cedar trees and woody brush. I went out there one day with a set of hand loppers and started cutting back the brush in an area I thought would be a good nesting place if the turtles were still around. It turned out that small patch of sand was a hint of what the area once was — a relic of the past, a ridge of sand pushed up where the glaciers stopped in our area. What started as a small project to keep a little area of sand open has turned into much more. Now I have a small group of other volunteers helping me remove the cedar trees all along the sand ridge and restoring it back to what it once was. That in turn encouraged some friends to do restoration work on properties in nearby counties, including two properties where timber rattlesnakes overwinter.

I'm also involved in many other projects that I don't have room to tell you about (such as HerpMapper), but I hope that my message is clear: there are plenty of opportunities for anyone to get involved with education and citizen-science projects. I don't have any formal education in herpetology or land conservation or public education, but what I do have is a willingness to get involved and give my time, which (as you can see) can open one door after another.

[Don Becker]

iNaturalist home page at www .inaturalist.org.

This unfortunate carnage from a country road one evening in Florida had a small silver lining: the specimens were donated to the Florida Museum of Natural History and will be used for future scientific research.

species. While iNat skews locality coordinates for threatened species, it also recommends that you consider not using its platform to record such sensitive observations.

DOR Specimen Collection

DOR (dead-on-road) herps are a sad sight to see, but they can still be useful to science. If they are brought to a museum or university, they can be added to their collection of preserved specimens. DORs with locality information can provide data on presence and abundance; before collection, they can be added to databases like HerpMapper and iNaturalist. Their stomach contents can be analyzed to see what the animal was eating, and any eggs or embryos present can be examined and counted. Prior to preservation, tissue samples can be collected for DNA analysis.

Make arrangements with your local museum or university before bringing them any DORs. You'll want to know ahead of time whom you need to contact, what kinds of specimens the institution is interested in acquiring (it may not

STRADDLING THE LINE
TURNING AMATEUR FIELD
HERPING INTO A CAREER

Many young field herpers grow up aspiring to turn their hobby into a profession. I knew from an early age that I wanted to be either a pilot or a herpetologist. Looking back, I realize how little I understood about the world of professional herpetology. However, I had a bit of confidence that my passion for reptiles and amphibians would somehow give me an edge in the field. Eventually I found myself with a dream job that I never thought possible as a kid, because at the time it did not exist.

As a high school student, I enrolled in a college course titled Amphibians and Reptiles of Kansas. Years before, I had familiarized myself with a book bearing the same name as the class, and that book was the "bible" for anyone in Kansas interested in the state's herpetofauna. When I walked into class the first day, I discovered that the professor teaching the class had also authored the book, and I nearly lost my composure. A rock star in the world of herpetology, the late Joseph "Joe" T. Collins stood before me and delivered my first serious dose of education in reptiles and amphibians. I still lacked any idea how to become a herpetologist, but I knew I must somehow impress this man.

After sitting wide-eyed through each lecture and thoroughly enjoying our two class field trips, I earned an

A. I kept in touch with Joe through college, and he invited me to go herping with him in Florida. I seriously did not recognize this as work, but apparently it qualified. I volunteered my time and drove halfway across the country each winter to participate in these annual herpetofauna surveys. On these trips, I found many exciting species and even wrangled my first alligator. Joe contributed some gas money and lodging in beautiful beachfront houses, and his wife, Suzanne, fed us well with fresh seafood from Apalachicola Bay. Joe became a steadfast reference in my future search for employment and gave me a "walks-on-water" recommendation to anyone who asked.

Soon after earning my bachelor's degree in biology, and with Joe's recommendation, I enjoyed a couple of seasonal jobs, performing herp surveys in Colorado and radio tracking massasaugas in Missouri. I eventually applied for a position in Florida participating in field research on American alligators. My previous experiences prepared me to outcompete nearly one hundred applicants, but I still felt extremely fortunate to land this job. Coming from Kansas, I thought capturing alligators in the Everglades sounded very exotic; Steve Irwin had inspired my interest in crocodilians during high school and college. This new job felt like a dream come true and soon exceeded all my expectations. The position expanded to work with American crocodiles, which involved driving airboats and

flying in helicopters, and eventually led to work with invasive Burmese pythons, a new phenomenon in Florida. Tracking pythons enabled me to fly in Cessnas and helicopters weekly, combining my two career ambitions into one perfect job. I even appeared on several television specials about pythons.

If I can stress one thing to aspiring biologists, I recommend considering your career a lifestyle. When I was young, you could not keep me away from my job. You could find me road cruising or catching crocodiles any night of the week. However, most importantly, I respected and willingly tackled the less enjoyable duties. There are hundreds or thousands of kids dying to catch pythons and crocodiles for a living, but what can elevate you above the rest is education and a willingness to complete less-than-glamorous tasks. Work harder than everyone else, and eventually you can live your dreams. [*Mike Rochford*]

Mike Rochford (right) wrangles a Burmese python (*Python bivittatus*) in the Florida Everglades.

While still in college, Josh made this observation of a brown watersnake (*Nerodia taxispilota*) consuming a brown hoplo catfish, a new natural history observation that he was able to publish in *Herpetological Review*.

have a need for very common herps), and what data you need to gather along with the specimen. Check also to see if your state or province requires you to have a collecting permit for this activity (some do).

Publishing Notes on Natural History and Geographic Distribution

Publications like *Herpetological Review* provide opportunities for reporting natural-history observations and notes on distribution. Your observations of dates, conditions, and behaviors for activities like mating, egg deposition, birth, emergence from brumation, diet, breeding, courtship rituals, or social behaviors may be scientifically important and worth publishing as a natural-history note.

"County records" are a standard unit of measure for the presence and distribution of herp species. The herp field guides for many states make use of county records to plot species distributions, and if your state has a herp atlas, it may also indicate which herps are recorded in which counties, along with any gaps in the distribution. Some herpers are very knowledgeable concerning the county records for their area and know where species are missing; for them, filling in the gaps is often a goal and a challenge. If you find a species in a county where it was previously undocumented, you have the justification to write and publish a distribution note.

Herpetological Review has an "instructions for authors" page that provides guidelines and formats for submission. If you're not sure about the process, or if you're wondering if your observations are noteworthy, talk to a herpetologist. You might also consider subscribing to *Herp Review* and other herp-focused publications to keep up to date.

A simple picture of a pine woods treefrog tadpole (*Hyla femoralis*) can open up an opportunity to talk about topics from metamorphosis to fish-stocking practices.

CHAPTER 9
HERP PHOTOGRAPHY

It is hard to imagine field herping without photography. It is safe to say that the advent of the digital camera helped popularize field herping; even herpers who aren't really into photography will use their cell phones to capture a herp or a moment they want to remember ("pics or it didn't happen" is a common phrase in the herper community). At the very least, photos and video can stimulate memory. Opening up an album or folder, even months or years later, can bring back memories and feelings from past field trips.

There is a great deal of fun to be had in sharing your experiences on social media platforms, where potentially thousands of field herpers can enjoy your photography. Photos can lead to interesting discussions and new friends, but remember that ethics and etiquette come into play on social media, and you can find yourself at the center of controversy if you're not careful. It is likely that non-

top Photos helped identify this banded pampas snake (*Phimophis vittatus*) from the Paraguayan Chaco.

bottom You don't need expensive equipment to take good herp photos, but some people do go all out. Here a herper with a high-end camera setup photographs a black swampsnake (*Liodytes pygaea*).

herper friends and family will also be interested in your photos, and you may end up providing them with some knowledge and education.

"One picture is worth a thousand words" may be a cliché, but it is certainly true. Photos are useful for identification purposes, and there are few herpers who haven't relied on them to pin down an ID. It can be frustrating to find that you didn't get a photo that can clearly identify an animal, and that experience can teach the value of taking multiple photos of a mystery herp and from different angles. Such photos are also valuable to herp databases and other citizen-science projects. For most, a "voucher shot" is the minimum proof required for a credible record, and researchers using the data want to confirm species identification themselves. An incorrect ID can be fixed if the photo or photos provide conclusive evidence, but blurry photos or ones taken too far away will likely be of little use.

Cameras

Herp photography doesn't require a lot of expensive gear or years of experience. To get started, you can simply use your cell phone camera, and where you go from there is up to you (there are plenty of field herpers online who will be happy to discuss cameras at length with you). Regardless of equipment, the most important task is to understand your camera — how it works, what kinds of photos (and videos) it can take, and what its limitations are. For example, a cell phone may take great photos of a frog within arm's reach, but you may not get the same results from thirty feet away. How good is the zoom, and does

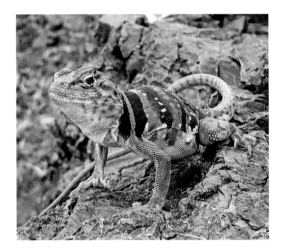

Tiburón Island collared lizard (*Crotaphytus dickersonae*). Photo taken with an iPhone 7s.

zooming in affect photo quality? How does it handle low-light conditions? It may take some time and effort, but knowing what your camera's capabilities are will help you get better results.

Nature Photography Fundamentals for Herpers

In this chapter, we describe some aspects of photography that pertain to field herping, but there isn't space (and we don't have the expertise) to cover cameras, gear, and photography fundamentals. There are plenty of other resources for this, including books on digital nature photography; we can recommend in particular *John Shaw's Guide to Digital Nature Photography.*

Types of Photos

Field herping photos typically fall into one or more categories, each with its own purpose or set of conditions. *Portraits* are posed photos in which the herp is the sole subject and takes up most of the photo. These are perhaps the most common herp photo, and in many cases they are the easiest to arrange. Portrait photos are used to highlight life-listed herps, are frequently used in posts on social media, and can be useful in educational presentations. They are sometimes poorly executed, with the animals in stiff, unnatural poses, but with a little skill and persistence, the herp can be photographed with a more "natural" appearance. A subset of portrait photos is the so-called meet-your-neighbors

SECRETS OF HERP PHOTOGRAPHY REVEALED

Some of my friends are excellent photographers, and they get amazing images of herps and other animals under a variety of conditions. Although I take thousands of photos each year, I would not dream of putting myself on the same level as my talented friends. I'm not good with exposures and shutter speeds or optics, and photographic principles never seem to stick in my mind. But I do manage to take some good photographs on occasion, and despite the tongue-in-cheek title, I want to describe how I make herp photography work for me.

First of all, there's my camera. An expensive and complicated rig would be wasted on me; I use a point-and-shoot model, currently a Panasonic Lumix FZ1000, which is on the upper end of that type of camera. I rely on reviews and ratings before selecting a brand and model — there's no point in getting one with drawbacks or limitations that I will have to work around in the field. (I like the Lumix line, but I'm not suggesting that you run out and buy one — you might find some other brand that works for you.) I also use an old Canon D-10 for underwater shots, and I use the camera on my iPhone 7 quite a bit these days; cell phone cameras are getting better all the time.

Second, I usually shoot in program mode and let my camera do all the heavy lifting for things like aperture and film speed. I may use the aperture priority mode under certain lighting conditions, but otherwise, I let the camera figure it out — a lot of money and research has gone into making cameras good at that sort of thing. My focus mode is set to a single point; I don't let the camera decide what to focus on. When it comes to herps, the

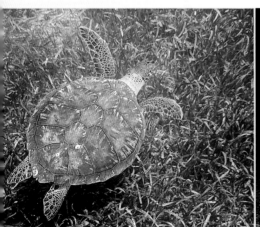

left Green sea turtle (*Chelonia mydas*) shot with a Canon d-10 waterproof camera while snorkeling.

right Salamander activity on a rainy night presents an opportunity. The umbrella is to keep the downpour off Mike's camera.

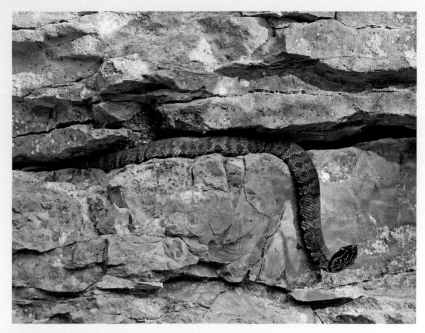

Take advantage of opportunities in the field. An in situ shot of a young cottonmouth at a den site, soaking up some late afternoon sun.

eye is always the point of focus, and it's my job to get that part right. Time of day and light exposure determine if I use the built-in flash, and when I do, I have a little plastic diffuser rig that softens the flash.

That's the end of the technical part; the rest is artistic process, framed in a long list of questions that I ask myself. Photo sessions can happen at the drop of a hat, and they can be exciting; it's easy to get distracted by seeing cool herps in your viewfinder, so before I shoot one shot, I look over my subject with an objective eye. Is there anything blocking the view, like a twig or blade of grass? Does the background look natural or contrived? Is anything sticking to the

subject? Amphibians are notorious collectors of organic material. Is that a natural pose? Are any ugly scars visible from this angle? Is it missing any body parts, such as a toe? There's nothing worse than getting home from a long and possibly expensive trip, only to find that your lifer poison frog had a small hair stuck to its leg (true story).

The shooting starts, and I evaluate the first few shots for technical details such as focus, exposure, depth of field, and flash intensity. After some tweaking and further checking, the photo session kicks into gear, and I start thinking about the herp and what kind of shots I want from it. A common herp shot is to

Getting underneath a map treefrog (*Boana geographica*) led to this dramatic shot.

drop to one knee and shoot down at a forty-five-degree angle; you can get some great shots that way, but I don't like to overuse that angle or any other. I tend to think of the subject as lying at the center of a sphere; I can take a shot from any single point on that sphere that lies aboveground, but from which points? I usually end up shooting from multiple angles on both the x and the y axis, and I'm not afraid to get on my belly or back and try to shoot upward from beneath. I may shoot in macro mode to get close-up shots or head shots, and I'm also likely to back off a bit and grab shots that include some surrounding habitat. I check each shot to make sure the eye is in focus and that the subject is framed properly inside the photo. If it's a herp I especially like or haven't seen before, I may take fifty to one hundred shots — bits and bytes are cheap. If I do my job of focusing and framing the subject and make sure that the camera is doing its job, then I usually come home with some photos that I like.

I also try to let the herp inform me how it should be photographed, and in situ photos are the most obvious method for doing that — there's the herp, doing what comes natural, so take some shots! But good in situ shots may not be possible, and posed shots will have to do. With rattlesnakes, you obviously want poses that show off both the head and the rattle. Why shoot a treefrog or an arboreal snake on the ground? Pose them in a tree or bush, where they look like they should be, and take advantage of shots from the side and from underneath. When you place a treefrog on a branch, its initial pose will often look awkward; that's easily fixed with a slight poke to the behind. The frog may move a little, or it may jump to another branch, but chances are, its limbs are now in a natural position and it looks more alert and much more photogenic.

Finally, you have to be willing to examine your work with a critical eye. I use Photoshop for post-processing, mostly to crop and resize and to make

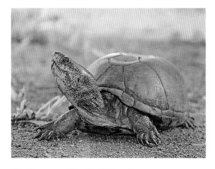

Mexican mud turtle (*Kinosternon integrum*) shot with a zoom from a hiding spot.

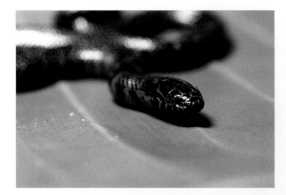

A young eastern mudsnake. Portrait shots let the intrinsic beauty of the species come forward.

minor adjustments. That's when I examine my images to see what I got right and what I got wrong. I've worked hard to learn from my mistakes and my successes, to let my cameras do what they do best, and to know what their capabilities are. As you spend time shooting in the field, you will acquire a number of tricks to make your photos better. For example, I had a hard time getting mud and musk turtles (*Kinosternon* and *Sternotherus*) to come out of their shells; no matter how patient I was, they would never poke their heads out if I was close by. I finally solved this by backing off; I place the turtle on open ground in front of me, retreat ten to fifteen feet, and hide behind something. It isn't long before the turtle's head pokes up in the air to see if the coast is clear, and I use the camera zoom to get the close-up shot I wanted. If you run across any *Kinosternon* or *Sternotherus* shots of mine, you can bet I was shooting from behind a rock or a bush!

[*Mike*]

format, where the animals are shot in an all-white box, removing any material that may be a distraction.

Field-guide photos attempt to show the colors, patterns, field marks, and other attributes of an animal, for purposes of identification and in some cases, education. The herp may be posed, or it may be simply photographed in someone's hands. While aesthetics aren't the primary goal of a field-guide shot, some photographers manage to make them beautiful all the same. *Macro photos* sometimes fit into this category; close-up and on the small scale, macro shots either feature very small herps or focus on a portion of the anatomy, instead of the whole animal.

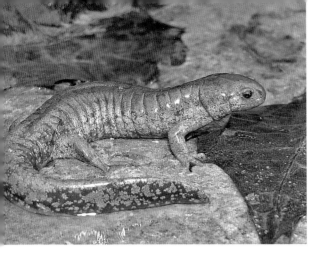

Formal portrait of a streamside salamander (*Ambystoma barbouri*) photographed in southern Indiana.

The Latin term *in situ* translates as "in place." For our purposes, in situ photos feature herps photographed "as found," upon discovery, and neither touched nor moved. In the hands of a canny photographer and under the right conditions, in situ photos can be very evocative, but often a good photo is not possible because of the herp's position or obstructions that prevent a clear shot. Of special interest are in situ photos that illustrate some element of natural history, such as rattlesnakes emerging from a den, frogs calling in a pond, or a herp stalking or eating a prey item. Many field herpers prefer in situ photos over all others because of their win-win nature; the animal can be observed, enjoyed, and photographed without needing to be captured, handled, or posed.

Herp-in-habitat photos are another popular form, which despite the awkward name, are precisely that: photos of herps that include their surrounding habitat. For many people, place is just as important as the animal, and when pictured together, they make for a story with depth and meaning. This makes

Portrait or field-guide shot? This photo of a map treefrog manages to show characteristics of the front and back feet, the ventral and dorsal pattern, pattern marks on the inside of the thighs, eye color, and the shape of the pupil.

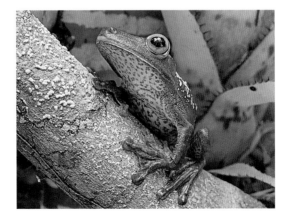

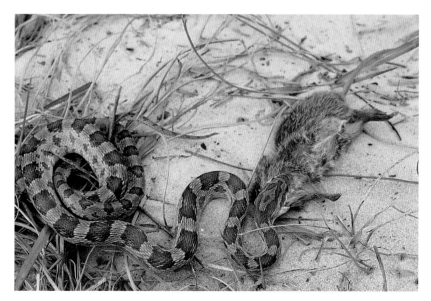

In situ shots can feature natural history and behavior, like this photo
of a cornsnake eating a rodent in the wild.

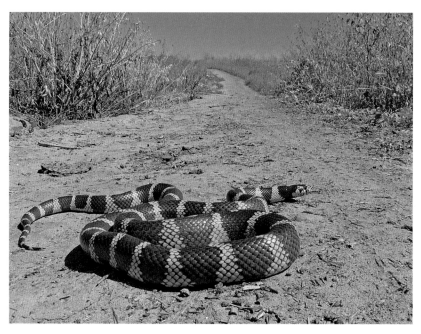

California kingsnake (*Lampropeltis californiae*) and surrounding habitat.

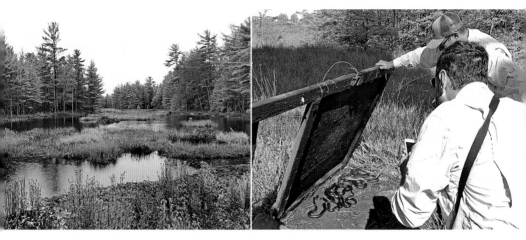

left Habitat for Blanding's turtles (*Emydoidea blandingii*) in Ontario, Canada.

right A mating group of western ratsnakes (*Pantherophis obsoletus*) provide an exciting moment for visiting Hong Kong herpers.

herp-in-habitat shots very useful for presentations and educational purposes. These photos typically feature the animal in the foreground, framed on one side or the other, with an expansive view beyond. It can be a wide shot showing a small herp against a bigger world, or a mid-range image with a larger animal as the subject but with some room left to show the surrounding habitat. A wide-angle lens is useful for creating these images but is not a requirement; they can also be achieved with a "belly shot," where the camera is held just off the ground. It is important to exercise caution with sensitive or threatened species; too much detail may reveal locations to poachers and others with malicious intent. Have fun with the format, and keep your eye open for an opportunity to capture a combined in situ herp-in-habitat moment!

Habitat shots may or may not have a herp in them, but their purpose is to capture the surrounding area where you found the animal. Habitat shots may not always contain magnificent landscapes and grand vistas, but they can provide an important frame of reference for your own use, for educational purposes, and for inclusion in database records.

Herpers-herping shots document the social aspects of a field trip. Group shots with the whole motley herping crew are standard fare, as are trophy shots with favorite finds. The most appreciated photos and videos are the ones where you and your companions are captured in action and in the moment: raising a large

piece of tin to reveal snakes underneath, noosing lizards, snorkeling for turtles, or perhaps photographing a rattlesnake on a dark desert highway. The main component of herpers-herping shots is "herpers having fun," and those moments are worth documenting. Herpers-herping is a popular theme in social media, but remember to show consideration for your companions and refrain from posting any embarrassing moments.

Posing Herps for Photographs

In situ photographs are not always possible, and sometimes you're left holding a wiggly or jumpy creature, and you need to shoot some photos. Over the years, field herpers have come up with techniques for posing amphibians and reptiles, commonly known as "wrangling." If you're alone, you're the photographer *and* the wrangler, which can be difficult; with groups, people can take turns wrangling for others. The wrangler's job includes posing the animal, wriggling hands and fingers to provide distraction, and if the animal moves, retrieving and re-posing it. The wrangler must also make sure that the herp is not suffering from undue stress or dehydration.

Some herps are calm enough to be easily posed and photographed, but most are anxious to get away or defend themselves; in either case, you're not likely to get the photos you want. The best way to calm them down is to detain them with an opaque cover object (also known as a "lid"). Plant saucers and shallow plastic containers work well as cover objects (even a Frisbee will do). Hats and shirts can also work if no container is available, but they can be difficult to lift away without disturbing the herp. After a minute or so under a lid, most herps will calm down a bit, especially thigmotactic herps that prefer dark, enclosed spaces. If no lid is available, or if the herp won't calm down after several "lid sessions," you can try the "palm press" technique. Using one or both hands, the herp is gently pressed into the substrate and firmly held there for a minute or two. As you might expect, this technique can work especially well with fossorial snakes.

Sometimes when the cover is lifted, a nice pose is revealed, and cameras click away. Other times, the animal is in a less-than-photogenic pose; its head may be hidden, a leg or a toe may be in an odd position, or it may just not look natural and relaxed. When this happens, the wrangler can replace the lid and hope for a better result, or he or she can gently manipulate the animal into a better pose. Twigs, sticks, long tweezers, or small hooks can be used to gently lift a head or move a limb or tail.

left Plant saucers and jar lids used in the field as cover lids.

below The palm-press technique used on an eastern milksnake (*Lampropeltis triangulum*).

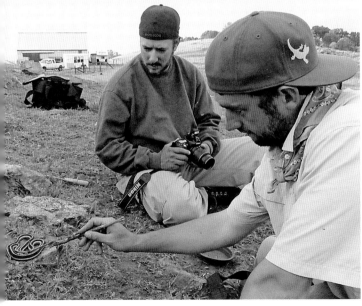

Using a twig to raise the chin of a valley gartersnake (*Thamnophis sirtalis fitchi*).

Shooting a sidewinder (*Crotalus cerastes*) in Arizona. The snake was photographed in place without any manipulation and then nudged off the road to safety with a snake hook.

Photographing Venomous Snakes

For venomous snakes, the best scenario is one where the snake can be photographed in situ or with minimal contact and handling. This is not always possible, and there may be times when hot snakes need to be manipulated with snake hooks into a posed position. Of course, your primary concerns should be the safety of the photographers, along with the well-being of the snake. The handling guidelines for venomous snakes outlined in chapter 4 also apply here.

A photo shoot with venomous snakes can be exciting, and it is easy to get caught up in the moment and not pay proper attention. Experienced field herpers have been bitten during photo sessions, either by getting too close, or from underestimating the reach of the snake. If you are alone, the risk of snakebite can be higher; along with manipulating and posing a snake, you also have to keep an eye on it while trying to use your camera. Keep a safe distance if you need to multitask. A group of herpers should use a designated wrangler to move the snake into position and remain ready to act if the snake moves. The wrangler stands ready with a hook and doesn't shoot photos until someone else takes over. The wrangler's other important duty is to make sure that photographers

AQUATIC HERP PHOTOGRAPHY

Aquatic herp photography is a small but growing genre of herp photography. There are a number of reasons for the increasing interest. Perhaps foremost is that many amphibians and reptiles are aquatic by nature, so a photographer who wants to show them in a natural setting must take to the water. Additionally, some species cannot survive being removed from the water (egg masses, tadpoles, etc.), and others (hellbenders, sea turtles, etc.) are protected by law, so shooting them in their element is essential.

Aquatic herp photography can add its own specific nuances not

American toads (*Anaxyrus americanus*) in amplexus on the bottom of a shallow creek.

present in terrestrial photography, and if done right, the results can be eye-catching. Buying a waterproof housing for a DSLR camera can be expensive, but there are many waterproof point-and-shoot cameras that take phenomenally good photos, and they often cost only a couple hundred dollars. You never know when you'll have an opportunity to take some aquatic shots, so be sure to bring your waterproof camera whenever you go herping.

A good way to get good aquatic shots of smaller species is to make a photography tank. For this purpose, 2.5- or 5-gallon aquariums work well, or you can make your own shallow enclosure from glass or acrylic. These setups allow you more control of your photography, while keeping gear relatively dry. Aquatic photography is still in its infancy, and there is no "how-to" instruction set, which means you have plenty of opportunity to be creative. [Josh]

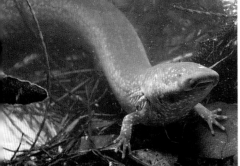

Using an aquatic photography tank to photograph a greater siren (*Siren lacertina*).

Photo shoot of a small rattlesnake in Sonora, Mexico. Note that the wrangler (orange cap) has a hook ready, should the snake attempt to move.

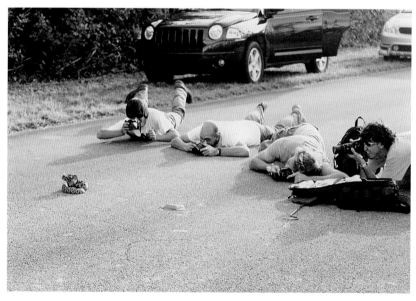

It's a good idea to have a wrangler when working with venomous snakes. When close to a road, the wrangler can also keep an eye out for passing vehicles.

stay a safe distance (including arms and hands) from the snake. While looking through your camera, you can lose perspective of the space around you, and you're unable to react quickly. Everyone in the group should understand what the wrangler's role is and take it seriously; if the wrangler tells you that you're too close, pay attention and move back.

Fortunately, many pit vipers can be coerced to coil up and pose without much manipulation, and cover lids can be used with small specimens; lift the lids off with long tweezers or a snake hook. As mentioned in chapter 4, coralsnakes can be flighty and unpredictable, and even small corals should be given plenty of space. Use cover lids whenever possible and remember that elapids do not have to strike in order to bite — they can bite from any position.

APPENDIX 1
HERP DISEASES TO KNOW

Although amphibians and reptiles have been succumbing to disease since time immemorial, a few diseases have, in recent history, become a cause for grave concern. One of them, *chytridiomycosis*, commonly known as chytrid, has caused a number of amphibian species to go entirely extinct. As humans, we should be concerned because these diseases are part of a one-two punch when combined with habitat destruction and other human-caused ailments, and at least one of these diseases (again, chytrid) has been readily spread around the globe by humans. This appendix will introduce you to the three most concerning herpetofaunal diseases in North America and offer some insight on helping contain and combat these diseases in your backyard.

Chytrid

What is it? Chytridiomycosis ("chytrid") is a disease caused by the fungus *Batrachochytrium dendrobatidis* (often abbreviated *Bd*), which can cause mortality in amphibians, especially frogs. It thrives in cooler temperatures, especially in perennially cool microhabitats like montane streams, and is responsible for devastating effects on many populations of many species. Chytrid is responsible for the extinction of numerous amphibian species worldwide. The fungus's most rapid growth occurs between sixty and seventy-five degrees Fahrenheit, but it cannot live in temperatures above approximately ninety-eight degrees F.

Bd spreads by microscopic spores in moist soils and waters; thus it is easily transported elsewhere on boots, nets, and other gear. It's always a good idea to

wash your boots and other gear when moving between sites (see sidebar on gear sanitation in chapter 6).

Where is it? *Bd* is present worldwide wherever amphibian populations occur but doesn't appear to be as common in Asia. Whether this is due to poor sampling by herpetologists, an invasion that is just getting started, fungus-resistant amphibians, or some other reason is not yet known.

Where did it come from? It appears as though *Bd* originated in African frog populations that were naturally resistant to *Bd* but were still carriers. In years past, African clawed frogs (*Xenopus* sp.) were common lab experimentation and pet animals worldwide, and they may be the biggest culprit in the spread of *Bd*.

How to identify it in the field It's impossible to know for sure if an amphibian has a chytrid infection without lab tests, and some animals exhibit no apparent signs of infection before death. Certain signs, however, do at times occur. They include shedding or discoloration of the skin (especially reddening) and odd behavior (including seizures). Once again, the only way to be sure is laboratory testing, as many of these symptoms are also caused by other amphibian diseases.

Who to contact if you see it It's best to take photographs (or collect dead specimens, if legal) and contact your state wildlife commission. Many states where *Bd* is known have monitoring programs in place that may be interested in your observations.

How it spreads *Bd* spreads by spores and may be dispersed by the environment (e.g., water movement), affixing to movable objects such as boots or bird legs, or by reservoir species that carry the disease without succumbing to it. Crayfish may act as an important reservoir species in many instances.

How to help prevent the spread On a basic level, use standard disinfection protocol (see sidebar, chapter 6) for any gear that contacts the water or mud when traveling between bodies of water. If you must collect/detain an amphibian (e.g., for later photos), store it in disposable, single-use containers such as plastic bags. Additionally, never use the same gear (e.g., nets, snake hooks) with captive herps and with herps in the wild, and never relocate any amphibian or reptile to a new area.

 In addition to personal changes in habit, you can also volunteer to help your state wildlife agency in surveying and swabbing amphibians for chytrid. You'll

be helping detect its presence, monitor the spread, and increase our understanding of the disease.

Ranavirus

What is it? Ranavirus is a virus that can cause death in frogs, salamanders, and some turtles and tortoises, mostly box turtles. In amphibians, ranavirus is most commonly found in larval forms (e.g., tadpoles), but it can also infect adults.

Where is it? Ranavirus has been observed throughout the continental United States, as well as other areas of North and South America, Australia, and Asia.

Where did it come from? Ranavirus probably originated in North America, as it was first detected there in 1965. It wasn't considered a problematic virus until the 1980s, when it began to affect some wild amphibian populations.

How to identify it in the field Ranavirus outbreaks can cause the sudden death of hundreds or thousands of amphibians in a single system, such as a stream or wetland, in just a couple of days. Usually individuals suffering a ranavirus infection will have red markings (hemorrhages) on their underbelly — especially in their groin region — and they may also behave abnormally and have swelling in the extremities. In turtles, signs of ranavirus include lethargy, swollen eyes, and white or yellow discoloration in the mouth.

Who to contact if you see it It's best to take photographs and contact your state wildlife commission, especially if you find a mass die-off of ten or more animals. Many states where ranavirus is known have monitoring programs in place that may be interested in your observations.

How to prevent the spread As with *Bd,* use standard disinfection protocol (chapter 6, gear sanitation sidebar) for any gear that contacts the water or mud when traveling between bodies of water. If you must collect/detain an amphibian (e.g., for later photos), store it in disposable, single-use containers such as plastic bags. Detaining box turtles with signs of ranavirus is not advised; take pictures in the field, and wash your hands afterward. Additionally, never use the same gear (e.g., nets, snake hooks) with captive herps and with herps in the wild, and never relocate any amphibian or reptile to a new area.

Some state wildlife agencies also have programs that monitor for ranavirus and may appreciate volunteer field help.

Snake Fungal Disease

What is it? Snake fungal disease (SFD) is a disease that infects the skin of snakes and is especially common in snakes that have recently emerged from hibernation. It is likely caused by the fungus *Ophidiomyces ophidiocola*, but it may also be caused by a combination of skin fungi. In some individuals, symptoms of an SFD infection may flare up in the cooler months during brumation and decline over the course of the spring and summer. Although it may have been present in the snake population for a long time, it has only recently become a commonly observed ailment.

Where is it? At this time, snake fungal disease is known only in the central and eastern United States.

Where did it come from? Unknown at this time. SFD may have always been resident in the snake population and only recently became apparent for some unknown reason. Study of snake fungal disease is still in its infancy.

How to identify it in the field Snake fungal disease is often associated with sores and lesions on a snake's scales and may include some premature signs of shedding, such as eye clouding. Snakes with SFD may look similar to captive snakes with bad water sores.

Who to contact if you see it It's best to take photographs (or collect dead specimens, if legal) and contact your state wildlife commission. Many states where SFD is known have monitoring programs in place that may be interested in your observations.

How to prevent the spread It is unknown how snake fungal disease is spread, but it is wise to use protocols akin to the ones used for *Bd* and ranavirus (see above). Because it targets snakes, it is a good idea to wash snake bags between uses.

Resources for More Information on Chytrid, Ranavirus, and Snake Fungal Disease

amphibianark.org/the-crisis/chytrid-fungus/

journals.plos.org/plosone/article?id=10.1371/journal.pone.0120237

ncbi.nlm.nih.gov/pmc/articles/PMC3323396/

nwhc.usgs.gov/disease_information/other_diseases/ranavirus.jsp

nwhc.usgs.gov/disease_information/other_diseases/snake_fungal_disease.jsp

phenomena.nationalgeographic.com/2012/12/18/fungus-bd-frog-crayfish
-chytrid/

PARKS AND OTHER PUBLIC LANDS
Ownership (and What You Can Do There)

Public lands undoubtedly provide some of the best options for recreational herping, due mostly to their ubiquity in North America (and to some extent worldwide) and for the fact that they are often established specifically for the conservation of wildlife and the public's enjoyment thereof. Often they are situated strategically to protect some important cultural or natural resource: historical sites such as battlefields or buildings, springs, shorelines, mountain ranges, rare habitats, or any other feature able to garner enough public and/or political support to be protected. Unfortunately, herping as a mainstream outdoor pursuit is a relatively recent development, and the regulations in place in many public areas typically do not consider the tactile, up-close nature of herping. Nonetheless, there are many interesting habitats and species to be encountered in such places, and herpers would be doing themselves a disservice to avoid them.

Public land can be managed by government on any level: locally by cities, townships, and counties; by states; or by the federal government. It is important to remember that though these lands are managed by differing governmental entities, they belong to the people. They exist for citizens to enjoy the benefits of biological diversity and being outdoors. The governments that manage them attempt (sometimes successfully) to run them in a manner that will ensure the most enjoyment for the most people, trying to avoid what is known as "the tragedy of the commons," that is, avoiding having the land exploited by some to the detriment of all. It is for this reason that destructive (or potentially destructive) activities such as development, mining, and logging are either strictly regulated

or forbidden. Sometimes rules and regulations designed to protect the area end up also precluding less harmful field herping activities, such as flipping cover and handling animals. Citizen-science projects (see chapter 8) can provide ways to enjoy herping in otherwise prohibited areas.

Locally Managed Parks and Natural Areas

Local parks are often the first natural areas we explore in our formative years, and they are often the places where many of us saw our first wild herp. Local parks are ubiquitous throughout the United States and the world and are just as likely to be found nestled within the city limits as in the boondocks. They are often the smallest parks, reflecting the budget and staffing capabilities of local municipalities. Despite their small size, it is a growing (and welcome) trend that local municipalities are increasingly acquiring areas of high conservation priority (i.e., rare habitats or areas with rare species) and also investing in the restoration of preexisting parks. For this reason, even small local parks can boast formidable diversity, abundance, and quality of herp finds. This is especially true for amphibians: because many species don't have large home ranges, a small, local park can do much by protecting important habitat such as breeding wetlands.

Local parks are typically more open to allowing herpers to look under cover objects and handle amphibians and reptiles, although the rules and regulations can vary from place to place. This variability also makes it difficult to define the types of local parks, and as such it is best to do one's research ahead of time to maximize herping potential. Types of locally managed natural areas often include city parks, municipal water supplies, mitigation banks, and nature preserves/nature centers.

State-Managed Parks and Natural Areas

State-managed lands are, predictably, vaster than locally managed lands and often smaller than federal lands. Because of the resources and clout of state governments, state-managed lands are often strategically placed, and land may be acquired to maximize wildlife corridors for larger and more transient species. Such lands often have their own biologists to help determine the species that occur there and how best to manage them; this can be helpful for a herper who is new to an area, as the agency managing state-owned lands will often make

its own species lists or management plans available. Management plans are a particularly valuable resource as they often contain maps, species lists, habitat descriptions, and other useful information for finding herpetofauna. Such reports can be obtained by contacting the parks or by doing an Internet search of "management plan for [name of state-managed land area]."

State-managed lands are often (but not always) managed by state wildlife agencies or park services and may include state parks, wildlife management areas, and state forests. Each different area designation will have its own set of regulations in each state — state forests, for example, typically do not regulate herping activities but instead protect the flora, whereas state parks are usually hands-off areas for herps and other wildlife.

Federally Managed Parks and Natural Areas

Most of the information on federally managed lands comes from the respective agencies' websites as well as the authors' personal experiences. Federally managed lands are often the largest and most iconic of places to explore and herp — think Everglades National Park, Grand Canyon National Park, and Yellowstone. Due to their popularity, these lands are the easiest to find good information about online. Four federal organizations together manage the largest swaths of land in the United States: the National Park Service (NPS), the U.S. Forest Service (USFS), the U.S. Fish and Wildlife Service (USFWS), and the Bureau of Land Management (BLM) in the western United States. Each agency was established for differing reasons, each has differing goals, and each establishes acceptable uses for the public lands it oversees.

The National Park Service The NPS manages approximately 84 million acres throughout the United States and its territories and exists to preserve and maintain special places for the enjoyment of the American people. Known mainly for its stunning national parks, the NPS also manages other lands such as national battlefields, historical parks, lakeshores, memorials, parkways, preserves, scenic trails, and wild and scenic rivers. By and large, invasive methods of herping such as flipping cover objects and handling and collecting herpetofauna are not permitted, but they may be permissible in areas such as national preserves. National parks are often open at all hours, making nighttime herping possible. It should be noted that although observing herpetofauna is legally per-

missible, some NPS law enforcement officers might discourage even noninvasive herping methods such as road cruising.

The U.S. Forest Service The USFS manages 154 national forests and 20 national grasslands — together some 193 million acres. Unlike the National Park Service, whose lands are typically for recreation, the USFS strives to manages its lands for sustainable use; on these lands certain amounts of logging and other natural-resource gathering are allowed. As such, they also have some of the most relaxed herping regulations, except for some areas that have other special designations. A classic example is Snake Road in southern Illinois, which although it is located within Shawnee National Forest, is also a part of the La Rue–Pine Hills Research Natural Area. This designation protects all flora and fauna from collecting, destruction, or harassment. Regulations in national forests/grasslands typically protect the plant life, but under normal circumstances, no herpetofauna regulations above and beyond normal state and federal laws are enforced. Most national forest roads are open all hours, making nighttime herping possible.

The U.S. Fish and Wildlife Service The USFWS is responsible for managing the national wildlife refuge (NWR) system, which consists of approximately 560 refuges, encompassing 150 million acres. The NWR system exists for multiple recreational purposes, including hunting, fishing, birding, and photography, and is somewhat friendly to typical herping methods. However, regulations vary highly between refuges, including rules on flipping cover objects, hours of operation, and handling. As such it is best to research each refuge individually prior to an outing.

The Bureau of Land Management The BLM manages more land than any other agency in the United States, an impressive 245 million acres, though you may not be aware of this if you haven't traveled across the western United States, where the majority of its land is located. BLM land is perhaps the friendliest federal land for herpers and generally does not carry the burden of additional regulations other than typical state/federal laws.

APPENDIX 3
KINDS OF AQUATIC TRAPS

Many different types of aquatic traps can be effectively used for herps. Each will have benefits for capturing different species. Some of the tried-and-true varieties are described below.

Collapsible Crayfish Traps

Collapsible crayfish traps such as the Promar TR-503 are perhaps the best traps to use for a wide variety of species. They have two primary advantages. First, they can be placed in water nearly a foot in depth, which is an excellent depth range for most herps that forage in the vegetated zone on the edges of deeper bodies of water. For deeper water, these traps are usually light enough to float when one or two twenty-ounce soda bottles are placed inside. The second advantage is that these traps have a large and self-sealing funnel, which *significantly* reduces escape rates. Escaping can be a large problem with most other trap types — Josh has conducted experiments finding a greater than 90 percent escape rate with some species after twelve hours in pyramid and minnow traps. One potential disadvantage with these types of traps is that because they are made of nonrigid netting, some smaller snakes may get stuck in the strings. Having individuals actually get stuck to the point of dying is rare, provided the traps are checked daily, and newer models are now available from online retailers such as Amazon.com that are made out of much smaller mesh. Collapsible crayfish traps are efficient at trapping most snakes, including large-bodied snakes such as cottonmouths (be careful!), as well as large salamanders like sirens and amphiumas and some smaller turtles.

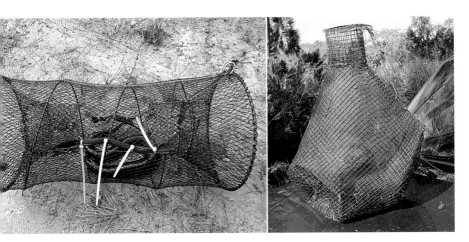

left Collapsible crayfish trap.

right Pyramid crayfish trap.

Pyramid Crayfish Traps

Unfortunately, pyramid crayfish traps aren't readily available for purchase from any vendors, but they are relatively simple to construct from chicken wire lined with screen of the desired size to retain small species. Pyramid traps have the benefit of being tall (ca. 2.5 feet), which allows them to be placed in much deeper water than typically possible with unfloated traps. Pyramid traps are excellent for catching bottom-traveling species such as sirens, amphiumas, and kinosternids (mud and musk turtles).

Wire or Plastic Minnow Traps

Although they aren't the best traps to use for many herps, wire or plastic minnow traps are the most widely used, primarily because they are cheap and readily available, and they stack to allow for easy transport. They suffer from the disadvantages of having a relatively small funnel entrance (though the reader *might* be surprised at how large a snake can fit in these traps!) and being so small that they can't be placed in water deeper than about ten inches without having some sort of float (PVC insulation or pool noodles work the best, but soda bottles will suffice too). Some wire minnow traps (especially the Gee's G40 trap) can be modified to allow a larger trap opening by forcing a beer bottle into the funnel to open up the entry choke point.

120 G40 traps ready to catch some herps for Josh's thesis work.

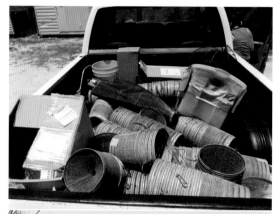

Although it has cover boards as placeholders only until water levels rise, a drift fence combined with funnel traps can vastly improve trapping efficiency.

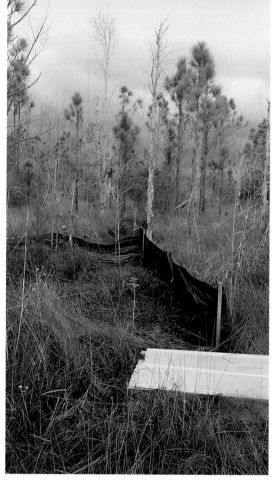

Drift Fence Funnel Traps

For those interested in getting good survey data for citizen-science programs, drift fences with funnel traps are extremely helpful. Drift fences are typically made of either erosion fencing of the type used on construction sites or metal flashing for more permanent arrays. Funnel traps can be made from window screen. For aquatic usage, it is often helpful to prop up the inner part of the trap with a bent coat hanger to allow traps to be set in deeper water.

——

A NOTE ON BAITS IN AQUATIC TRAPS: Aquatic trapping for herps typically does not entail baiting, as traps will "self-bait" very quickly with fish, tadpoles, and other prey items. Using outside bait is generally not encouraged because of the risk of spreading disease and the heightened risk of a trap being raided by a scavenger (raccoons, alligators, etc.). In some situations, though, "light baiting" with glow sticks may be useful, especially for salamanders.

PLACES OF PILGRIMAGE
World Hot Spots for Herping

One of the many things we hope you'll get out of this book is the knowledge that, chances are, a dazzling array of amphibians and reptiles can be found close to where you live. Your own backyard (figuratively speaking) can be a wonderful place to herp, which leads to the logical conclusion that lots of other people's backyards can also be wonderful places to herp. Here are some places of pilgrimage — herping hot spots, some famous and well known, others off the beaten path — for your consideration. If your backyard is actually close to any of these places, count yourself lucky!

Everglades National Park

Mention the Everglades to people, and ask them to name the first thing that comes to their mind. Chances are it is things like snakes or alligators — maybe even "giant killer pythons," if they've read the news. Everglades National Park, or ENP, is deserving of most of its hype: it is a wonderland for herpers, so much so that if one goes between the months of June and September, the only other people you're likely to see during an evening road-cruise are, indeed, other herpers. Although it can be herped at any time of year, the best times are between April and October, when temperatures are high enough to keep most of the snakes moving in the evening hours. During these times, it is not altogether uncommon for an evening road cruise to turn up a dozen or more species of snake on the main park road. Along with native lizards that can be seen in

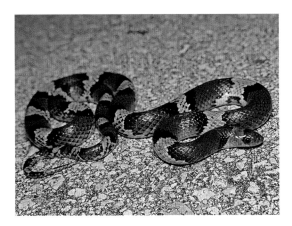

A scarlet snake on the main park road in Everglades National Park at night.

the park and surrounding areas, exotic and introduced anoles, iguanas, tegus, and chameleons all call the towns and city parks outside ENP home. Frogs and toads are present in the park, but you won't find as many species as you will in surrounding areas of southern Florida that have more fishless wetlands. In ENP you can expect to see southern toads (*Anaxyrus terrestris*), pig frogs (*Lithobates grylio*), southern leopard frogs (*Lithobates sphenocephalus*), and farther south in the mangroves, Cuban treefrogs (*Osteopilus septentrionalis*). Alligators are abundant throughout the park, especially in the public boardwalk areas, including Royal Palm. The magnificent American crocodile can be found in the southern mangroves along with other mangrove-dwelling herps, like mangrove saltmarsh snakes (*Nerodia clarkii compressicauda*), scarlet snakes (*Cemophora coccinea*), and pygmy rattlesnakes (*Sistrurus miliarius*).

———

NOTE: Everglades National Park protects all wildlife within its borders, from panthers to diamondbacks to the invasive pythons. Don't bring hooks into the park, and don't touch any animal you see — just look and enjoy! [*Josh*]

Snake Road

So many factors come together to make Snake Road one of the premiere field herping spots in North America. First is its general location: it lies in southern Illinois, where a number of biophysical provinces (and the species inhabiting them) meet and mingle — the southern coastal plain, eastern forests, the Ozark

plateau from the west, and prairies and glacial till plains from the north. Second is its specific location: Snake Road runs along the base of the Shawnee Escarpment, a series of limestone bluffs rising several hundred feet. The bluffs lie to the east, and bottomland swamp stretches away to the west, toward the Mississippi River. In the fall, herps emerge from the swamps and head for winter dens up in the bluff; they have to cross Snake Road to reach their winter dens, making it the perfect stage for field herpers to witness this annual migration. In the spring, the process is reversed, as herps leave their dens and head back to the swamps, but the return trip is not as concentrated as the fall migration. In spring and fall, the rough gravel road is closed to vehicles to protect the migrating animals, but herpers can hike up and down the 2.5 mile road; on a good weekend in October, with some afternoon sun, it's possible to see several dozen species of herps or more, including a pit viper trifecta — copperheads, cottonmouths, and timber rattlesnakes. Cottonmouths are by far the most numerous venomous snake, and often, the most numerous snake of them all.

Geopolitical boundaries also shape Snake Road. Lying on the western edge of the Shawnee National Forest, the road runs through the La Rue–Pine Hills Research Natural Area. The designation as a research natural area provides protection for all the flora and fauna there; no collection, detention, or harassment of any plants and animals is allowed. No hooks, tongs, bags, or other collecting tools or containers are allowed, and law enforcement vigorously enforces these rules.

The north gate at Snake Road.

This Yonahlossee salamander (*Plethodon yonahlossee*) emerges from its burrow to forage. The southern Appalachians are the world's salamander diversity hot spot.

The best time for visiting Snake Road is a six-week window in the fall, starting in late September and running through October, weather depending. On October weekends, the road is often crowded with herpers, but generally there are fewer people there during the week. Snake Road is a great place for new herpers to see a lot of herps and to meet a lot of field herpers as well — perhaps we'll meet on the road sometime! [*Mike*]

The Southern Appalachians

Salamanders don't always get a lot of respect from the more snake-centric field herpers, but they are a diverse and unique group and are gaining recognition from the field herping community as a whole. Although salamanders can be found throughout North America, no place offers a more diverse species set than the southern Appalachians — from Virginia southwest to Alabama. The southern Appalachians (SAPPs) have at least seventy species of salamander by the most conservative taxonomic estimates. In addition to high diversity, there is also an abundance — the moist forests of the SAPPs are literally crawling with them, and night hikes can yield over one hundred salamanders during the spring and fall. Often the problem with many species-diverse parts of the country is access, but that is not a problem in the SAPPs. They are the cradle of forestry, and as such there are millions of acres of undeveloped montane habitat, permanently protected from development and easily herp-able. Finding a place to

herp in the mountains is as easy as looking up the range of the species you want in a field guide and finding a nice, public hiking trail there — the cool nights are typically when the salamanders come out to forage, and a wet night can yield a lot of good finds. For daytime herping, you can flip rocks for salamanders, and exposed cliff faces can be searched for basking snakes. The SAPPs are home to such herpetofaunal legends as eastern hellbenders (*Cryptobranchus alleganiensis alleganiensis*), spring salamanders (*Gyrinophilus porphyriticus*), Yonahlossee salamanders (*Plethodon yonahlossee*), and timber rattlesnakes (*Crotalus horridus*). The high elevation also allows some northern species such as the wood frog (*Lithobates sylvaticus*) to venture into the heart of the South.

———

NOTE: Strict sanitation of clothing, gear, and skin should be practiced. For a big chunk of North America's population, the southern Appalachians are less than a twelve-hour drive. What are you waiting for? [*Josh*]

Mexico

Mexico gets a lot of bad press, and herpers watch the news and think, "I'm not going herping there!" I'm here to tell you that you should go herping in Mexico, and soon. Sure, there are dangerous places in Mexico, but there are dangerous places in the United States as well. I recommend two places in particular, and both are peninsulas: Baja Sur and the Yucatán. Both places are safe, both have good roads and good food, and both offer an awesome array of herps that will blow your hair back. Late August is a good time to visit Baja Sur, and the Yucatán is good in late June or early July. For both destinations, you fly into tourist hot spots (Cabo San Lucas and Cancún) that usually have good deals on flights and rental cars. But you don't want to hang around the tourist towns — get in your rental car and head for the interior! You can chase lizards (plenty of species) during the day, but road cruising lets you really strike gold in Baja Sur and the Yucatán. In Baja Sur, you can stay in San Jose del Cabo (where the airport is located) and cruise the roads in that area (the airport bypass toll road can be very productive), or you can drive up north of La Paz to the small towns along the eastern coast, where the road cruising is also excellent. Some nice snakes from Baja Sur include Mexican rosy boas (*Lichanura trivirgata trivirgata*), Baja ratsnakes (*Bogertophis rosaliae*), Baja rattlesnakes (*Crotalus enyo*), and Cape gophersnakes (*Pituophis vertebralis*).

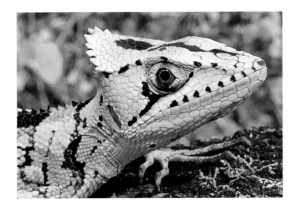
The amazing *Laemanctus
serratus* from the Yucatán
Peninsula.

Mayan ruins are scattered all over the Yucatán Peninsula, and the nearby towns cater to tourists, providing you with many options for places to stay. Don't miss out on playing tourist while you're there; the ruins, both the developed ones and those left alone in the forest, are awesome. Rainy roads at night can be very productive for both amphibians and reptiles. Look for casque-headed treefrogs (*Triprion petastatus*) and Mexican treefrogs (*Smilisca baudinii*) on wet roads. Cool lizards include black spiny-tailed iguanas (*Ctenosaura similis*), which are everywhere (they're all over the ruins at Chichen Itza), and casque-headed lizards (*Laemanctus serratus*). There are too many cool snakes to mention more than a few: cantils (*Agkistrodon russeolus*), the forest cat-eye (*Leptodeira frenatus*), tropical ratsnakes (*Pseudelaphe flavirufa*), and the Tzabcan rattlesnake (*Crotalus tzabcan*).

I've just given you permission to go herping in Mexico — what are you waiting for? [*Mike*]

Costa Rica

Costa Rica is a true gem for field herping. Not only is it home to a whole host of creeping things (and flying, walking, and swimming things, if you're into non-herps!), but the nation itself is one of the world's frontrunners in conservation, and it uses ecotourism to turn that conservation into a sustainable economic model. It means that visiting Costa Rica and doing some field herping contributes to conservation of a richly diverse set of wildlife. Costa Rica may be small, but its opportunities for herping are manifold: because of its mountainous geography, it's possible to herp cool, high-elevation forests, tropical lowlands,

and even dryer grassland habitat. Hike the lowland forests anywhere, and you'll have a good chance of turning up the impressive and venomous terciopelo (*Bothrops asper*), dart frogs of many colors, and countless other beauties. There are many eco-lodges, biological field stations, and national parks, from near San Jose (the country's capital) to places far away from roads and cars, at Tortuguero on the Gulf Coast. Tortuguero is a place that provides viewing opportunities for four species of sea turtle, including the endangered green sea turtle (*Chelonia mydas*). [*Josh*]

Arizona

It's amusing to hear old-timers complaining about all the "noob" herpers who flock to Arizona during the summer monsoon season. At some point in the past, they made their own first run at what is arguably one of the greatest places in the world for field herping. Arizona has it all: more than a dozen biotic communities, mountains, deserts, and 132 species of amazing amphibians and reptiles from one end of the state to the other. Arizona can wear you out — you can spend your days hiking in desert canyons or up in sky island mountain ranges and then road-cruise far into the night. Gila monsters are a big draw, as are thirteen species of rattlesnakes. The monsoon rains also kick off the breeding season for desert amphibians. Most herpers coming out for the first time will focus their attention on the southeastern portion of the state, which features mountain ranges like the Chiricahuas and the Huachucas. There's so much to see and so much to do that you'll likely need to make several trips. [*Mike*]

The Paraguayan Chaco

The Paraguayan Chaco is probably the least well known of our places of pilgrimage, but in terms of herp and general wildlife viewing diversity, it deserves its place. Paraguay is one of only two landlocked nations in South America, a small country with a small population — most of which live in the southeastern side of the country or in the capital, Asunción. A small portion of the population lives on the northwestern side of the Rio Paraguay, which divides the country in half. It is here, in Paraguay's portion of the Gran Chaco ecosystem, where things get really interesting. The Chaco grades upward from a swampy matrix reminiscent of south-central Florida, to steadily drier and drier thornscrub habitat. Like any overwhelmingly dry habitat, the adaptations among the herpetofauna are varied

and dazzling. Frogs and toads must either cling to the widely spaced bodies of water or take shelter in subterranean haunts until the rains come. The latter is a tactic used by a number of species of horned frogs (family Ceratophyridac, also called Pacman frogs). Other interesting herp adaptations include the paradox frog (*Pseudis platensis*), a species whose tadpole stage is often twice as large as its adult stage — while most organisms grow up, paradox frogs grow down! On the snake front, several species of lancehead (*Bothrops* spp.) and neotropical rattlesnakes (*Crotalus durissus terrificus*) reign as the venomous cohort, but other exciting potentials include anacondas, an interesting phase of the Argentine boa (*Boa constrictor occidentalis*), and even cribos (*Drymarchon corais*). In addition to the herp life, the diversity of other animals is high, and some of the megafauna typically associated with rainforests are both common and, because of the less dense vegetation, more easily viewable in the thornscrub. It is not altogether uncommon to see jaguars and pumas in the more remote parts of the Chaco. [Josh]

The Peruvian Amazon

Disclaimer: I spend a couple weeks every year in the Peruvian Amazon, serving as a herp wildlife guide for a nonprofit eco-tour outfit. I don't want to turn this into a commercial, so I'll just say that this gig is a great excuse for me to visit

A seven-foot cribo (*Drymarchon corais*) found at a field station near Iquitos, Peru.

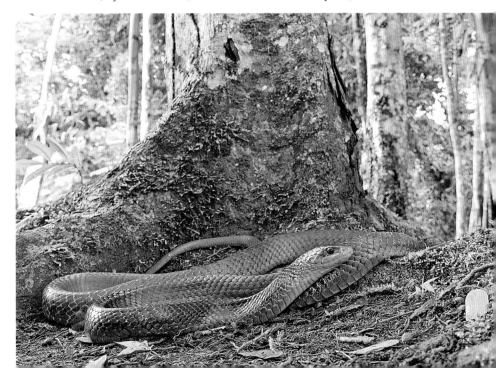

Peru every year. There are a number of tour companies that can put together a great herping trip for you, so I urge you to consider a trip to Amazonia sometime. If you've never been to the tropics, every plant, every animal, *everything* you see will be a new experience for you; the sheer number of herps, birds, and other wildlife can be amazing and at times overwhelming. Over the years, I've been able to see around 160 different species of amphibians and reptiles in just one region, from thumbnail-sized poison frogs to the bushmaster, the largest venomous snake in the Western Hemisphere. Of course, the Amazon River itself shouldn't be missed — be sure to book a tour that spends some time on the greatest of rivers. The river city of Iquitos, only reachable by plane or by boat, is where many tours start. I had wanted to see the Amazon since I was in middle school, and it took me way too long to get my feet wet — don't wait as long as I did! [*Mike*]

APPENDIX 5
HERP EDUCATION

Perhaps one of the most wide-reaching impacts you can have for herp conservation is being a herp educator. This can be as structured or unstructured as you prefer: nearly all herpers will informally tell family and friends about the beauty and benefits of snakes that they find in their backyards, and some go to the level of speaking at school assemblies and giving other educational talks to large groups, exposing them to snakes, frogs, salamanders, and the like. Both activities are beneficial — nearly anyone who has a love of snakes and talks about it will have personal anecdotes about someone near to him or her who no longer kills every snake because of the herper's passion and education. This adds up, and one herper can make a big difference just by informal teaching moments.

Often you don't need to work from the ground up if you'd like to go beyond one-on-one educational moments. Local herpetological societies often have outreach programs to bring the love of herps to the community and often need volunteers to show off animals. Zoos often have a more structured volunteer or docent system where you may need to undergo certain training, but when that occurs you will typically get a chance to work with a wide variety of exciting herpetofaunal species and will also be exposed to a wide audience of visitors who are eager to learn about reptiles and amphibians. We've asked our friend Marissa Dubina, who works as a full-time herp educator, to give us some insights into what she does.

HERP EDUCATION

"Snake!"

A little boy shrieks, and his mom covers their faces from fright, but I notice their fingers parting enough for their eyes to peer through at the legless reptile.

Reptiles mesmerize humans. Snakes, lizards, crocodilians, and dinosaurs have been the fodder of legends for millennia. Due to this innate intrigue, you, as a herper, have a powerful position because people will ask you to solve the reptile problems they encounter! I turned this type of education into a career. As a herpetology presenter, I'm going to give you some insights from my line of work to help you, whether it becomes your full-time occupation or you are the local "snake expert."

My ambition is to educate, entertain, and inspire people to enjoy nature, and this is reflected in my presentation style. For instance, I choose not to use sensational scare tactics in order to gain an audience; doing so would only widen the divide between people and snakes. Goals are important when educating, so decide ahead of time what you want the audience to come away with. To help you learn how to do this effectively, consider seeking out an experienced mentor who can help guide you. When I was a kid, I developed an animal show based on the style of Steve Irwin (the Crocodile Hunter). When I was a teen, I met my mentor, Christopher Carmichael, who gave me most of my experience with live reptiles. Both Steven Irwin and Dr. Carmichael used similar techniques:

1. Passionate, theatrical enthusiasm
2. Interesting information
3. Hands-on experiences, and
4. Kindness toward both people and animals

Let's delve into these areas.

1 Passionate, Theatrical Enthusiasm

A dynamic presentation is essential. While the animal doesn't need *you* to make it an amazing creature — it already is — you have the honor of helping others better view its splendor. Move around, look people in the eyes, and have purposeful hand gestures. While watching Steve Irwin, I was so entertained and enthralled that I ended up learning without realizing it. You don't have to have the most exotic animals; the herps found in your backyard will be intriguing and wonderful for your audience. There is not a creature on this planet that is not absolutely stunning.

2 Interesting Information

Do you want people sitting on the edge of their seats and sharing their knowledge with others? If so, then share didactic stories that seek to provide information while entertaining — humans love learning through story form! Fun facts are important, but remember that short and succinct is often best.

Josh and Tom Chesnes take time to talk to environmental science students visiting Everglades National Park about their work with mangrove saltmarsh snakes.

3 Hands-On Experiences

As herp educators, we sometimes need to shut up and let people learn on their *own*! Touching and observing inspire lifelong discovery! You can explain serpentine locomotion all you want, but when you put terms and chalkboards aside, people will learn best by watching the snake slither on the grass or carpet. Before allowing people to touch the animals, I explain a few rules. First, I instruct them not to touch the head. Often, I will tell the kids, "Hey, if you just met a person for the first time, would you touch him in the face!? No . . . umm, that would be awkward; let's not be awwwkward!"

4 Kindness toward Both People and Animals

When presenting to an audience, be sure to maintain control of the group, while still being loving toward each person. If you don't have time to listen to children's stories, you may want to encourage them to only ask questions. Drawing this distinction is actually a form of being kind — you're being kind to the whole audience and not just to one individual. Set the audience at ease, showing that you are in control, while still being very caring and nurturing toward them as well as the animals.

Final Thoughts

May the passion, knowledge, kindness, and experiences you provide others help those around you gain just a little more appreciation of the nature that surrounds them! There are beautiful animals in our own neighborhoods. Perhaps your interaction with others will spark in them a lifelong shift in thinking, so that they will better appreciate what's around them and approach it with respect, love, and passion. May you experience as much fulfillment as I have, as you observe the eyes of those around you widen in ignited, well-informed passion! Thank YOU for being a reptile-human relationship advocate!

[Marissa Dubina]

APPENDIX 6
A PERSPECTIVE ON THE HISTORY OF FIELD HERPING

Mike Pingleton

The year 2018 marks my forty-sixth year as a field herper, which places my start in the middle of the era when field herping developed into a recreational activity. My education and experiences in the field have been informed by those who came before me, but at the same time, I've witnessed many changes since I flipped my first *Storeria dekayi* in 1972. Few of us can recognize history as it happens and change as it unfolds, but we always have the opportunity to look back and try to understand what happened and why.

It is safe to say that there have always been people interested in amphibians and reptiles, but only in the last hundred years or so has field herping developed as a pastime, something done for sheer enjoyment. When science emerged as a fully formed discipline, and natural history came under its wing, herps were part of the living world to be collected, studied, and classified. Prior to the twentieth century, they were pursued by the likes of "gentlemen of means," poor country parsons with time on their hands, and collectors employed by museums and zoos, although herps were rarely their sole focus. Many other people who might have had an interest were too busy raising families and scratching out a living.

Field herping is often compared to bird-watching, and one more thing they share are similar origin stories. The Industrial Revolution brought change to parts of the world, including the gift of leisure time. A growing segment of the working class now had days off from work, and they were free to pursue their

A FIELD BOOK OF
North American
SNAKES

The First Practical, Illustrated Handbook for the Identification of North
American Snakes. Equally Valuable to the Amateur and Herpetologist.

RAYMOND L. DITMARS
Curator of Mammals and Reptiles at the New York Zoological Park.

own interests, including outdoor activities like fishing, hunting, birding, and herping. Among these was a young Raymond Ditmars, who worked as an assistant in the entomology department at the American Museum of Natural History in New York. In his spare time, Ditmars studied amphibians and reptiles and amassed a personal herp collection that included local and exotic species. Bright and ambitious, he was hired in 1899 as assistant curator of reptiles for the newly constructed Bronx Zoo, and his home collection jump-started the zoo's reptile house. As he grew the zoo's collection and continued his study of amphibians and reptiles, Ditmars engaged in other pursuits that would help lay the foundations of field herping.

Ditmars had spent time working as a reporter and was media savvy; he made sure that zoo animals and his own exploits as New York's "snake man" received regular attention in the press. He learned to use cameras, and along with still photography, he made motion pictures that featured herps and other zoo animals. At the same time, he began writing books; *The Reptile Book* was published in 1907, *Reptiles of the World* in 1910, and he continued to write and publish for the rest of his life. Intended for the general public, his books were very popular and filled with his own photographs, along with vignettes about some of his personal experiences with herps. These days, Ditmars is sometimes dismissed as some old-timey guy who wore funny clothes, but he was a master of social media in his day, and he got the general public interested in herps and other animals. He was also the first herper to write about his exploits and to take pictures in the field; his books were an inspiration to first-generation field herpers, and others long afterward. Published in 1932, Ditmars's *Thrills of a Naturalist's Quest* includes stories from his early days; 1935's *Snake Hunter's Holiday* (coauthored with William Bridges) details a trip to Trinidad, and features vampire bats as well as herps. Both are considered classic works in field herping literature.

Ditmars was not alone in his efforts; accounts of nature and adventure travel were popular subjects, and information and resources concerning herps and other wildlife continued to flow to a receptive general public. Through the early decades of the twentieth century, zoos sprang up in many major cities, museums continued to add to their collections, and biology and ecology (and by exten-

sion, herpetology) became established fields of study at many universities. The Boy Scouts of America established a Reptile merit badge in 1923, and replaced it with a Reptile Study badge in 1927 (as of 1993, the Reptile and Amphibian Study badge). Books continued to be an important source of information and a force for inspiration. Public libraries became widespread and put books in the hands of many who couldn't afford to own them, enabling many a wide-eyed kid to read Ditmars and other authors. Mary C. Dickerson's *Frog Book* (1906) explored the life histories of common North American frogs and toads. Serpents were featured in Clifford H. Pope's *Snakes Alive and How They Live* (1937) and Percy A. Morris's *Boy's Book of Snakes* (1948). Field guides began to make an appearance, such as Karl P. Schmidt and D. Dwight Davis's *Field Book of Snakes of the United States and Canada* (1941), which included enough technical information to make it useful for laypeople and scientists alike.

This age of herpetological enlightenment enabled people from all walks of life to observe and appreciate herps. They could go out in the field and catch herps, learn their identities, and take them home if they wished. Herp husbandry was in its infancy, but the lack of knowledge didn't stop people from collecting anything that caught their eye. However, herp social networks developed at a snail's pace; communication was slow, and there were few channels. It could take a while to find other field herpers, and much correspondence was by letter.

After World War II, herpetological societies began to spring up across North America, usually in large cities and often in association with zoos or museums. Herp societies attracted field herpers like moths to a porch light; at monthly meetings, they could make friends, share information, and best of all, find someone to go herping with. For younger people who didn't experience those times, it can be hard to understand just how important herp societies were. In those days you might know only a handful of other herpers, and usually your nonherper friends and family couldn't understand your interest in "those slimy things." For one night every month, it was great to hang around with people who thought you were perfectly normal; small wonder that tight bonds were formed, and lifetime friendships flowered.

The postwar period saw the increased popularity of field guides. In 1958, Roger Conant's *Field Guide to Reptiles and Amphibians of Eastern North America* was published as part of the Peterson Field Guide series, and in 1966, Peterson released *A Field Guide to Western Reptiles and Amphibians* by Robert C. Stebbins. These books were of exceptional quality, and if you owned both of them, you could reasonably identify every herp found in the United States, Canada,

and northernmost Mexico. There have been subsequent editions of these field guides to accommodate new species, range extensions, and taxonomic changes, and they continue to be a valuable resource for field herpers.

In 1957, a year before Conant's field guide was released, *Snakes and Snake Hunting* was published. Carl Kauffeld was the curator of reptiles at the Staten Island Zoo, and he drew from his own past to put together a collection that was part memoir, part natural-history lesson, and all herping adventure. Kauffeld was an all-around naturalist as well as a herpetologist; his passion and fascination shine clear amid his elegant prose, and sixty years later, herpers are still fascinated with this book. All praise aside, the most significant thing about *Snakes and Snake Hunting* is that Kauffeld told readers exactly where he herped. He named names, he named locations, and anyone with a snake hook and gas money could go check them out. Many did, and as you might expect, some places were overcollected, habitat was trampled, and private property wasn't respected. Later in life, Kauffeld expressed regret for revealing so much, but in all fairness, he likely had no inkling of the impact *Snakes and Snake Hunting* would have or how many people were eager for snakes and snake adventures. All negatives aside, with *Snakes and Snake Hunting*, Kauffeld made a huge gift to field herping: he gave people *permission*. Sometimes people need a little nudge to realize their abilities. Given time and money, anyone could go where Kauffeld went and see the things he saw, and they could go to other places and find their own herping spots. They could plan herping vacations. A new generation of field herpers gassed up their cars and hit the road.

Books continued to serve as sources for inspiration and information. In 1969, Kauffeld's *Snakes: The Keeper and the Kept* was published. A portion of the book addressed snake husbandry; more people were attempting to keep and breed snakes and other herps in captivity, and Kauffeld's vast zoo experience was put to good use. For many, *The Keeper and the Kept* was an introduction to snake keeping. A precious 120 pages were devoted to field herping, but the stories and locations were fresh and exciting. Kauffeld was a bit more circumspect with regard to some locales, but there was enough juicy in-

formation to send herpers in search of road maps and atlases. In 1988, *In Search of Reptiles and Amphibians* by Richard M. Bartlett was published. Bartlett had been writing brief accounts of his field adventures for *Notes from NOAH*, the newsletter for the Northern Ohio Association of Herpetologists. *In Search of Reptiles and Amphibians* was a collection of those accounts, which included herping spots from coast to coast and down into Mexico. Like Kauffeld, Bartlett was a naturalist who conveyed his excitement and passion to the printed page. His book was a new source of inspiration for field herpers, and in a snake-centric culture, his inclusion of all kinds of herps was a breath of fresh air. Along with his wife, Patti, Bartlett wrote prolifically, publishing a number of state and regional field guides, captive care books, and magazine articles featuring his herp adventures.

For decades, collecting was a large part of field herping, and there was no real line between field herpers and people keeping herps in captivity. Many people engaged in both activities; herp societies catered to both interests, as did emerging magazines such as *Reptile & Amphibian, Reptilian, Vivarium,* and *Reptiles Magazine.* Herpers and keepers attended the same shows, conferences, and symposia. This began to change in the last decade of the twentieth century, as field herping and herpetoculture (a term coined by the late Tom Huff of the Reptile Breeding Foundation) both grew in popularity and began to develop their own identities.

Beginning in the 1990s, a number of interrelated factors (many of them new technologies, with an impact on a global scale) brought sweeping change to field herping. First and foremost, the globalization of the Internet via the World Wide Web opened a brand-new communications channel. The first web pages featuring herps appeared in 1994, the first herp life lists appeared in 1996, and a fair number of herp-related discussion forums sprang up in those first few years. This broad channel made it easy for people to come together and share interests, and also for people to insulate themselves from others, which contributed to the divergence of field herpers and herpetoculturists.

Another factor was the emergence and rapid improvement of digital cameras. It was a tedious process to digitize and upload photographic prints to the Internet, and the process didn't scale well. Digital photos were free of the time

delays of film processing, and once uploaded, they could be shared with anyone who cared to look and for indefinite periods of time. It became possible to photograph a herp in the field, upload the image, and then share it on a web site or a forum, all on the same day. As time passed, the process became even shorter, and two decades later we share pictures and video from the field in real time and think nothing of it.

The transformation of the cellular telephone into a mobile device with an Internet connection also had an impact. Cameras, GPS, and a full suite of apps have allowed herpers to share photos and to record locations and track movement. Apps like eBird, iNaturalist, and HerpMapper have turned phones into useful tools for collecting wildlife observations in the field as they happen.

The 1990s also saw a proliferation of wildlife shows on television. David Attenborough's acclaimed Life series (beginning with *Life on Earth* in 1979) lovingly documented plants and animals and was broadcast repeatedly by public television and channels like Animal Planet. National Geographic soon followed suit with a set of nature-related programs. Herp-centric programming of this era included *The Crocodile Hunter* with Steve Irwin (1996), *Going Wild with Jeff Corwin* (1997), and *O'Shea's Big Adventure* (1999).

Much has been said and written about the merits and flaws of these television shows, but they had an undeniable impact on young audiences. Herps and other animals were presented to kids in new and exciting ways; they were filmed in the wild and in different places around the world. While scenes of encounter and capture might be staged, the herps were still in their natural habitat, instead of in a zoo or in a television studio. Kids who watched absorbed every detail; they learned about natural history and conservation, and that some herps were endangered and why. They soaked up in-depth facts about *hundreds* of herps — their names, where they lived, natural history facts — much like some kids do with dinosaurs. They learned to respect living creatures, and they yearned to have cool adventures like their heroes did. It may be difficult to measure the degree of influence these programs had on children, but it shouldn't be underestimated. Much like books did for earlier generations of field herpers, these TV shows presented a world of possibilities. Kids saw the planet as a place filled with plants and animals, and they could see themselves as a part of it. There is no shortage of young biologists who were inspired in their choice of profession by the likes of Steve Irwin, Jeff Corwin, and Mark O'Shea, and it is hard to find younger field herpers who weren't influenced by them.

The impact of this "television herping" generation brought change to field

herping. The old "bring 'em back alive" paradigm was fading; the new kids on the block were interested in field experiences, but many had no desire to collect animals and were opposed to the practice. Their television education had given them a different perspective on herps, habitat, and conservation. Women and minorities had a larger presence in this generation, changing the demographic and adding new voices and viewpoints. There was also a degree of change in relations between academia and field herpers, as young biologists kept close ties with their nonacademic herping friends. A natural exchange of ideas and information developed, and each group could inform the other. Field herping and herpetoculture assumed their own identities, and while plenty of people were still engaged in both, a growing number did one or the other. Additionally, many field herpers who kept captive herps at home did not collect animals from the wild and viewed both interests as completely separate.

As the century and the millennium turned, the popularity of wildlife shows waned, but the Internet and social media platforms were ready to fill the gap. Online forums like kingsnake.com and Field Herp Forum were hangout spots for the field herping community where herpers could post photos of their trips and see what others were up to in the field. New herpers could soak up information and ideas, including herping ethics and etiquette. In this visually rich environment, someone could virtually herp online by following the exploits of others. In the first decade of the twenty-first century, hundreds of herp-related books were available, and field herping magazines like *Fauna* and *Herp Nation*

were launched. In 2006 the North American Field Herping Association (NAFHA) was formed, which used Field Herp Forum as its base of operations. NAFHA featured regional chapters with their own subforums; these chapters bonded socially online and on organized field trips.

Things changed again as social media platforms, with their abilities to instantly share images and other information, gradually pushed the forums into a corner. Instead of "building a post" and relying on a photo-hosting website, you could take a picture with your phone and share it instantaneously on Facebook, Instagram, YouTube, and other platforms. There was no longer a need to carry your experiences to the Internet; the Internet came with you. The forums lost many of their participants, and the community activities that were a part of NAFHA waned under the weight of Internet 2.0 and its active social networks. For all their merits, however, social media platforms are much better at showcasing individuality than they are at building communities. Future technologies may remedy this problem, but in the meantime, today's single-digit crowd can approach field herping through books and magazines, old *Crocodile Hunter* reruns, and the endless Internet.

In the course of about 120 years, field herping has grown in stages that can be traced to advances in technologies and, in some cases, simply by the efforts of a few people. What started as a pastime for perhaps a few hundred souls is now enjoyed by tens of thousands. Herping, like birding, has enjoyed a surge in participants in this new millennium. Can we attribute this to the millennials, who never knew "life as it was before the Internet"? Is the growing popularity of outside activities a reaction to a life spent staring at small screens, or is it enabled by the Information Age? Perhaps it is both. Whether we like it or not, so much of field herping these days relies on, and consists of, information that doesn't exist if the electricity is turned off. For the foreseeable future at least, we still have the option of pulling on our hiking boots, stepping outside our door, and going to see what's hopping and crawling under the warm light of the sun.

YOU MIGHT BE A HERPER IF

- You accidentally forget to remove your headlamp when you go into a gas station at the end of the night and wonder why you're getting all the weird looks.
- You wake up earlier on your day off than on your workdays.
- You visit friends and start flipping things in their yard.
- When someone warns that you might get bitten by a rattlesnake while walking in tall grass, you think to yourself, "Well, at least I found a rattlesnake."
- You've driven over a thousand miles to find a single species — and didn't find it!
- You slam on your brakes for banana peels, bungee cords, and rope.
- You feel as if you've failed as a person if you forget to put your hook back in the car's doorjamb.
- You can drive just as fast in reverse as in drive and are quite adept at jumping from a moving vehicle.
- Musk, a form of defense meant to repel, is in fact the smell of victory.
- Your wife, who isn't into snakes, has better snake ID skills than most biologists.
- You compulsively check the weather every fifteen to twenty minutes.
- You use terms like DOR and AC in everyday speech.
- You well up with pride when you get bitten by a nonvenomous snake.

GLOSSARY

Aestivation A period of inactivity based on excessively warm or dry conditions. Aestivating reptiles and amphibians will typically seek a refuge underground or in a sheltered microclimate.

Amphibian An animal in the class Amphibia, usually able to live in or around both terrestrial and aquatic environments, and having a larval and adult life stage. Amphibians are ectothermic — getting their warmth from the environment — and generally have very permeable skin.

Amplexus The term used for breeding frogs and toads, wherein the male grasps the female from behind in order to externally fertilize the eggs as she releases them into the water.

Artificial cover (AC) Manmade objects that provide shelter and possibly a good place for thermoregulation for amphibians and reptiles. Examples of AC include aluminum sheets ("tin"), plywood boards, and roofing shingles.

Brumation A period of inactivity when temperatures are cool. This period often prepares many amphibians and reptiles to breed, physiologically.

Circadian rhythm The daily activity pattern of a species or individual, for example, nocturnal, diurnal, crepuscular.

Crepuscular An activity pattern in which an organism is active around dawn and dusk.

Ectothermic Ectothermic animals get most of the heat needed for their metabolism from the outside environment, as opposed to endothermic animals, which generate adequate amounts of heat internally. Ectothermic animals maintain their internal temperature by thermoregulation, using a number of different strategies, but ultimately the majority of their heat comes from the sun.

Diurnal An activity pattern in which a species is active during the daytime.

Flipping A herping method that involves turning over artificial or natural cover for amphibians and reptiles taking shelter underneath, then returning the cover object to its original place. See chapter 3 for more elaboration on flipping as applied to different amphibian and reptile groups.

Fossorial (or semi-fossorial) A species that spends a portion of its life underground, sometimes emerging during rains, humid weather, or other conditions that are conducive to aboveground movement. Examples include black-headed snakes (*Tantilla* spp.), mole kingsnakes (*Lampropeltis rhombomaculata*), and mole salamanders (*Ambystoma* spp.).

Generalist A species that has general requirements for some part of its ecology — usually applied to diet (e.g., a dietary generalist) or habitat (a habitat generalist). Compare with *specialist*. Examples include racers and whipsnakes (*Coluber* spp.), which are dietary generalists, consuming a wide variety of prey.

The Herp Activity Model (HAM) For the purposes of this book, the Herp Activity Model is an application of optimal foraging theory to amphibians and reptiles, which states that amphibians and reptiles will seek to obtain food, shelter, water, reproduction opportunities, and optimal basking sites while attempting to avoid wasting energy and predation. The HAM states that the location where a given amphibian or reptile is found represents the individual's trade-offs between these imperatives, and this will differ from species to species, population to population, and individual to individual.

Herpetofauna The term, from the Greek *herpeton* (creeping things), refers to amphibians and reptiles. Although amphibians and reptiles are not closely related, they have classically been grouped together, so the grouping has stuck.

Herps, herptiles See *herpetofauna*.

In situ A Latin term meaning "in place." In situ images of amphibians and reptiles are those in which the animal was photographed as found, unmolested and unposed.

Neotenic A life stage that involves retaining juvenile characteristics into adulthood in salamanders. Neotenic salamanders retain their gills and aquatic lifestyle. This word is often used interchangeably with the term *paedomorphic*.

Nocturnal An activity pattern in which a species is active at night.

Paedomorphic See *neotenic*.

Poikilothermic The term refers to organisms with varying internal body temperatures. See *ectothermic*; amphibians and reptiles are both poikilothermic and ectothermic.

Poisonous The terms refers to a species that has a toxin but no ability to inject it, such as poison dart frogs (e.g., *Dendrobates* spp.) or cane toads (*Rhinella marina*). Thus poisonous species must be eaten or physically handled for their toxin to take effect. Outside the scientific community, *poisonous* was historically used as a catchall term for any toxic animal, but now *poisonous* and *venomous* are differentiated in biology.

Reptile An animal in the class Reptilia. Reptiles are usually ectothermic — getting their heat from the outside environment — and have tough, often scaly, impermeable skin.

Road cruising A field herping method that involves driving roads through proper habitat for herps crossing. See chapter 3 for more elaboration on road cruising as applied to different amphibian and reptile groups.

Specialist A species that has special requirements for some part of its ecology — usually applied to diet (e.g., a dietary specialist) or habitat (a habitat specialist). Compare with *generalist*. Example: Black-headed snakes (*Tantilla* spp.) are dietary specialists, eating mostly centipedes.

spp. The abbreviation for species, referring to all the species within a given genus. For example, "*Thamnophis* spp." refers to the many species of gartersnakes and ribbonsnakes within the genus *Thamnophis*. The singular form, sp., refers to any species within a genus; sp. nov. stands for "species novum," or new species — used when the organism being discussed is not yet described by science but is generally thought to belong within the given genus.

Thigmotactic Species that are thigmotactic have a preference for dark, tight, and enclosed spaces such as in rock crevices or underneath cover objects.

Venomous A species that has a toxin with the ability to inject it — for example, venomous snakes such as rattlesnakes. Historically, *poisonous* was an acceptable term for such species, but most biologists now differentiate between the two terms. See *poisonous*.

Vernal pool Wetlands found primarily in the eastern United States that fill up in the spring and are often dry by late summer. These are important breeding grounds for many mole salamanders (*Ambystoma* spp.), frogs, and other species. Elsewhere, similar wetlands may have local names, such as Carolina Bays or Prairie Potholes.

ABOUT THE AUTHORS
(AND A LAST WORD)

Mike Pingleton

I live in Champaign, Illinois, where I have been gainfully employed at the University of Illinois for more than a quarter century. I work as a computer operations manager, and I'm sure you can guess what I do in my spare time. I became interested in herps in my early teens, when I found several species of snakes in my backyard. On that day, there was a large, inaudible *click* somewhere inside my head, and I became that weird kid who spent all his spare time trudging around the landscape looking for herps.

Over the years, I managed to immerse myself in field herping and herpetoculture; I helped to keep several herpetological societies operating, I attended regional conferences, organized field trips, and kept and bred a wide (too wide) variety of amphibians and reptiles, which made me very tired. In 1993, thanks to my proximity to cutting-edge technology, I became an early navigator of the World Wide Web, as it was called. I learned to code HTML and put up a herp-related web page. It was a natural idea but new; at first there was me, a belly dancer with her pet python, and a guy in Florida with a pet anole. There may have been more, but I can only recall Rebecca, Paul, and me.

Around this time, I decided to curtail my herpetocultural activities and committed to spending more time in the field, which of course spiraled out of control. In 1996 I decided to start journaling about my field herping trips on my web page; I like to brag that I was blogging before it was invented. I also put my life list online, and I was pleased when other herp journalers and life-listers began popping up like toadstools after a rain. I felt like we were onto something.

Between web pages, online forums, and field trips, I made a lot of friends in the field herping community, and my herping trips went farther and farther afield. This development was a relief to me because before the Internet, it was hard to connect with other field herpers. Some of my friends are biologists who gave me opportunities to participate in surveys and other research activities — some of which remain among my most memorable field experiences. Once my kids were grown and out of the house, my herp trips expanded to international locations, and I began to spend a lot of time in Mexico and Peru. (I now spend several weeks a year working as a wildlife guide and herp enabler in the Amazonian rain forest.)

Working in computer operations, I wrote a lot of "how to" procedures documentation for my staff, and the experience came in handy when I sat down to write a how-to book on redfoot tortoises, published in 2009. In turn, that experience came in handy when it came time to coauthor this "how-to" book. I'm looking forward to working on other writing projects (maybe a "why-not" book this time). In the meantime, I continue to write blog posts about field herping at *www.fieldherping.org* (pretty cool that I snagged that name).

Josh Holbrook

I've been an amphibian and reptile fanatic my whole life, starting with amphibians — but mostly because I wasn't initially good enough at herping to find reptiles. I eventually moved from the coastal salt marshes of Connecticut to the Florida Everglades — where, consequently, I earned my bachelor's degree in biology at Palm Beach Atlantic University and my master's in environmental science at Florida Atlantic University. While working on my degrees, I found paid opportunities to work with herps lacking, so I made my own opportunities for herp work. It's amazing all the cool stuff you can do if you'll work for free. I herped every weekend and conducted a study of the effect of Burmese pythons on mammal populations in the Everglades. I teamed up with my undergraduate advisor, Tom Chesnes, and after converting Tom into a herper, we published our

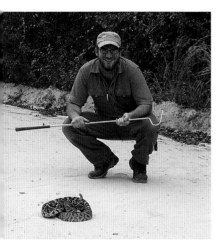

work in an obscure, regional peer-reviewed journal. Our work never made much of a splash until it was cited in another paper by some colleagues with much more PR savvy.

While working on my undergraduate degree, I also authored *A Field Guide to the Snakes of Southern Florida*, which included my own photographs and sold approximately seven copies (thanks for buying six of those copies, Mom). I also met my wife, Rebekah, in my undergraduate years (although I met her before she was actually my wife, if you can believe it). When asked if she also likes herps, Beka typically responds, "I married into it." But she has handled it all like a champ from the first time I threw a scarlet snake into her hands.

After college, I worked as an educator at the Palm Beach Zoo, where I discovered that (a) as fascinating as animals are in the relative vacuum of captivity, the wilds are much more interesting, and (b) although I am good at it, teaching elementary-aged students on a daily basis was not good for my mental health. So, with that wisdom in hand, I departed for graduate school in the Dorn Lab at Florida Atlantic University. Like Gandalf before him, my advisor Nathan Dorn gave me the kick out the door I needed to be a good scientist, and in the long run a better herper and person. I studied wetlands and the reptiles and amphibians (and fish and invertebrates) that inhabited them, and Nate proceeded to expose every flaw in my logic, writing, and field methods. In the end, this meant I was able to produce some real, meaningful, and solid research that could contribute something significant to wetland herpetofaunal conservation.

As grad school wrapped up, I was given the chance to go on a couple of TV shows on the Weather Channel, the History Channel, and the Discovery Channel to talk about herps. I also decided that it was as good a time as any to embrace a life of poverty and self-denial and took up a job as a teacher of missionaries in sustainable agriculture and tropical medicine at Equip International, all while my family and I (now plus two, Chava and Josephine) lived solely off the kindness of friends, family, and sometimes relative strangers.

Nowadays, I'm a professor at Montreat College in the salamander mecca of western North Carolina and teach classes in biology and environmental science — and work herpetology into the mix whenever I can. At any given time,

I can be found leading students seining for creeping things in the local creeks, road cruising for snakes, or anything else I can do to introduce them to the wondrous natural world all around them, and perhaps — just perhaps — get a couple to catch "the herping bug."

Last Words from Mike and Josh

There's no better time to get out in the field than right now. Make no mistake: we live in a time when many animals are teetering on the brink of extinction. It may be that you are the last generation to see some species, or you may be the ones who turn the tide and help save them. We sincerely hope it is the latter. The oft-quoted "we only save the things we love" may seem like a cliché, but that does not diminish its truth.

Our hope with *The Field Herping Guide* is that we've offered some sage advice, practical instruction, perspective, and direction in the pursuit of amphibians and reptiles. We hope that the methods, ethics, and strong citizen-science and conservation mind-set we've imparted will be enjoyed and heeded for the up-and-coming and the old-timer generations alike. We also hope this book inspires you to have some awesome adventures in the field. Thanks for letting us take part, and we'll see you in the field.

INDEX OF TOPICS

effects of moon phases on, 51, 52, 53; of
 lizards by snakes, 61; refuges from, 22,
 57, 82–83
privately owned land, 24, 157
protected species, 154
public lands, 21, 157, 210–13

radiant heat, 35, 66, 68. *See also*
 thermoregulation
rain: absorbed by amphibians, 92, 96;
 frogs and toads calling during, 91, 95;
 as stimulator of activity, 26–27, 45, 65,
 68, 84. *See also* water
ranavirus, 207
rear-fanged snakes, 112
refuges: predator, 57, 62–64; thermal, 58,
 64
releasing herps, 147–48
reproduction, 39, 47–48, 92–93
reptiles, activity of, 27–28
reputations, 145
road cruising: described, 66–70;
 dynamics of, 69–70; jargon, 63; law
 enforcement and, 135; safety issues and,
 134–35; for salamanders, 97

salamanders: finding, 96–103; handling,
 129–32; migration of, 26, 97; on rainy
 nights, 26; taxonomy of, 9
sanitation, 126, 149–50, 151
scientific names. *See* taxonomy
search images, 31
snakebites, venomous, 110, 116, 134,
 138–43
snake fungal disease, 208–9
snake hooks, 20, 21, 111; and handling
 venomous snakes, 110–11; and
 photographing venomous snakes, 200

Snake Road, 159, 219–21
snakes: bites from, 107–8; finding, 61–78;
 handling, 106–18; musk of, 109, 118;
 rear-fanged, 112; taxonomy of, 10;
 venomous, 110–16, 139–43
snorkeling: for aquatic salamanders, 100;
 for turtles, 86, 87, 191
social media, 9; etiquette, 161; reputations
 and, 145–46; trigger points on, 160
southern Appalachians, 221–22
species. *See* taxonomy
squamates, 61
subspecies. *See* taxonomy

taxonomy, 4–6, 9–10, 12–13, 162–72
tentacled snake, 155
thermoregulation, 34–36, 51, 58, 68, 71
thigmotactic behaviors, 62–64
ticks, 136, 137–38
toads. *See* frogs
traps (aquatic), 122–23, 129, 130, 131,
 214–18
turtles: finding, 78–88; handling, 122–23;
 in parks, 86; on railroad tracks, 80;
 on roads, 78–80; taxonomy of, 10;
 trapping, 122–23

venomous snakes: handling of, 110–16;
 snakebites from, 110, 116, 134, 138–43

water: drinking, 45, 83; as microhabitat,
 60; as part of edge habitat, 56–57, 93; as
 part of gear, 16, 147; as place to herp,
 21–22, 54–55, 74–76; relationship to
 herps, 45; stimulating movement, 48;
 of temporary wetlands, 176–77
wrangling, 198, 200, 202

INDEX OF SCIENTIFIC NAMES

oreganus, 138; ornatus, 35; pyrrhus, 63;
 tzabcan, 115, 223
Crotaphytus, 73, 120; collaris, 119;
 dickersonae, 190
Cryptobranchidae, 100
Cryptobranchus alleganiensis, 26, 100, 101,
 131, 222
Ctenosaura, 73; similis, 223
Cuora amboinensis, 88

Desmognathus, 99, 104; monticola, 169;
 quadromaculatus, 99
Diadophis punctatus, 52, 65, 109
Dicamptodon, 99, 131; ensatus, 132
Dipsosaurus dorsalis, 76
Dispholidus typus, 112
Drymarchon: corais, 225; couperi, 77, 78,
 83, 150
Drymobius margaritiferus, 149

Elaphe,168
Elgaria, 72
Emydoidea blandingii, 87, 197
Ensatina, 98; eschscholtzii xanthoptica,
 96
Erpeton tentaculum, 155
Eurycea, 37, 99; lucifuga, 98

Farancia, 51; abacura, 74; erytrogramma,
 41
Furcifer oustaleti, 72

Gambelia, 76; wislizenii, 73
Gerrhonotus, 72
Glyptemys insculpta, 87, 152
Gopherus, 80; agassizii, 82; berlandieri, 82;
 evgoodei, 82; morafkai, 82; polyphemus,
 77, 78, 82–83
Graptemys, 86
Gyrinophilus porphyriticus, 59, 99, 222

Haldea striatula, 65
Heloderma, 121–22; horridum, 121;
 suspectum, 121
Heosemys annandalii, 88
Heterodon, 49; gloydi, 77; platirhinos, 49,
 112, 126; simus, 49
Hydromantes, 98
Hyla, 162; arenicolor, 95; cinerea, 39, 162–
 63, 168; chrysoscelis, 94, 126; femoralis,
 188; gratiosa, 47, 93, 127, 163; squirella,
 91; versicolor, 94, 95
Hypsiglena: chlorophaea loreala, 112; jani
 texana, 25

Iguana iguana, 73, 79, 120

Kinosternon, 87; integrum, 193

Lachesis, 115
Laemanctus serratus, 223
Lampropeltis, 74; alterna, 66; californiae,
 196; calligaster, 161; floridana, 24; nigra,
 167; rhombomaculata, 65; triangulum,
 64, 199; zonata, 148
Leptodeira frenata, 223
Lichanura trivirgata, 222
Liodytes: alleni, 37; pygaea, 75, 189
Lithobates, 93; capito, 83; catesbeianus, 41,
 54; grylio, 70, 219; palustris, 126; sphe-
 nocephalus, 219; sylvaticus, 27, 93, 222

Macrochelys, 43–44, 123; suwanniensis,
 167; temminckii, 167
Malayemys macrocephala, 88
Masticophis: flagellum, 105; lateralis
 euryxanthus, 42
Micrurus: diastema alienus, 143; fulvius,
 113

Necturus, 26, 100, 129; maculosus, 101;
 punctatus, 102